The Art of Reflection

The Art of Reflection
Women Artists' Self-portraiture in the Twentieth Century
Marsha Meskimmon

Columbia University Press **New York**

Columbia University Press
Publishers Since 1893
New York Chichester, West Sussex
Copyright © Marsha Meskimmon 1996

First published by Scarlet Press
5 Montague Road, London E8 2HN

Library of Congress Cataloging-in-Publication Data
Meskimmon, Marsha
The art of reflection : women artists' self-portraiture in the
twentieth century / Marsha Meskimmon.
p. cm.
Includes bibliographical references and index.
ISBN 0-231-10686-6 (hc). — ISBN 0-231-10687-4 (pb)
1. Women artists—Psychology. 2. Self-perception in women.
3. Self-portraits. 4. Art, Modern—20th century. I. Title.
N71.M45 1996
704.9'424'082—dc20 96-14028
∞
Casebound editions of Columbia University Press books are printed
on acid-free paper.

Printed in Great Britain
c 10 9 8 7 6 5 4 3 2 1
p 10 9 8 7 6 5 4 3 2 1

Contents

2: The Autobiographical Model

3: Women's Self-portraiture Explorations of the Body

4: The Body Politic

Conclusions: Reflecting on the Future

Notes

Selected Bibliography

Acknowledgements

There are many people whom I would like to thank for their support, encouragement and assistance during the production of this book. I would like to thank those galleries and museums who agreed to let me reproduce works (often at vastly reduced rates or for free) and all of the artists who gave such generous assistance, both in terms of permission to use their works and in encouraging correspondence about the project itself. The Centre for Interdisciplinary Research in the Arts and Humanities, School of Arts, Staffordshire University, helped with the funding of the illustrations and Iris: The Women's Photography Project, also at Staffordshire University, was an invaluable archival resource for contemporary women photographers.

Both colleagues and students of mine read drafts of the manuscript and provided insightful and constructive comments. To Paul Jobling, Martin Davies, Shearer West, Mark Shutes and especially Helen Chapman, I owe a debt of gratitude. My former undergraduate and postgraduate students, Esther Sayers, Christina Langdon and Tiffany Care, all agreed to read the manuscript and their comments were particularly important in the editing process in which I sought to ensure that the book was accessible to a wide range of readers. Special thanks must go to my former student and friend Effie Delphinius who voluntarily acted as my research assistant during the summers of 1994 and 1995, helping to complete the literature search. Effie also read sections of the manuscript and provided insights into material less familiar to me. My editor at Scarlet Press, Avis Lewallen, deserves thanks for her encouragement and constructive criticism throughout the project. She was a subtle and genuinely committed reader.

Finally, I would like to thank my partner Graham. He has given me the courage to understand my own situation as an 'embodied subject' and my own investments in my work.

Illustrations

Cover, Joan Semmel, *Me Without Mirrors*, 1974, courtesy of the artist and Greenville County Museum, Greenville, South Carolina

Karen Augustine, *Joe/Not in Me*, 1992, courtesy of the artist

Charlotte Berend-Corinth, *Self-portrait with Female Model*, 1931, courtesy of the Alte Nationalgalerie, Berlin

Louise Bourgeois, *Torso/Self-portrait* (photo by Peter Bellamy), 1963–4 courtesy of the Robert Miller Gallery, New York.

Deborah Bright, *Untitled* from the *Dream Girls* series, 1990, courtesy of the artist

Chila Kumari Burman, *I Am Not Mechanical* (photo by Christine Parry), 1991, courtesy of the artist

Helen Chadwick, *Vanity 2* (*Of Mutability* series), 1986, courtesy of the artist

Paraskeva Clark, *Myself*, 1933, courtesy of the National Gallery of Canada, Ottawa

Tee Corinne, *A Self-portrait Dialogue with Time and Circumstance*, 1967–92, courtesy of the artist

Susan Czopor, *The Mother Gives, the Child Takes*, 1991, courtesy of the artist

Margaret Dawson, *Maori Maiden*, 1985, courtesy of the artist

Cheri Gaulke, *This Is My Body* (photo by Sheila Ruth), 1982, courtesy of the artist

Elsa Haensgen-Dingkuhn, *Self-portrait with Little Son in the Studio*, 1928, courtesy of the artist's family

Marikke Heinz-Hoek, *From the Foundations of the Second World War*, 1979, courtesy of the artist

Susan Hiller, *Self-portrait*, 1983, courtesy of the artist

Frida Kahlo, *Self-portrait with Cropped Hair*, 1940, courtesy of The Museum of Modern Art, New York and the Museo Dolores Olmedo Patiño, Mexico

Roshini Kempadoo, 'What do they expect me to be today?' from *Identity in Production*, 1990, courtesy of the artist

Marie Laurencin, *Group of Artists*, 1908, courtesy of the Baltimore Museum of Art

Marisol, *Self-portrait*, 1961–2, courtesy of the Museum of Contemporary Art, Chicago

Rosy Martin (in collaboration with Jo Spence), *Dapper Daddy*, 1986, courtesy of the artist

Rosy Martin (in collaboration with Jo Spence), *Unwind the Ties that Bind*, *c.*1988, courtesy of the artist

Maedbhina McCombe, *Clitoris Allsorts*, 1990, courtesy of the artist

Alice Neel, *Self-portrait*, 1980, courtesy of the National Portrait Gallery, Washington, DC

Anne Noggle, *Facelift no. 3*, 1975, courtesy of the artist

Anne Noggle, *Reminiscence: Portrait with My Sister*, 1980, courtesy of the artist

Gerta Overbeck, *Self-portrait at an Easel*, 1937, courtesy of the artist's family

Cath Pearson, *25 October; 5 Months, 2 Weeks*, 1990, courtesy of the artist

Cath Pearson, *13 November; 6 Months*, 1990, courtesy of the artist

Sarah Pucill, *You Be Mother*, 1990, courtesy of the artist

Jenny Saville, *Self-portrait* (with Glen Luchford), 1994–5, courtesy of the artist

Esther Sayers, *A Picture of Me*, 1995, courtesy of the artist

Eva Schulze-Knabe, *Self-portrait*, 1929, courtesy of the Gemäldegalerie Neue Meister, Dresden

Cindy Sherman, *Untitled no. 224*, 1990, courtesy of Metro Pictures and the artist

Renée Sintenis, *Drawing Nude: Self-portrait*, 1917, courtesy of the Stadtische Kunstalle, Mannheim

Sylvia Sleigh, *Philip Golub Reclining*, 1971, courtesy of the artist

Sylvia Sleigh, *SoHo Gallery*, 1974, courtesy of the artist

Jo Spence, *Exiled* (with Dr Tim Sheard), 1988, courtesy of the Jo Spence Memorial Archive

Jo Spence, *Mother and Daughter Shame Work: Crossing Class Boundaries* (with Valerie Walkerdine), 1988, courtesy of the Jo Spence Memorial Archive

Diana Thorneycroft, *Untitled (Brother Mask with Toy Gun)*, 1990, courtesy of the artist

Charley Toorop, *The Meal of the Friends*, 1932–3, courtesy of the Museum Boymans-van Beuningen, Rotterdam

Charley Toorop, *Three Generations*, 1941–50, courtesy of the Museum Boymans-van Beuningen, Rotterdam

Marevna Vorobieff, *Homage to the Friends of Montparnasse* (undated), courtesy of the Petit Palais Museum, Geneva

Foreword

How Do I Look?
by Rosy Martin

How do I look? What image do I present to the world? How do I activate the power of the look and with what preconceptions? How do I find myself reflected in the images that surround me, or not? How do I mediate and interrelate those pre-existing images with my ever changing self-image? How might I represent myself?

Searching for myself in the mirroring offered by others, learning later that I, as a woman, am defined as 'other' and perforce perform the roles ascribed or rebel against them, caught in the acts of the masquerade. Is the impetus for self-portraiture an endless seeking for the answer to the question 'Who am I?' Always, already too complex to answer, as identities are forged and continually in flux, subject to the play of history, culture and power.

Self-portraiture is a way of coming into representation for women, in which the artist is both subject and object and conceives of how she looks in the sense of how she sees rather than how she appears. She presents an embodied subject. How will you as an audience read her?

As a practitioner who has chosen to use self-portraiture, or rather portraits of a multiplicity of selves, in my work, I believe this book gives a fascinating historical overview of women artists' differing strategies towards self-portraiture throughout the twentieth century and an analysis of why this area has proved so fruitful and inspiring for women. By situating individual women's practice within their time, place and culture, a critique of both their intentions and achievements is provided which offers a contextualised clarity of understanding. What comes

across particularly clearly is the watershed of the second wave of feminism, the advent of postmodernism and an articulated cultural politics. This book is an invaluable reference, and includes a range of work: some well known, some of which I had come across in my own continuous research and some engaging unfamiliar surprises.

The first chapter provides an historical analysis of the ways in which women artists have used self-portraiture as a strategy to say I am here, to insert themselves as practitioners within the masculinist myth of the artist as hero/genius and how they challenged, unpicked and re-appropriated conventional tropes. The group portrait was also employed as a means of showing their creative involvement within the avant-garde movements of modernism, which despite seemingly offering an alternative had elided women's active contributions.

By critically contesting traditional notions of autobiography – the true story of the life of the already famous – and self-portraiture – a route to knowing the creative personality through the image – the impossibility of any transparent relationship between the author and subject of the text is established. Arguing against any simplistic anecdotal reading of women's self-portraiture, individual artists' oeuvres are repositioned back within their intellectual and aesthetic concerns. Since 1968, with the emergence of feminism and postmodernism, the autobiographical has been refigured as a site of conflicting social discourses and definitions and a valuable starting point for the examination of the constructed and mediated roles of women, through personal experiences.

Questions of gender, sexualities and maternity as addressed by women through self-representation are considered in chapter 3. The problematics of reappropriation for women who explore their heterosexuality within their work is considered. For lesbians the challenge is to claim their visibility while undermining notions of deviance. Women have examined gender positions of masculinities as parody, femininities as masquerade and excess. The androgynous position has been the most thoroughly explored, shifting during this century across New Woman, lesbian and cyber-feminist, moving from playing with the boundaries of gender divisions to stressing the lack of fixity in gender positions. Coming to terms with being both creative and

procreative has been expressed through investigating the lived realities and fantasies of the maternal body in pregnancy, childbirth, and the social and psychic complexities of the mother–child relationship.

The politics of representation and how women have contested what constitutes art practice are addressed in the final chapter. Women's engagement with institutional discourses within self-portraiture offer a model of negotiating the public/private domains. Practitioners have addressed the issues of difference within the term 'woman' with regard to race, ethnicity, class, age and disability through an exploration of self-image which confronts stereotyping and proclaims self-defined presence.

Questions concerning the representation of women and the role of the gaze have been foregrounded since the 1970s. This book offers an overdue opportunity to consider how women artists have used their own self-representations to explore, expand and reclaim the act of looking and making meanings within cultural production for themselves. In so doing they have made visible complex, multilayered, fragmented and diverse subjectivities.

If the task was to find oneself, then the crisis for the postmodern subject is that nowhere is home, everything shifts and changes. What is the reflection in the mirror that 'vanity' holds? She refuses now to be the 'site' of another's desire and reflects back to you the insubstantiality of your projections.

Introduction: Reflections on Women's Self-portraiture

Me Without Mirrors

In 1974, the American artist Joan Semmel painted a self-portrait entitled *Me Without Mirrors*. This image represents in microcosm the enquiries of this volume as a whole. Semmel's work is the encounter between a woman artist engaging in self-representation and a masculine tradition. Significantly, it is not a negative encounter marked by stalemate or impasse; women artists throughout the twentieth century have challenged the conventions of the genre and concepts of the self and have negotiated new and extraordinary spaces in which they have produced their self-portraits. Semmel's work stands as one such moment.

Me Without Mirrors can be interpreted within a framework of interconnected traditions and subversions. Its primary encounter is with traditional self-portraiture in which the internal rules of the genre require the use of the mirror. On this model, it is expected that artists will produce accurate renderings of their features based on their reflection in the mirror. The reflection itself represents a second stage in self-portrait production between the artist as the subject and the self-portrait as an objective imitation. This is especially true of western figurative painting in which naturalism, or forms of representation which follow rules of 'truth to nature', have been privileged. Semmel's work is monumental figural painting and thus harks back to the most traditional areas of fine art practice, yet subverts them. To deny the mirror in a painted likeness of the self is to defy convention in respect of the genre of self-portraiture. This self-portrait, 'without mirrors',

asserts a different model of seeing, likeness and representation through the simple device of challenging the mirror.

Furthermore, *Me Without Mirrors* can be connected to the conventional representations of women in western fine art practice. In this way, the work engages in a whole series of body politics. The female nude, displayed in painting, sculpture and fine art photography and graphics, has come to connote beauty, wholeness and, in many ways, 'art' itself. The forms in which the female nude finds representation are highly stylised and have little to do with images of particular (individual) women's bodies. They are more often meant to be universal metaphors for masculine desire, creativity and culture. 'Woman' as 'nature' or material form is transcribed by masculine creative energy into 'the nude' as an icon of cultural production.

Semmel's representation of her own body confronts these stereotypical ideals of the female nude. The image does not privilege the spectator by posing the body as a displayed object, rather the image is one of first-person intimacy which actually 'protects' the body of the artist from specular dissection. The title of the work compounds this by asserting that the nude is the artist, not just an unnamed 'model' to be viewed as an object produced by the artist on the canvas. The power of the artist (usually male) over the nude female model was multiple; he had economic control, 'aesthetic' or representational control and social control within the economy of the studio. When women artists approached the subject of the nude female in representation, they frequently subverted these power politics by representing themselves. This confounds simple constructions of the difference between the subject and the object of the work (the woman artist is both) and forecloses on the traditional disempowerment of the female nude.

Yet another western fine art tradition is subverted by Semmel's image, the iconography of 'vanity'. The sin of vanity was most commonly represented by the image of a woman staring intently at herself in a mirror. This iconography was frequently built into representations of women both as an enticement to the spectator to join in this pleasurable viewing and as a warning about the sins of the flesh. Semmel's work represents the artist drying herself with a towel and, as such, it can be associated with a whole tradition of paintings which

show the nude female bathing or at her toilette. This device was used in order to find a plausible scene in which to display the nude female form, but it often inscribed the nude body of 'woman' into a whole set of readings concerning the inherent nature of the sexes and their proper roles. Most significantly, nude female 'bathers' or women dressing in artworks are generally represented with mirrors. These mirrors indicate both that the woman is an appropriate object of specular consumption and that she colludes with this. That is, the traditional representation of vanity (the female figure with a mirror) is implied by these works and acts to legitimate our voyeuristic looking at the body of woman. Women 'want' to be looked at – it is in the nature of woman to be passive and viewed, while man looks, actively. The gendering of our whole specular economy is in-built in fine art representations of 'woman', and especially in those which incorporate the tropes of the nude female and the mirror. Semmel's nude self-portrait again suggests readings which are against the grain by negating the mirror and the whole masculine viewing paradigm of the western figural painting tradition. Her work alters the relationship between viewer and viewed, thus disrupting simple binary structures.

If *Me Without Mirrors* can be read as subversive of a host of traditional fine art practices ranging from conventions within self-portraiture to the representation of the female nude, then it is also subversive of the western, masculine traditions of thought which privilege a link between seeing and knowing. In this way, it acts as a visual metaphor for feminist theory and is akin to the writing of such feminist philosophers as Simone de Beauvoir and Luce Irigaray, both of whom challenge the specular economy.

The mirror as a metaphor for painting itself is a significant one.[1] Conventionally, we read mirror images as accurate visual reflections of real objects. The way that the mirror mimetically reproduces the image of reality is a model for the rules of aesthetic naturalism. The painting should conform to the logic of the mirror; it should succeed or fail, in part, in the extent to which it 'mirrors' the likeness of the world. Its imitative properties are based upon ideas of appropriate reflection. Clearly, works of art have been expected to do more than this, but one aspect of our reading of them is based upon such notions of the power

of representations to mirror or simulate reality itself. This is associated with the privilege of sight over the other senses in western philosophical discourses on knowledge. To see, fully and accurately, is to know; consider the enormous significance granted to seeing bodies, cells and atoms in our scientific understanding of the world. To represent the objects in the world correctly is to know and understand them. Representation is inextricably linked to the power of knowledge. The conventions of the mirror, described so far, have influenced not only painting, but all aspects of the visual arts.

In addition to the issue of likeness, the mirror also acts as a metaphor for framing images. In the aesthetic realm, as in the philosophical, the frame constructs the image or the knowledge. The frame places certain material into the centre of discourse and marginalises others. That which is within the frame of the mirror is proper; it can be described, seen and understood. That which remains outside the frame of the mirror is out-of-bounds, disturbing and indecipherable. To move the mirror is to change the frame and thus to consider different knowledges and different subjects. Western art has been strictly controlled with regard to framing, as has western knowledge. Only a very limited number of subjects have been considered appropriate for 'art'; the rest fall into the realms of, for example, 'primitive' fetishes, low popular cultural forms or obscenity. That is, they become the marginalised, unframed 'other' to elite art. Yet again, Semmel's deliverance from the mirror challenges the propriety of what is within the frame of her work. This is not the high art nude, framed for display and delectation, it is the particular body of a woman which confronts the limits of representation in every way.

Yet another critical meaning of the mirror pertains specifically to the definition of the 'self' and thus to its visual representation. In psychoanalytic theory, it is through the so-called 'mirror stage' that the infant's undifferentiated psyche becomes part of the social fabric and acquires its identity as an individual subject or 'self'.[2] Through seeing itself in the mirror with the mother, the infant is enabled to differentiate its polymorphous experiences of its body from those of the mother and first form a specular image of its whole self. In short, it is contended that this 'mirror stage' is both to do with an observed phenomenon of

infantile development and, significantly, acts as a metaphor for the construction of the subject. The self, in western knowledge systems, must be constituted as a whole in opposition to 'others' in order to make sense of language and the society into which it is thrust. The privilege of sight, as an 'objective' sense through which we can 'objectively' understand the world, makes the logic of the mirror a cultural norm and is itself a gendered account.

Not surprisingly, feminists have questioned the 'logic of the mirror' which operates to marginalise and disempower women. Feminist sexual politics have challenged the notion that women have any form of innate desire to be viewed as objects. They have argued that it is her position within a male-dominated society which assigns such a role to woman, not any form of biological imperative. The subject and object roles traditionally associated with masculinity and femininity respectively cannot be treated as natural and inalterable. Rather, they must be seen as signs of unequal power relations between the sexes and hence revised. At the level of representation, women artists have consistently confronted the stereotyping of woman as an object in western culture by revealing the viewing structures which support it. Challenging traditional iconographic modes such as the representation of the bathing female nude as 'vanity' has been one such form of powerful feminist critique. Another has been to take on the metaphor of the mirror directly. Significantly, feminist authors as diverse as Virginia Woolf, Simone de Beauvoir and Luce Irigaray have developed this trope in their writing. Woolf wrote in 1929: 'Women have served all these centuries as looking-glasses possessing the magic and delicious power of reflecting the figure of man at twice its natural size.'[3] This quip elegantly poses the relationship between men as subjects and women as objects in our society. The economy itself is masculine; 'woman' can have a value within it only in relation to 'man'. Her role is defined as that object which accompanies, enhances, reflects *him*. Women as individuals have no identity in this system.

Simone de Beauvoir took up this position at much greater length in 1949 in her book *The Second Sex*. This pivotal piece of feminist history and philosophy questioned the role of woman in society and related this to a logic built round the binary opposition between the self (the

one) and the other. Woman was other to man; the second sex could find a voice only within the language of the 'first sex' or the one. Significantly, de Beauvoir continued the references to the mirror as an important metaphor in connection with the place of woman in a masculine society:

> But all her life the woman is to find the magic of her mirror a tremendous help in her effort to project herself and then attain self-identification ... Man, feeling and wishing himself active, subject, does not see himself in his fixed image; it has little attraction for him, since man's body does not seem to him an object of desire; while woman, knowing and making herself object, believes she really sees *herself* in the glass.[4]

Yet again, it is the logic associated with the mirror and its rules of specular knowledge which best define the gendered subject/object divide. De Beauvoir's text sets out both to explain the situation of women in society and to show the way to change this for the better. To challenge the mirror and its associations for women is again perceived to be an important stage on the path to female emancipation.

Finally, Luce Irigaray identified the masculine mirror metaphor with stunning accuracy in her work *Speculum of the Other Woman* (1974). Irigaray pitted the speculum, the convex mirror used in vaginal examinations, against the flat Lacanian mirror (of the 'mirror stage') which reflected only the order associated with masculine law. The mirror, used in western philosophy to define a form of truthful representation, could, for Irigaray, be truthful only in an economy of the same, an economy of the 'one' against 'the other'. This economy is by definition 'masculine' and marginalises woman and 'the feminine' by placing them outside the frame of the mirror. In order to 'see' them, the mirror itself – that is, the logic of our systems of thought – must be altered as the speculum is, to reflect 'the other' in its own terms. As Elizabeth Grosz has written:

> This may explain Irigaray's attraction to Alice, the character in Lewis Carroll's *Through the Looking-Glass* and *Alice in Wonderland*. She acts

as a metaphor for the woman who, like Irigaray (herself an A-Luce), steps beyond her role as the reflective other for man. She goes *through* the looking-glass, through, that is, the dichotomous structures of knowledge, the binary polarisations in which only man's primacy is reflected. On the other side is a land of wonder, a land that can be mapped, not by the flat mirror, but by the curved speculum.[5]

Joan Semmel's self-portrait, *Me Without Mirrors*, is part of a whole body of feminist interrogations concerning the interrelationship of seeing and knowing in a masculine culture. It is not important to know whether Semmel read any or all of these particular authors before producing her work; it is clear that the implications of the mirror metaphor are powerful for women seeking to come into representation outside the male-dominated structures of art, philosophy, history and literature. This book is about women who use the visual arts to stage interventions into the representation of the female 'self'. It ponders the possibility of woman's voice in masculine language. Rather than asserting the theoretical limits or possibilities of 'woman's voice' and then looking for instances of this, the text is led by the practical interventions to suggest theoretical positions. *The Art of Reflection* argues not for a new language, but for new and alternative ways of using the one which already exists. Each of the self-portraits acts both within its own particular context (of place, period, medium) and within the wider context of the representation of 'woman'.

The Art of Reflection: Themes, Issues and Terminology

Theory and Practice: Situated Knowledges

One of the key issues in feminist theory has been that of women's voice in male language. To what extent is it possible to enunciate a truly different position when you are always already within the structures which mark your difference? For feminists considering their own

position as 'speakers', this has revealed a double-bind: to be rendered silent by taking up the traditional and 'appropriate' place of the feminine woman in patriarchy or to adopt a position of power which colludes with patriarchal discourse. If women, for example, merely take up roles normally associated with men in our society, such as positions of political, legal, economic or academic authority, without questioning those roles themselves, they simply replicate the very system they have fought to attain those positions. Women can easily be reinscribed by token gestures without actually changing the structures which marginalise them.

This 'reinscription' is a very important issue in the case of women artists and the consumption of their work. To be a woman and an artist is already going against the grain. It is a profession whose history is dominated by men and thus standard notions of professional practice tend to be masculine. Even now, for example, women artists who have studios within the domestic spaces of their homes are viewed as less professional, possibly less committed to their work, than male artists without domestic responsibilities. Female practitioners also work within a visual language which, like other discursive forms in our society, has been developed by and for men. In order to produce meaning, they must use the dominant codes, but they may use them in alternative ways.

This debate further concerns those who wish to study the work of women artists. The history of art itself is an area of scholarly work formed within a masculine tradition. The modes of writing about art and artists have privileged the work of male artists and particular masculine tropes and iconographies. The history of art, dealing as it does with the sphere of visual representation, has been gender-blind but never gender-neutral. Merely adding women artists to the pre-existent norms and canons of the history of art does nothing to further understanding of their artistic production. It is imperative to explore the significance of gender difference in both the making of the work and in the reading of the work. Women artists produced their work within a system which defined them as different; we cannot now override those differences and force this body of work into masculine-normative structures without seriously misrepresenting it.

This is where the link between theory and practice is most crucial. As Donna Haraway discussed in 'Situated Knowledges: The Science Question in Feminism and the Privilege of Partial Perspective', feminist theory has definitively challenged the myth of pure, scientific objectivity.[6] Knowledge is produced by people with investments in that knowledge. Though Haraway was describing scientific discourse, her points are more widely applicable to academic discourse in general. The myth of objective academic examination has also been exploded by feminist theory. However, this has produced a dilemma for feminist academics who simultaneously wish to produce rigorous intellectual work and to acknowledge that this cannot be totally objective. The point which permits these two positions to function harmoniously is that of situated, or embodied, knowledge. Significantly, Haraway uses vision as the metaphor with which we can construct an embodied knowledge, but not the model of seeing which assumes that there can be an objective, disembodied eye which innocently collects and processes information about the world. Rather, we must acknowledge the positions from which we see, the particular embodiment of our own eyes, and then be both critical of our vision and accountable for it.

But what of women's self-portraiture? This book is about women artists exploring, seeing, knowing and representing the 'self' within male social and discursive structures. As the author of this book, it is not my intention to suggest that I act as that objective academic eye, examining and explaining the works of women artists. Rather, I am myself engaged in a dialogue with these works. This volume, like the works it examines, is a feminist intervention into the masculine structures of seeing and knowing; its structure as well as its subject-matter present a challenge to the traditions of discussing masculine, western self-portraiture. I am committed to the challenges with which women's art practice forces us to engage. It refuses the old canon, it rewrites the old tropes and it makes us think again about representation.

Hence, the structure of this book departs in a number of ways from traditional texts. There is no attempt here to present a straightforward chronology in which 'every' work would find its place in a simple ordering of style labels. Many works are considered in the book from the whole of the twentieth century, but many other works exist which,

though equally significant, could not fit into the format of the text. In order to consider some works at length, it has been necessary to leave others out, lest the book become an encyclopedic listing. Additionally, the structure of the text privileges thematic consideration of the works, rather than a general historical overview. This is, again, a conscious strategy to encourage new ways of looking at self-portraiture and the works of women artists which deal with self-representation. These themes are not exhaustive, but suggestive. They indicate ways in which women's work might be recontextualised and rediscovered.

Most importantly, *The Art of Reflection* seeks to challenge that flat mirroring in which the self is static and knowable. 'Reflection' is about embodiment, about the provisional definitions of 'self' which women artists have constructed through their self-portraits. The works in this volume, and the many others which could not be discussed here, are the practical interventions of women into self-representation. Theory and practice find here a viable model of action. Theories about woman in language must encounter women speaking; the two must interact, rather than remain separate, before any changes may occur. This text has been led by the artworks themselves and informed by feminist theory so as to find a form which might just possibly do some justice to the remarkable production of self-representations by women throughout this century.

Terminology: The Sub-text in the Text

There are four thematic chapters in this book, each of which, in some ways, can be read independently of the others as an argument in itself. However, these debates, and the issues they raise for self-portraiture and women's art, are interconnected and the wider structure of the book enables the connections to be brought out. For example, the first chapter deals with the concept of myths of the artist in relation to tropes in self-portraiture. Women artists producing self-portraits encountered a variety of masculine stereotypes with which they interacted in order to make work. The chapter thus concentrates on self-portraiture as a genre which must be rediscovered through the works of women artists. The second chapter continues the focus upon the notion of self-portraiture

as an art historical genre and considers traditional readings of self-portraits as biography and autobiography. Again, the exploration of women's self-portraiture requires a renegotiation of the limits of this model of self-portraiture. The first two chapters together can be seen to begin with the definitions of the genre and then reinvestigate these by means of the self-representations of women in this century.

Chapters 3 and 4 shift the opening of the debate from the genre of self-portraiture and the concept of the artist to the definitions variously ascribed to 'woman'. The third chapter develops ideas associated with gender and sexuality as they are made manifest in and through self-representations. By starting with issues to do with definitions of 'woman' as a gendered and sexed body, it is possible to begin a dialogue with self-portraits by women artists which can explore new configurations of identity and subjectivity. Identity and subjectivity are again taken up in the fourth chapter, but in the light of the politics of the positioning of 'woman'. The chapter looks at the ways in which women artists engage with alternative models of politics through self-representation. The four chapters taken as a whole present a series of discussions around the concept of the 'woman artist' as it emerges through self-portraiture. 'Woman' and 'artist' are not terms which can be juxtaposed simply; rather, they require representational strategies which make their connection meaningful. In self-representation, it is imperative for women artists to find forms which give voice to their situation as both 'woman' and 'artist'. This volume examines the ways in which such situated knowledges come into practice and the implications of this for both the artists and the viewers.

Some difficult choices had to be made regarding the range of material to be covered by this book. Certainly, women artists had produced self-portraits before the twentieth century. However, by the beginning of this century, particular ways of understanding the genre and the structure of the individual subject had become the norm. Thus, more unified debates could be made about work produced in this century than would have been possible had other periods also been included. Furthermore, institutional changes, such as women's entrance into art academies and the rise of the art market, again enabled more general points to be made across the board with regard to the historical

climate in which the works were produced. That is not to say, however, that the twentieth century is a perfectly unified field for discussion.

One of the most significant issues in terms of chronology which arises time and again throughout the book is linked to the radicalism of 1968, a date used as shorthand by a number of scholars to indicate a shift in the political and intellectual climate of Europe and America. The strikes and student uprisings of that period marked a sea-change in many traditional attitudes, not least those concerning women. So-called 'first-generation' or 'first-wave' feminism, the early women's movement from the late nineteenth century concerned with suffrage, marriage law and sexual morality, gave way to 'second-generation' feminism around 1968. This period marks what is most commonly described as 'feminism' or the 'women's liberation movement'. For this text, this date is important; women artists working after 1968 frequently engaged with feminist theory and politics in a highly self-conscious way. This can differentiate their works sharply from those of women artists in the pre-1968 period who engaged with issues critical to 'feminist' politics, but often without explicit consideration of 'feminism'. It is not intended here to place overdetermined feminist interpretations on to works which were produced before such concepts were developed; rather, it is clear that women artists over the whole course of the century developed many similar themes in their work. Hence, the links between the works from before and after 1968 are discussed while particular contexts are also signalled in order to make important differences apparent.

Chronology is significant in other areas as well. One of the main dividing points for the arts in this century is the division between the so-called 'modern' and 'postmodern'. These terms arise in the chapters as work is discussed and require some brief clarification here. While arguments about the definitions of 'modernism' and 'postmodernism' have in no way ceased, the context in which they are used within this text is the most basic and unproblematic one. 'Modernism' in this text refers to the work produced up to about 1960, when the European and American formalist avant-garde 'movements' ('isms') held sway. There are, of course, many valid debates about the particulars of this terminology (such as the role of Dada as a precursor of postmodernism), but for the purposes of this text, the most widely

accepted term will suffice. Modernism, on this model, tends towards formal experimentation, utopian programmes and a concept of the artist as 'avant-garde', literally in advance of the times. Postmodernism, by contrast, refers here to art which rejects utopian formalism in favour of parodic reappropriation and pastiche. It is an art in which high art mixes with low popular culture and its aims are far more self-conscious and even cynical.

The theoretical stance of this volume is indebted to what is known as 'poststructuralist' theory, that body of critical writing developed mainly on the European continent over the past three decades. Without attempting to define and reduce the complexities and contradictions of poststructuralist theory itself, it will suffice here to make a few general points about the relationship between this body of ideas and notions of subjectivity, which, it will become clear, are so critical to the making of self-portraiture. The concept of the individual as a fully self-cognisant and independent entity who can attain objective knowledge about, and mastery of, the objects in the world has been definitively challenged by poststructural theory. Individuals are formed through their encounters with the world; there is no pre-existent essence that is the subject. We are formed by an elaborate interweaving of identifications with socially defined roles and expectations. These become part of our internal, or psychic, identities and can be both pleasurable and/or confining. Furthermore, we may experience contradictory positions within ourselves; some of the roles we 'play' may themselves define us in contradictory ways. For example, a woman artist is in a position in which the social expectations placed upon her as a 'woman' are often in opposition to those she experiences as an 'artist'.

Poststructuralist theory enquires into the constructions of the self and denies myths which attempt to suggest that the self is completely unified and natural. It allows for the interaction between the subject and a host of social forces and seeks models of subjectivity which permit contradiction and tension within individuals. It anticipates that individuals shift between positions and provides a means by which these fluid identities can still be examined critically. In terms of exploring women's self-representations, it brings insights which are crucial to the topic.

One such insight is the sophisticated interplay between representation and identity within the subject. Representation and representations in all their various forms are taken seriously by poststructuralist theories of the subject. In terms of self-portraiture, this insight permits us to examine the interplay between images and the maker of the images, between the representation of the subject and the subject herself. Furthermore, self-portraiture is implicated in the complex interweaving of the subject and object roles we play. The 'author' of the self-portrait is both subject and object. For women, this interaction is particularly critical. 'Woman' has been the object of art for centuries, while women have remained marginalised as producers. To act in both roles, simultaneously, is to stage a crucial intervention. This point is brought out throughout this volume in many varied ways.

One final point remains to be explained here: namely, the distinction made in this volume between 'woman' and 'women'. 'Woman' is used to refer to an abstract notion or symbol of 'the second sex'. It is that body traditionally defined as 'nature', or passive material through which masculine ideals find metaphorical form. 'Women', by contrast, refers to those actual individuals defined through their combined experiences of biology and social life. They are the subjects of this book, the producers of the art examined here. 'Women' is a non-essential term, one which changes from place to place and time to time as the social context which defines it changes. Just as the self-portraits considered in this text mark encounters between the subject and the object, they also explore the relationships between 'woman' and 'women'. The art produced by women bears the mark of the masculine language within which it is produced, but is not simply reducible to it. The practice of women artists engaged in self-representation invokes female subjectivity and the issue of women's voice. The works examined here precede theory and give life to it. We are forced by the power of the work to reconsider the genre of self-portraiture as well as the extent to which 'women' can redefine their roles as speaking subjects in a masculine culture.

1: The Myth of the Artist

The Artist as a Type in Myth and History

The history of the self-portrait in western art practice is linked to the concept of the 'artist' as a type. The 'artist' was defined both historically, in relationship to other occupations and social roles, and, significantly, in mythical terms as a personality type. Self-portrait iconography, in representing 'artists', developed in tandem with changing concepts of the artist. Thus, one of the key features of self-portraiture as a genre is the representation of the variety of roles into which artists have been placed over the last few centuries. The self-portrait as a form is dependent upon the concept of the artist as a special individual, worthy of representation in his own right. And, indeed, it is in *his* own right; since, linked to the status of fine artists, self-portraiture has evolved features mainly exclusive to male artists.

The 'artist' as a special category operated via particular cultural exclusions rendered as the norm through the discourses surrounding artistic production as much as through the artworks themselves. Self-portraits acquired and maintained their meaning and significance through the discourses of art history and criticism which supported a mythology around the figure of the artist and a canon of 'great artists'. This canon, not surprisingly, was class-, race- and gender-exclusive; the 'artist' was an empowered white man. Self-portraiture, as a genre specific to the western tradition, embodied these exclusions and marginalised groups rarely came into representation within self-portraiture at all. The structure of self-portraiture iconography was itself difficult to negotiate for artists who stood outside the white male norm.

Certain tropes, the iconographical 'clichés' of the genre, were meant to give visual form to definitions of the artist. By the twentieth century, the genre was well established and its tropes were particularly resonant with the myths surrounding contemporary artists. Addressing the self-portraiture practices of women artists therefore makes it necessary to engage with the development of self-portraiture itself and to examine critically the modes associated with it. Women's works parodied, challenged and rewrote masculine norms in self-portraiture and thus provide an insight into the far from seamless visual construction of the myth of the 'artist'. Furthermore, their coming into representation in the form of the self-portrait requires a re-examination of the concept of the artist and the art historical discourses which maintained the canon. A wholly new set of embodied knowledges and perspectives of difference move to the centre of the concept of the 'artist' when women artists contend with the self-portrait as a viable form of self-representation.

Prior to the Renaissance, self-portraiture as a genre was all but unknown. There were instances of artists representing artists at work, or commemorating artists in the occasional monument, but these are not self-portraits as the term came to be used in the western tradition. Only with the increased social status guaranteed to artists during the Renaissance, where they laid claim to being considered as more than mere craftsmen, did the self-portrait as an independent sub-genre of portraiture come into its own. It thus evolved as a system of representing the artist as an individual who was as worthy of representation as any wealthy patron. Its visual links to artist 'types' are played out in order to reinforce the significance of the artist as such an individual.

Although the twentieth century is what concerns us here, it is important to discuss the development of myths surrounding artists which coloured the dominant definitions of our century. Most particularly, Enlightenment and Romantic theories of genius fundamentally challenged many of the stereotypes from the post-Renaissance period and determined the definition of the 'artist' from the nineteenth century. For example, in the seventeenth century, the successful artist was a man of means, an acceptable bourgeois. Thus, Rubens's self-portraits (such as *Self-portrait*, 1639), use iconography to

display his wealth, power and social status. Or, at the high point of the academic tradition in the eighteenth century, self-portraits by, for example, Sir Joshua Reynolds (*Self-portrait*, 1773) and James Barry (*Self-portrait*, *c.*1780) used classical references in the form of sculptural busts and paintings to display the learning of the fine artist and his link to the high art tradition.

However, by the beginning of the twentieth century, such displays of the artist as an intellectual bourgeois had become less prevalent as the academic tradition declined in favour of Romantic theories of the 'creative genius', the avant-garde and modernism. These ideas tended to posit the special nature of the artist as a visionary, someone who stood on the periphery of middle-class society rather than in the centre of it. The genius was beyond such mundane tasks as earning a living or caring for a household. The genius simply was; he was born, not educated into this position. Unconcerned with the common chores of daily life, the genius was not absorbed into the rules and regulations of ordered society. His personality set him apart. William Blake and his responses to Joshua Reynolds's *Discourses* at the end of the eighteenth century foreshadow the changing nature of the social role of the artist at this time as reactions to the academic tradition became more prevalent.

In *Discourses on Art*, Reynolds codified the academic standards for fine art practice with which he intended to mould a generation of British artists in the likeness of their continental counterparts. These *Discourses* were, in fact, first delivered as a series of lectures by Reynolds as the President of the Royal Academy to his students between 1769 and 1790. The need for the correct approach to the classical tradition, the Old Masters and life study, as well as the sense that a fine artist must be trained, were all features of the *Discourses*. Significantly, William Blake, whose production always stood on the periphery of the Royal Academy and notions of 'high art', read and annotated his copy of the published form of Reynolds's talks. Blake's responses are the epitome of the attitudes which would lie behind Romantic concepts of artists and genius as well as the burgeoning avant-garde which would challenge the academies all over Europe a century later. Blake was outraged by the idea that art could be taught. According to him, genius simply was, and he contended that:

> Reynolds's Opinion was that Genius May be Taught & that all Pretence to Inspiration is a Lie and a Deceit, to say the least of it ... The Man who says that the Genius is not Born, but Taught – is a Knave ... If Art was Progressive We should have had Mich. Angelos & Rafaels to Succeed & to Improve upon each other. But it is not so. Genius dies with its Possessor & comes not again till Another is Born with It.[1]

Thus, a true artist was born and not made. Additionally, he could not be a slave to tradition; he had to stand outside the tradition and be faithful to his vision. This 'vision' completes the picture; an artist's inspiration comes from within and cannot be contained or learned through institutions. The artist as a creative genius, standing on the margins of institutionalised life, is here epitomised.

The Romantic Genius

This notion of the artist as a particular personality type was a commonplace by the beginning of this century. The rise of psychoanalysis added fuel to the fire, and the fact that Freud chose to write about both Michelangelo and Leonardo da Vinci was not mere coincidence. The type was characterised by a so-called 'bohemianism' and moodiness, by extraordinary skills and innovations which were not appreciated in their own day. Clearly, this mythical artist figure bore little resemblance to the actual lives of most practising artists, but its recognition was critical. As Simone de Beauvoir has argued, the archetypal genius artist was Vincent van Gogh, whose legacy as a type has filtered down to us even in the present day.[2] Van Gogh stands for the misunderstood genius of the avant-garde whose works are, literally, in advance of common taste in their time, but which are vindicated for their innovation generations later. He was, biographically, a model of the suffering, alienated bohemian and became a paradigm for a generation of artists after him who would champion his work.

There are two very important points to be made about the myth of the artist as a genius. The first is its historical construction. During the Renaissance, fine artists challenged for a particular type of social status which would differentiate them from 'artisans' or 'craftsmen' as they had been defined through the medieval guild system. This status relied upon their work being understood as more than mere manual labour; fine art was associated with the liberal arts, above craft production and the low concerns of the marketplace. However, art has always been informed by material circumstances, despite its claims to independence. State and private patronage systems from the Renaissance to the nineteenth century enabled artists to have the very financial stability they needed to develop ideas about the 'independence' of art practice. In this system of patronage, they had a relatively stable source of both income and social status.[3] When artists found themselves producing for an art market in the latter half of the nineteenth century, rather than for a system of relatively stable official patronage, guaranteed by such marks of social status as membership of a powerful academy and royal patronage, it was necessary for their role to be reinvented lest they become extinct. They became marginalised figures with respect to social institutions which no longer financially supported them, but they, in turn, adopted the marginal position as one of power. They could argue for their special insights into life as they were not 'co-opted' by the system; their freedom as creative individuals was itself a selling point for their art. As Carol Duncan pointed out, with specific reference to the overt sexuality of the male bohemian lifestyle and the art produced through it:

> [T]he artist ... in his turn must merchandise and sell himself, or an illusion of himself and his intimate life, on the open avant-garde market. He must promote (or get dealer or critic friends to promote) the value of his special credo, the authenticity of his special vision, and – most importantly – the genuineness of his anti-bourgeois antagonism ... In acquiring or admiring such images, the respectable bourgeois identifies himself with this stance.[4]

This is in keeping with the concept of the author-function as developed in the work of Michel Foucault. For Foucault, artists and writers were socially defined authors who validated texts through their social position. So, for example, we expect the name of the author of a literary work to appear on the work; this expectation is derived from the assumption that a writer puts 'himself' into a creative work. By contrast, the author of advertising copy is anonymous, in keeping with the social definition of this sort of writer as less 'creative'. The all-important signature of the fine artist ensured the authenticity and the originality of the artwork which was, in turn, linked to the authenticity of his experience. Artists' status, in social terms, was implied through their authorship and limited our reading of their texts in ways which conformed to models of unique, creative production. As discussed above, the concept of the artist as it developed in response to the changes in the art market and the social position of artists was historically constructed and economically driven. The concept of the artist is not simply eternal and fixed. As Foucault wrote:

> In fact, if we are accustomed to presenting the author as a genius, as a perpetual surging of invention, it is because, in reality, we make him function in exactly the opposite fashion. One can say that the author is an ideological product, since we represent him as the opposite of his historically real function.[5]

In other words, it is because the artist ceased to have economic power that we invested creative power in the image. Understanding the social arena in which author-functions operate enables us to deconstruct seemingly natural definitions of artists as ideological products, responses to the historical definitions of their works and the myths which validate their production. There are no natural artists; the myth of the genius born and not made is an historical construct.

The second point which must be noted with respect to the cult of the artist as a genius is that it is exclusively masculine in its construction. Christine Battersby, in her book *Gender and Genius*, charted the chronological development of the concept of genius and its associations with both artists and maleness: 'The genius can be *all* sorts of men; but

he is always a "Hero", and never a heroine. He cannot be a woman.'[6] She explored notions of artistic creativity and 'genius' in the western philosophical tradition from the classical period to the present day, reiterating the critical moment in the formation of this masculine creative type as a personality in the Romantic period. Significantly, the concept of genius crystallised in this period provided women with a double-bind. Battersby again:

> From its inception and up to our own time, this notion of a genius-*personality* would trap women artists and thinkers. On the one hand – even before Freud – the driving force of genius was described in terms of *male* sexual energies. On the other hand, the genius was supposed to be *like a woman*: in tune with his emotions, sensitive, inspired.[7]

This distinction between being like a woman and being a woman corresponds to the dichotomy indicated by Duncan and Foucault in terms of the genius as an historical type. That is, the genius myth valorised the economic marginality of the artist and turned that weakness into a strength. In many ways, the assumption of the position of the genius was, precisely, a marketing ploy. Artists in the 'free market' sold their work through their authorship which ensured its authenticity. Thus, their social position was critical to their marketability. Furthermore, the adoption of the qualities associated with 'feminine' intuition and vision, marginalised in mercantile bourgeois society, turned apparent weakness into strength. However, as Battersby and others have perceptively noted, it was a very different matter for male artists to parade their virile sexual energy, 'feminine' natures and marginal social status to great effect than for women to adopt such positions.[8] Men were taking on the semblance of feminine powerlessness, while women were socially defined by this weakness.

It is important to note here that, in the last few decades, the poststructuralist theoretical interventions into subjectivity and the feminist interventions into art history and art practice have meant that the concept of the Romantic genius has tended to be radically revised as a paradigm. Most theorists and practitioners would not attempt to

maintain such an uncritical position with regard to their authorship as this model implies. However, certain features of the 'genius myth' are still pervasive in our society; the artist as a personality type still retains a fashionable currency and maintains a stranglehold in representations of artists in popular cultural forms. Moreover, even those artists and critics who distance themselves from the notion of artists as a special category of individuals are obliged to contend with the peripheral positioning of artists in our culture. This position means that artists still find themselves attempting to assert some cultural authority through their marginality; it still bears a critical resemblance to the bohemian genius role. As June Wayne argued in her essay 'The Male Artist as a Stereotypical Female', there are still today associations of the feminine position (as marginal, decorative and so on) with male artists.[9] This reinforces some of the ambivalent gender roles from the beginning of this century in no uncertain terms. If we wish to understand the ways in which gender difference is inscribed in art practice, we must still contend with the fact that a male artist asserting his cultural authority through marginality is operating in a different system from that of his female contemporary.

Emasculating the Tropes in Self-portraiture

The representations of artists throughout the twentieth century fit into all of these categories of social marginalisation and cultural authority, not least when the works are self-portraits. With respect to the German context, Irit Rogoff has argued convincingly after Foucault that the deployment of particular self-portrait types by a number of male artists from the 1870s to the present was meant to ensure their status as cultural authorities.[10] The use of self-portraiture was, therefore, a culturally defined and defining practice which worked within gendered structures of meaning. Despite being socially and economically marginal, artists as diverse as Arnold Böcklin, Lovis Corinth, Max Liebermann, Ernst Ludwig Kirchner, Jörg Immendorff and Julian Schnabel produced powerful concepts of themselves as culturally dominant by employing certain visual tropes. These tropes, which

ranged from portraits of the male artist as Christ to representations of the clothed male artist and his female nude model, operated to define the status of the male artist as a special creative individual and ensure the authenticity of his vision. Women artists have had to contend with these images in order to find a place for themselves as both 'woman' and 'artist' within representation. They have engaged with the standard formations of the genre, including occupational self-portraits, self-portraits which associated them with styles or well-known groups of artists and representations of themselves as god and with the nude model, in order to rewrite critically the norms of self-portraiture.

The Male Artist as Creator and Procreator

Male artists during the course of this century have relied upon ideals of dominant masculinity outside socially acceptable limits to represent themselves, as in Kirchner's *Self-portrait as a Soldier* of 1915 and in the 1987 photograph for *Die Zeit* of Schnabel, Immendorff and Baselitz standing bare-chested in front of their works entitled *The Strong Men of the Art Market*. By representing themselves as simultaneously marginal and empowered, these later twentieth-century artists' representations of themselves are directly linked to the self-portraiture practices of male artists from the beginning of the century when the modernist avant-garde was first making its claims to authority. Both self-portraiture and artist myths have been formed along gender-exclusive lines. As Rogoff has argued:

> Following along these same lines self-portraits by male artists have been accepted as the standard representation of 'The Artist' regardless of gender or of any other form of differentiation ... Patriarchal culture has therefore constructed a role for the male artist and a visual mode for representing that role which in turn have been accepted by cultural descriptive practices as the standard normative representation.[11]

The features which have consistently been stressed throughout the century in the self-portraits of male artists include their isolation, their alienation and their uniqueness. As discussed above, it was important for the male avant-gardist to flaunt certain features of his social situation in order to invent himself as an authentic artist-genius. As Edmund Feldman argued in *The Artist*, the type was signified as much by lifestyle as by any aesthetic sensibilities or common artistic style.[12] Thus, links between life and art ensured authenticity as much as a signature could; the artist's real experiences outside conventional life meant that he could produce works which replicated this genuine feeling, uncontaminated by social posturing and artifice. Much self-portrait imagery was quickly caught up in this artist mythology and certain forms became standard means to ensure that artists were perceived in the correct way. Many representations of artists demonstrated their *autre* positioning and they were often represented in dangerous liminal or marginal social spaces such as cafés, bars and brothels. When self-portraits were set in the studio, that space was almost always conceived as beyond ordinary domestic routines and even, possibly, a dangerous anti-bourgeois place. Jill Lloyd has commented on the construction of the studio as a 'primitive' place by the expressionists associated with the Dresden group *Die Brücke* in her book *German Expressionism: Primitivism and Modernity*.[13] It is important to remember, however, that these spaces were chosen and structured as marginal within the terms of the bourgeois, art-buying public. This is not the same type of marginality, for example, experienced by a homeless underclass or a ghettoised ethnic minority.

Self-portrait tropes which went beyond evocations of liminal space also developed over the course of the century. The figure of the artist himself often played up to the concepts of marginality and alienation. Most commonly, the artist is represented as a tortured figure, sometimes in pain; this is exemplified by the well-known *Man with a Pipe* of 1889 by Van Gogh in which he portrayed himself with a bandaged ear, having cut part of it off himself, or the *Self-portrait as a Soldier* (1915) by Kirchner in which he is represented with a bloodied stump, having had his hand cut off (purely fictional, he sustained no such injury). In others, the artist swaggers and boasts in the image of his bohemianism,

as in the work by Otto Dix, *Homage to Beauty* (1922), in which the artist is represented at the centre of a brothel scene.

The most explicit conceit used in western self-portraiture to link the figure of the artist with alienation and creativity is the representation of the artist as Christ. This trope, used variously by Albrecht Dürer in 1500, Paul Gauguin at the end of the nineteenth century, Salvo in 1970 and Stephen Seemayer in performance in the 1980s, singles the artist out as a type in very particular ways. First, his creativity becomes associated with divinity; this is no academically educated artisan, this is a creator. Second, he is misunderstood and persecuted in his own day by the ignorant masses who cannot yet comprehend the truth of his work. This part of the myth is, of course, accompanied by the sense (following the Christian story) that he will posthumously become very famous indeed. Again, it is a paradigm in which the male artist adopts a seemingly weak position, but uses it as empowerment. The outsider as insider or the inversions of outside and inside were potent weapons in the struggle for positions in the avant-garde. One needed to find visual forms which asserted one's outside position without losing the sense of strength and urgency associated with an artist's vision.

Clearly, the most common and obvious trope employed by male artists to demonstrate their simultaneous marginality and power has been the representation of the male artist with his nude female model. Just as the Christ imagery was masculine in its construction and associations, this commonplace trope embodied the masculinity of artist mythologies in this century. In one sense, these are simple 'occupational' portraits; the artist in his studio at work with his model present. However, the sexual economy of the studio at the beginning of the twentieth century meant that these representations were more than occupational portraits. First, the use of working-class women as models was well established by the end of the nineteenth century. These women were often also identified with prostitution; many working-class women who could not make ends meet moved into occasional prostitution or modelling when necessary. In some instances (note Dix and Picasso, for examples), avant-gardists actually stressed their use of prostitutes in brothels as artist's models.[14] The analogy between the prostitute selling her body to the economically empowered client and the artist's model

selling hers to the artist was more than just a titillating cliché in the early
years of this century.

If the model was not always explicitly associated with the prostitute,
she was almost always thought to be sexually available to the artist
himself. Amedeo Modigliani, for example, refused to allow his
girlfriend Beatrice Hastings to model for another artist, suggesting that
'for a woman to allow herself to be painted was tantamount to giving
herself to the artist'.[15] Or, when Otto Dix was painting his self-portrait
with the model Muse (the name itself suggests everything; her role was
to be the inspiration to the creative man), who was the lover of the artist
Matthias Barz, the latter sat in on the sessions to ensure their platonic
nature.[16] Women artists, such as Nina Hamnett and Gwen John, who
made money as models, were often concerned with the loss of their
reputation and status as artists because of this sexual economy. Indeed,
John was only pleased to model for August Rodin because he was her
lover. Even if the actual relationships between male artists and their
female models were entirely without sexual content, the representations
of this scene tend to sexualise it. Moreover, they suggest the power of the
male artist as creator over his submissive inspirational 'material', the
body of woman. This may be a falsification of the actual relationships
between artists and models, some of which were closer to
collaborations, but it was the dominant stereotype. It is a stereotype
which suits ideally the cultural constructions of masculine and feminine
identity as they have been produced in western art over the last six
centuries. The critical link between nude female models as inspiration
to virile male artists and the standard trope of the male artist and *his*
female model is epitomised by the sculpture *Carpeaux at Work* produced
in 1909 by Antoine Bourdelle. Bourdelle often honoured great male
artists in his works (such as Beethoven, Rodin and Carpeaux), and the
trope he used for the Carpeaux piece reinforced the image of the
sculptor as the powerful creator, holding in his hand the nude body of
a woman, the 'raw material' from which a great man makes art.

The self-portraits of women artists in this century intervene in these
masculine artist myths and their favoured visual forms. At times, they
simply avoid the iconographies male artists used to promote themselves
as cultural authorities in favour of other more appropriate modes of

self-representation. At other times, the works of women artists engage particularly with the tropes, parodying, reappropriating or actively subverting them. Invariably, the self-portraits of women artists are forced to contend with the meaningful combination of the terms 'woman' and 'artist' which, as we have seen, have been defined in near-opposition in western fine art practice through concepts such as genius and bohemianism. Hence the works of women artists who attempted to produce images of themselves as 'cultural authorities' allow us to reconsider the masculine norms of the traditions of self-portraiture as a genre within the fine arts and art history itself.

Occupational Self-portraits: Tools of the Trade

For any marginalised group, simply 'coming into representation' is significant. This fact has been widely discussed with reference to black, lesbian and gay histories whose subjects had for so long been invisible in traditional western history or, when shown, wildly misrepresented. To bring marginalised people into representation in ways which explored their multifaceted experience was crucial in revising existing stereotypes and placing alternative viewpoints on the agenda.[17] In the case of women as subjects in western art, there were not too few representations, but too many all of a piece; 'woman' was consistently evoked, while 'women' were subjects who escaped representation. Stereotypical uses of women's bodies as subject-matter occluded the representation in art of women's multifaceted experiences. For the woman artist producing a self-portrait, this situation was peculiarly difficult to surmount. That is, it is difficult to find a form of representation which does not simply objectify the body of 'woman' but, rather, one which represents a woman as a subject. The most common feature of women's self-portraiture, the confrontation between subject and object, is a response to this paradoxical position.

In her etching of 1934, *Self-portrait*, Käthe Kollwitz represented herself in shallow foreground space, with little background detail to detract from the mimetic rendering of the facial features. Kollwitz was known for her powerful graphic works which unflinchingly detailed the

plight of the impoverished German working-classes in the period between the wars. Thus, her approach to her own image is in keeping with her oeuvre more generally; it is a powerful and evocative representation of the artist. Significantly, the image holds the gaze and in no way is the likeness 'prettified' by extraneous detail or pose. Such a sober rendering denies our expectations of 'woman' displayed as the carrier of 'beauty' or sexual difference. We are not allowed voyeuristic access to a woman's body as an object of delectation as we are, for example, in the standard female nudes of the western tradition. Nor are we encouraged to encounter this image as a fashionable society portrait demonstrating the wealth or social status of the sitter. Many women artists throughout the century, from widely different contexts than that of Kollwitz, employed the same sober self-portraiture techniques to challenge the objectification of women in their self images. Thus, these works, despite their simplicity, are positive assertions of women as subjects rather than objects in representation.

Representations of women artists at work in their studios or with their cameras are another powerful and challenging mode in self-portraiture despite the seeming simplicity of such iconography. The strength of these images is derived from both their assertion of women as active makers of culture, which is unexpected in terms of masculine norms in art history, and also their frequent reconsideration of studio space. Again, the very presence of women as artists was and still is a challenge to common assumptions about the sex of cultural producers. The vast number of self-portraits by male artists in their studios or with their trade tools have come to seem natural, and women at easels or holding brushes, cameras or chisels may still seem a startling inversion of the norm. Certainly, in the early part of this century, just representing oneself as an artist was a subversive statement for a woman and she would not have needed to have included or surrounded herself with tropes of bohemianism to seem extraordinary. By producing such occupational portraits, women asserted their professionalism and, in some cases, their economic independence. These were not common situations for most women whose identities were still subsumed by their relationships to men, as daughters, wives and mothers. And, significantly, it is exactly that sense of independence and

professionalism juxtaposed with the figure of a woman which is played upon in these representations and which makes them empowering tropes for women artists. Furthermore, the very statement of professionalism, juxtaposed with expectations about feminine domesticity, means that these works cross traditional boundaries between the public and the private spheres.

In 1913, the young English artist Nina Hamnett produced *Self-portrait*, a painting of the artist in her smock working at her easel. Though this work has since been destroyed, it was reprinted with the artist's permission in *Colour* magazine in June 1915, a fact which indicates that the artist felt that this work was a good piece of self-publicity. The image is typical of the working portraits of women artists which defy the traditional associations of women with femininity and domesticity to assert their public, professional connections. The artist is represented with her hair cut in the fashionable and very modern 'bob'; the figure dominates the canvas with her confident pose and holds the gaze. Therefore, the spectator is met with the subject of the work, rather than a representation of a woman which permits us to objectify her. The modern, fashionable image of Hamnett was critical to the context in which she worked as well. Hamnett lived and worked in Paris during the years preceding the First World War in the company of the most infamous bohemian male artists of the day such as Picasso, Modigliani and Henri Gaudier-Brzeska. In her autobiography, *The Laughing Torso* (1932), she admitted it was difficult for a woman in this context to be seen as an artist rather than a model; she argued that her case was rather extraordinary in this respect.[18] Whether or not one thinks that Hamnett was overgenerous in her estimation of her own status among these male avant-gardists, the *Self-portrait* was produced in the light of the fact that Hamnett was a woman artist attempting to be taken seriously. Thus, it asserts her professionalism, her self-confidence (verging on boldness), her fashionable appearance and her gaze. A seemingly simple self-portrait of an artist at an easel can become a powerful evocation of female emancipation when the subject is a woman.

The tradition of producing 'occupational' self-portraits has continued throughout this century with subtle inflections added by encounters with feminist theory. In 1979, the German painter Zeynep

Yüksel produced a triple representation of herself at work in her *Self-portrait*. Like the Hamnett self-portrait, Yüksel's work asserts the active role of women in representation and produces an image which confronts the liminal spaces of women's art practice. The central representation of the artist is in the act of drawing, seated at a drawing-board, looking at another representation of her 'self' in a mirror on the table. The 'third' image of the artist is shown standing behind this activity, dominating the whole scene with her look; this 'conscience' of the production of the self-portrait scrutinises the practitioner and the work which she is making. Even at this late date, when women were frequently found in public roles, the representation of the woman artist at work is being used to confound our attempts to objectify the body of the artist. Without being quite as obvious as Hamnett's work, the gaze is still controlled in Yüksel's piece by the figures on the canvas; they are not displayed to us. And yet again, we are confronted with the liminal spaces of women's practice since the work represents the artist at work in a domestic interior. The self-consciousness necessary for a woman artist to come into representation is explored in this work along with issues of multiple and disparate 'selves'. The variety of subject positions which women artists are forced to occupy are examined by the uses of multiple figures, framing devices and the internal relay of the gaze in the work.

In photographic self-portraiture, representations of the photographer with her camera are numerous. Like the painted and drawn occupational self-portraits described above, these works contend with the professional status of women photographers and the boundaries which such professionalisation forces women artists to break. The development of photography as an artistic medium was accompanied by a number of difficult questions regarding its status and the status of those who used it. It offered women artists new potential in terms of professional careers, but also marginalised their practice within areas of uncertain or dubious artistic rank. Many women were able to run professional photographic studios, to which the self-portrait on Louise Martin's business card of 1946 attests. On the card was reproduced a self-portrait of Martin cleverly montaged on to the lens of her camera. This image is ground-breaking in its mere existence; Martin,

as an African-American woman photographer, was advertising her own portrait studio. Simply coming into representation in this bold way asserted the variety of roles which women of colour were able to occupy in the period and counteracted the traditional objectification of images of 'woman'. However, it is important to remember that this was not the 'experimental' or avant-garde end of photographic practice in which different things were expected of practitioners.

In the context of the avant-garde, it is interesting to examine an early self-portrait by the American modernist photographer Imogen Cunningham and a later work by Ilse Bing. Cunningham had a long career as a highly respected photographer and was both associated with the avant-garde and produced a large number of self-portraits during her lifetime. Significantly though, her early self-portraits represent her struggling to find a mode in which to represent herself both as a young 'woman' and as an 'artist'. In 1913, for example, Cunningham produced *Self-portrait*, a photograph in which she is shown dressed in a lace collar, in an interior space with a bas-relief on the back wall and an open sketchbook on her lap. The work conflates three tropes and reveals just how difficult it was, even in that ostensibly liberating field of photography, for women to come into representation as artists. First, she is the middle-class woman, dressed well in an interior space; second, she is the (amateur, perhaps) fine artist with artworks and sketchbooks around her; and third, she is the subject of the piece, the photographer.

Ilse Bing was another woman who became known for her pioneering work within the context of German and French avant-garde photography in the 1920s and 1930s. In 1931, she photographed herself at work behind the camera, but used two mirrors rather than just one, which produced a double self-portrait. As with Cunningham's work, Bing here comes to terms with herself as both the subject and the object of the work but she does this through references to the nature of photographic viewing itself. The image is constructed in such a way as to show both the woman directly behind the camera looking at the spectator and a profile shot of the artist looking through the lens. In this way, the gaze is given fully to the woman as the subject of the work; she looks at us and enhances her view through the camera. Her active

looking is embedded in the very structure of the picture, which multiplies her viewing without permitting her image to be displayed as an object of delectation. The work also links, in its experimental aesthetics, the woman artist with the most avant-garde tendencies in photography at that time such as the concentration upon objects and contrasts produced through striking lighting effects.

Occupational Self-portraits: Subject and Object

The dangerous marginality for women artists in occupational self-portraits which stems from their simultaneous role as subject and object is strikingly examined in two particular works: Renée Sintenis's *Drawing Nude: Self-portrait* of 1917 and Rossella Bellusci's *Self-portrait* from 1981. Though in different media and from different time periods, both of these works subverts the traditional association of woman-as-object in art by representing the woman artist nude and in the act of producing images. The drawing by the modernist sculptor Sintenis represents the artist as a model, nude to the waist, seated with folds of drapery around her hips and, startlingly, in the act of drawing. This work, therefore, combines two types of imagery which are not wholly compatible into a picture which touches precisely upon the dilemma of women who wish to come into representation. This work comes from the years when Sintenis was herself an art student and would have been drawing from the life, so its combination of the artist and the model is particularly poignant as the search of a young female student for an identity.

Bellusci's self-portrait is a photograph of her own nude body, but with the camera indicated as a shadow which crosses her at her waist. Produced within the context of postmodernism by the young Italian photographer working in Paris, this image parodies the modernist conventions of both experimental formalist photographs and the trope of showing the artist with the camera. In this image, Bellusci is not actually represented as operating the camera, but, as the camera is without an operator, she is implied as the maker of the work. Her nude, supine figure also places her as the object of the piece. These images are very near to reappropriation at all points; the fact that the women's

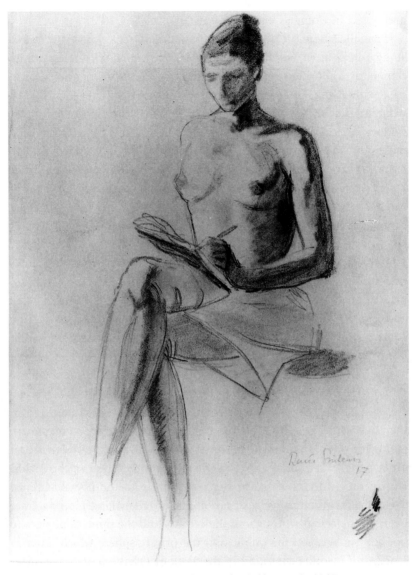

Renée Sintenis, *Drawing Nude: Self-portrait*, 1917

bodies are dangerously close to 'objects' is exactly the point of their production and they risk being misread in order to make their point all the more forcefully. They question the very boundary between subject and object in women's representations.

Spatially, some of the most fascinating representations of women's studios bear little resemblance to those of their male contemporaries but, rather, consider the studio as both domestic and professional. Professional practice itself and self-representations which considered women's practice were liminal areas of women's experience in the past century because they challenged the borders between feminine and masculine roles in terms of the private and the public sphere and in terms of the object/subject divide. For example, the *Self-portrait with Little Son in the Studio* of 1928 by Elsa Haensgen-Dingkuhn or the *Self-portrait at an Easel* of 1937 in which Gerta Overbeck showed herself pregnant and at work, both explored the little-represented area of working mothers' lives. These artists practised within the realist tendencies of the interwar years in Germany, when women's involvement in the public sphere was hotly debated. There was no distinction made in these representations between the places of work and home; those divisions are shown to be purely masculine constructions of space. Artists from much later in the century still found it necessary to contend with their experience of public and private spaces. Elsa Dorfmann in *Myself* (mid-1970s) used the occupational self-portrait format to engage with the fact that women artists who have children cannot simply divide the spaces of their work from those of their domestic lives. The American photographer is shown in the mirror taking the photograph while in the background we can see her bed and a playpen. As a woman artist experiencing motherhood in the 1970s, Dorfmann's work makes clear her relationship to the liberal feminist agenda of the time. Yet the issues at stake for working mothers have been on the agenda throughout the century and the same challenges to boundaries between the public and the private sphere which arose in Dorfmann's work were found in the work of Overbeck and Haensgen-Dingkuhn decades earlier.

In her *Self-portrait* of 1958, Grete Stern also examined liminal spaces and the representation of woman as artist, but used the dynamics of

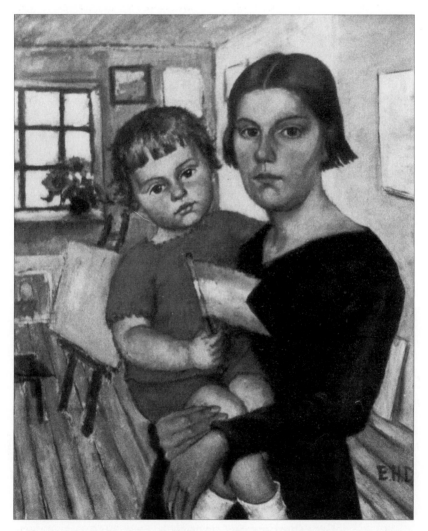

Elsa Haensgen-Dingkuhn, *Self-portrait with Little Son in the Studio*, 1928

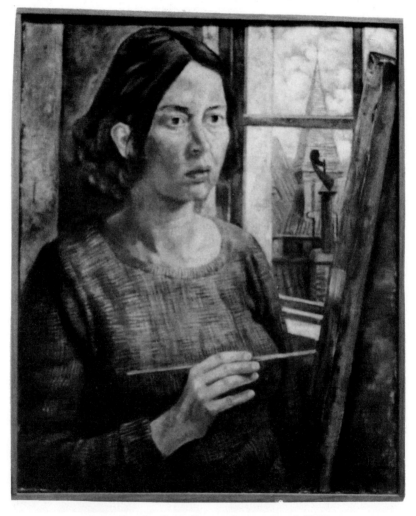

Gerta Overbeck, *Self-portrait at an Easel*, 1937

seeing objects as a means to an end. Stern was associated with the Bauhaus and with another woman photographer, Ellen Auerbach, ran a successful photographic practice for advertising. The self-portrait photograph is set up to look like a still life on a table; leaves, glass balls and marbles, draughting tools and a mirror are arranged for display. These objects combine notions of nature and culture, the organic and the machine. Furthermore, their display is about looking and objectification through sight; we are 'given' these materials as 'objects' and they concern looking. The visibility and invisibility of the glass beads, the mirror and the tools for drawing itself make one aware of the act of viewing. Amid these contexts, as a reflection in the mirror, is the self-portrait image of the artist. This placement is ideal. The woman artist is located within the dual realms of nature and culture, object and subject, imagery and production of imagery. The mirror reminds us of the falsity of the construction of the representation and our control is limited over the artist's body. The representation places Stern the artist at the centre of this complex intersection of meaning.

If women artists often used their self-portraiture to put themselves and their experiences into the centre of representation, they sometimes did this by self-consciously adopting the swagger of male artists. Two representations define this posturing best: Eva Schulze-Knabe's *Self-portrait* of 1929 and the promotional photograph of Lynda Benglis published in *Artforum* in November 1974. In Schulze-Knabe's self-portrait, the artist is posed in a man's coat with her thumbs hooked through the huge belt. The situation of the sitter on the canvas means that we must look up to the artist whose image returns our gaze with near-contempt. The sheer boldness of this pose and the painterly handling of the materials harks back to Gustave Courbet and the realists of the nineteenth century; this conceit was no accident as Schulze-Knabe was part of the political realism of the Weimar Republic. In an even more self-conscious adaptation of masculine artistic posturing, Benglis's promotional photograph showed the artist nude, wearing sunglasses and holding a huge erect dildo as though she had a penis. Where Schulze-Knabe played more with androgyny, like a number of modernist women artists, Benglis was usurping and parodying the strutting masculinity of her contemporaries and the art world itself. As

Eva Schulze-Knabe, *Self-portrait*, 1929

has been discussed in other places, Benglis was on target with her critique; a vast array of outraged letters arrived at *Artforum* after the publication of this 'shocking' image.[19] Benglis had usurped the position of the male artist in a pointed and parodic fashion. Throughout the century, it was often enough for women artists merely to represent themselves in professional roles in order to shock and provoke spectators. Their very situation as women artists was sufficient to render them outsiders; even more so when they linked themselves to the powerful 'isms' of modernism in their self-representation.

Associations with Artists and Styles

The 'isms' of modernist practice, such as Cubism, Futurism, Expressionism and Surrealism, were significant avant-garde ploys. Continually to reinvent your form, your aesthetic, and declare yourself 'new' were the hallmarks of avant-gardism which required perpetual calls to origins and originality.[20] These 'isms' were at the forefront of modernist practice and it was extremely important to be associated with them; the well-documented appropriation of Picasso by André Breton for the early surrealist group is a case in point, demonstrating the necessity of having the 'right' names in the group.[21] One of the primary ways to stress your alliance with a particular 'ism' was to produce a self-portrait which linked you to the style or the artists of one of these groups. Ernst Ludwig Kirchner did just that in 1926 with his work *A Group of Artists* in which he belatedly associated himself with his former friends and artists of *Die Brücke*.

For women artists, most of the avant-garde groups of the twentieth century have been difficult to infiltrate in any significant way. The groups were decidedly masculine, as discussed above, asserting their powerful cultural marginality through sexually dominating postures of maleness and concepts of artistic creativity to which women as women simply could not subscribe. For the most part, women artists attained only limited roles in such artists' groups; they were the models, lovers, students, muses and supporters of the male artists. However, this situation is complicated by the fact that the avant-garde, despite its

limitations, still offered women an alternative to domesticity which could be emancipatory and the aesthetics associated with the avant-garde could be used to explore female experience as well as male. Women artists, therefore, still sought to become involved with these 'isms', despite their masculinist poses. Generally, women artists were only partially successful in becoming integral members of these male-dominated groups, but their works are fascinating representations of the negotiations they made between their own experiences as women artists and their affiliations with the aesthetics associated with various avant-garde movements. Despite the fact that criticism has so frequently marginalised the production of women artists associated with groups in the avant-garde, a re-examination of their work requires us to reconsider the nature of these styles as well.

Hannah Höch is a case in point. As part of the Berlin Dada group, Höch pioneered the technique of photomontage which was used so critically by the Berliners. She took part in the scandalous First International Dada Fair of 1920, travelled to Holland and collaborated with Kurt Schwitters in Hanover. Yet she has tended to be marginalised because of her romantic relationship with Raoul Hausmann and because of her description as the 'good girl' and the 'little girl' in Hans Richter's memoirs of the group, *Dada: Art and Anti-art*.[22] This marginality is visually evident by comparing two self-portraits of the period, Höch's *Double Exposure Self-portrait* (c.1930) and Hausmann's *Self-portrait with Hannah Höch* (1919). In her own self-portrait, Höch skilfully manipulated the exposure to show a double image of herself at work in her studio. In Hausmann's self-portrait, Höch is a prop, she is his lover, his muse. It is a typical self-portrait of the male artist with the female 'model'.

Höch was well aware of the ambiguous position of women in the period and many of her photomontages are concerned with just this situation. She often used the advertising images of women from the new women's magazines and the pin-up images from Hollywood movie magazines to recombine and recontextualise representations of women in her photomontages. Working for the Ullstein Verlag (a powerful publishing house of the period), she was intimately familiar with the popular press aimed at women in the 1920s and, as Maud Lavin has

argued, used these images in ways which subverted their patriarchal authority while underscoring them as texts of female pleasure.[23] Höch managed to turn the masculine, authoritative view of women in the mass media into works which emphasised the fluidity of gender and thus could be viewed differently by women. Additionally, Höch's work was highly critical of the institution of marriage and the domestic sphere to which women were so easily assigned. Her self-portrait montage of 1922, *Meine Haussprüche*, examined the situation of the woman artist of the period, caught as she was between the avant-garde, the domestic sphere and new definitions of 'femininity'. The work is derived from the books of 'house-sayings' which were commonly kept for guests of bourgeois German households; visitors were invited to leave their favourite tips and sayings for the wife of the house. By montaging bits of wallpaper next to diagrams of insects and pictures of ball-bearings, Höch displaces the straightforward domesticity of this imagery and, by having had her fellow Dadaists enter anything but homely sayings on the page (for example 'Death is a thoroughly Dadaist affair'), removes all traces of comforting banality. Her own photograph forms part of the montage which used Dada's own montage techniques to produce imagery about the anomalous placement of the critical woman artist. Hence the aesthetics of the Berlin Dadaists were ideal tools for Höch's explorations of the gender politics of the period.

Like the montage of the Dada group, the techniques associated with Surrealism presented women artists with the potential to disrupt traditional ways of seeing. However, as Whitney Chadwick has argued effectively, becoming associated with the surrealist group was a mixed blessing for women artists.[24] On the one hand, it allowed women the opportunity to defy traditional domestic roles and to explore, in their art, female subjectivity. On the other hand, however, the group itself was strongly male-dominated and the women associated with it were severely circumscribed in their role as *femme-enfant* (child-woman), the muse to the surrealist male who, through the combination of sexual maturity and child-like intuition, inspired the art of the surrealists but rarely produced it. Women were denied 'genius' through a manipulation of Freudian theory which associated them with impotent intuition. One might argue that this permitted women a space in which

to remain aloof from the squabbles of male artists, but it produced a marginality more likely to silence women artists generally. This double-bind is epitomised by the case of Leonora Carrington, the English artist who became affiliated with the surrealists at the age of 19 when she eloped with Max Ernst (then 46). Her work, both written and painted, concerned her complex negotiations with feminine and masculine roles, male authority figures and, significantly, her autobiography and her self-representation.

Like other women artists associated through romantic liaisons with the surrealist group, Carrington was both muse and student of her more famous partner. As Gabriele Griffin argued in 'Becoming as Being: Leonora Carrington's Writings and Paintings 1937–40', the single recurrent theme in Carrington's production of this period is the struggle of the young student or daughter with the stronger, authoritarian male teacher/father.[25] For women artists attempting to assert their identity in the surrealist group, this is an ideal paradigm; certainly the autobiographical links with Carrington's circumstances are unmistakable. What is notable, however, is the fact that the surrealist aesthetic itself gave Carrington the tools with which to wage the struggle for self-determination. It was through her surrealist writing and transformative painting that she came into self-representation. Thus, her links to the group were equivocal. In her self-portrait of 1936–7, *The Inn of the Dawn Horse*, these complexities are played out. Carrington's alter-ego, the white horse (developed in conjunction with the bird, Lop-Lop, of Ernst), figures twice in the image. On the wall is a white rocking-horse, the site in Carrington's writings of a struggle between father and daughter for control (the father gets rid of the daughter's beloved rocking-horse), and outside the confined space of the domestic interior a white horse runs free. In the foreground of the picture, the likeness of Carrington sits startled and staring out towards the viewer. The image acts to play out the conflicts of the woman artist seeking self-representation and identification within the surrealist group. The personal symbolism and dream-like space of the works permitted freedom even while the group's own sexual politics were restrictive.

Group Portraits

Group portraits used to associate artists with a particular 'ism' or art movement could be more effective than just taking on the aesthetics of the group. The surrealists frequently produced just such imagery in order to enhance their sense of themselves as a group, such as in various works by Man Ray, René Magritte and Max Ernst. Women artists also adopted this method of aligning themselves self-consciously with other artists of similar interests, though these works more often examined the dynamics of the group itself. Looking at the group portraits of Marie Laurencin and Marevna, associated with the Parisian avant-garde from the pre-1914 period, those of Charley Toorop, part of the Netherlandish avant-garde of the interwar years, and the work of Sylvia Sleigh, who was involved in American feminist artists' associations during the 1970s, give enough breadth to understand the range of uses to which group portraiture has been put by women artists in this century.

Marie Laurencin and the Russian émigré Marevna were associated with the community of artists gathered around the Bateau Lavoir in Paris at the time of the First World War, including Picasso, Diego Rivera and Guillaume Apollinaire. In her works and writing, however, Laurencin took a particular position on the debate about the gender of 'genius' and used her 'femininity' as an advantage. The criticism of her most enduring promoter, Apollinaire, and a comment from Marsden Hartley should clarify her gendered positioning within the art scene of the period:

> Though she has masculine defects, she has every conceivable feminine quality. The greatest error of most women artists is that they try to surpass men, losing their taste and charm in the process. Mlle. Laurencin is very different. She is aware of the deep differences – essential, ideal differences – that separate men from women.[26]

> With her works comes charm in the highest, finest sense ... She eliminates all severities of intellect, and super-imposes wistful charm of idea upon a pattern of the most delicate beauty.[27]

Rather than dispute the concept that genius is inherently masculine, an idea which, as we have seen, was extremely pervasive in the period, Laurencin adopted the 'feminine' role as a model of artistic production. But Laurencin was particularly adamant about her lack of genius and her own talents being merely feminine. As she wrote:

> If I feel myself so different from painters, it is because they are men – and because men seem to me difficult problems to resolve. Their discussions, their inquiries, their genius have always amazed me ... But if masculine genius intimidates me, I feel perfectly at ease with everything feminine.[28]

In both *A Group of Artists* (1908) and *Apollinaire and his Friends* (1909), Laurencin painted her self-portrait in the company of Apollinaire, Picasso and Fernande Olivier. These paintings affirm Laurencin's position at the heart of the most experimental circle of the Parisian avant-garde during the period, yet, by virtue of their style, they do not challenge the formal innovations of 'proto-cubism' with which Picasso and Georges Braque were then associated. This stance, being simultaneously central and non-threatening, was echoed in Laurencin's memoirs:

> The little that I have learned was taught to me because Matisse, Derain, Braque, and Picasso, whom I considered great painters, were my contemporaries ... If I have not become a Cubist painter, it is because I cannot. I did not have the ability, but I was passionate about their inquiries.[29]

In this context, the group self-portrait of 1909 becomes particularly poignant. Laurencin again links the four friends and Max Jacob together on the right-hand side of the canvas while, on the left, she represents the three graces, acting as muses to the assorted artists and poets. Stylistically, she remained aloof from cubist fragmentation and in keeping with what Apollinaire and Hartley described above as her 'feminine' style, which was delicate, colourful and graceful. But her marginality in terms of the group and its legacy could not be made

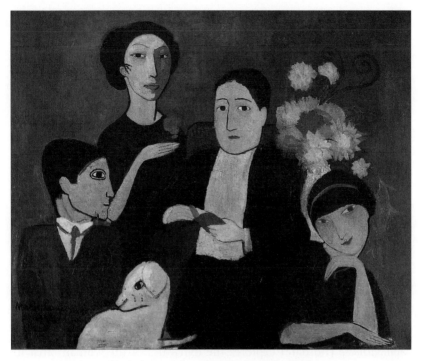

Marie Laurencin, *Group of Artists*, 1908

more clear than to compare this image with that watershed of cubist innovation, Picasso's *Les Desmoiselles d'Avignon* (1907). In Picasso's work, the 'muses' are prostitutes displaying themselves in a brothel rendered through the use of fragmented space and African masks as 'primitive'. The frightening, yet desirable, dark sexuality of 'woman' provides the impetus to masculine creativity and genius. It suffices to indicate the actual situation of Laurencin in this male-dominated avant-garde that Picasso included her as one of these prostitutes. In her image, she demurred to the male geniuses, but considered herself part of their circle; in Picasso's image, she is a dirty joke between himself and Apollinaire.

The Russian painter Marevna was more direct in her references to the difficulties which faced a young woman artist working within the Parisian avant-garde of the period:

> I had no desire for marriage or children ... I saw in this a loss of my
> beloved freedom and a hindrance to my work, and my work was
> more important to me than anything else ... [however] I was old
> enough and had no desire to become an old maid; all of me, body
> and soul, longed for someone to give me security and make a wife of
> me – a happy wife, not the slave of a man. And therein lay the
> problem.[30]

The acuity with which she identified the conundrum facing women
artists contrasts sharply with the position taken up by her
contemporary, Laurencin, who stresses the femininity of her production
as its strength. Marevna always found herself struggling for patronage
and enough money to make ends meet, despite her close association
with Diego Rivera and the support of other Russian émigré artists living
in Paris, such as Chaim Soutine. She also placed her production into the
centre of the avant-garde by adopting cubist stylistics as her own rather
than suggesting that she was unable to grasp the meanings of such
'masculine', theorised work. Her group portrait *Homage to the Friends of
Montparnasse* (no date) explores the dynamics of the woman artist in
this circle quite bluntly. Marevna is pictured in the work with, among
others, Amedeo Modigliani, Max Jacob, Soutine and Rivera.
Additionally, the woman artist Jeanne Hebuterne forms part of the
cubist portrait, as does Marevna's daughter (by Rivera) Marika
Vorob'eva. Hence, the work makes no attempt to claim a position of
'bohemianism' for women and acknowledges her situation as both
mother and artist. Clearly, this position was difficult in the extreme.

By contrast, the artist Charley Toorop was successful during her
lifetime as part of the New Realism in the Netherlands during the 1920s
and 1930s. As the daughter of the well-respected symbolist painter Jan
Toorop, Charley Toorop had an introduction to the advanced art circles
of the Netherlands and was part of the group around Piet Mondrian,
Gerrit Rietveld and Pyke Koch. Hence, Toorop worked within the
context of the politically radical art and design tendencies of the time,
such as the Bauhaus and Constructivism whose primary stylistic
impulses ran to abstraction, though she was a realist painter.
Significantly, she produced a number of self-portraits in which she was

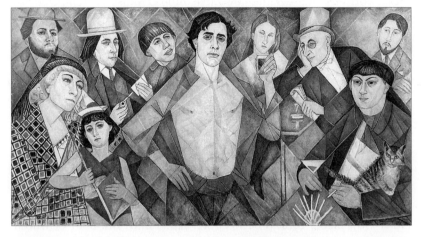

Marevna Vorobieff, *Homage to the Friends of Montparnasse* (undated)

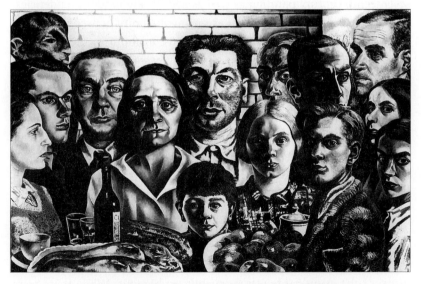

Charley Toorop, *The Meal of the Friends*, 1932–3

depicted as the androgynous 'New Woman' of the day and she painted three group self-portraits. Although the psychobiographical readings of these works as 'self-defence' by Erika Billeter must be tempered, as Billeter argued, these works can be read in the context of the difficulties facing a woman artist working in close association with an avant-garde group in the period.[31] Toorop's determined self-representations combine her gender and her profession and assert her position within a Dutch tradition of portraiture and still life, a family of artists and a contemporary avant-garde context.

The three group self-portraits produced by Toorop confirm her sense of artistic lineage and connection. The first two works (*The Meal of the Friends*, 1932–3 and *Portrait of H.P. Bremmer and his Wife amidst their Circle of Contemporary Artists*, 1936–8) position Toorop within the contemporary avant-garde, while the third work, *Three Generations* (1941–50), places Toorop between her father and son, both of whom were also artists. The works themselves, being realist group portraits with still life elements, link the artist with the heritage of Dutch seventeenth-century painting as well as specifically modern tendencies. *Three Generations* places the artist as the pivotal point between the other two artists; she is the mother and daughter linchpin in the family of artists. *The Meal of the Friends* and *H.P. Bremmer* link Toorop to the major figures of the period such as Gerrit Rietveld, Pyke Koch, Bart van der Leck and John Rädecker. Bremmer and his wife were powerful patrons and critics who supported the young artists. Significantly, Toorop has included a number of wives as equal members of the circles, from her son's wife to Mrs Rädecker, and she has again indicated her familial links to these art circles with the inclusion of her son. Furthermore, *The Meal of the Friends* positions one of Toorop's students as heir to her role. Thus, the work counteracts the tendency to see artistic lineage and art groups as exclusively masculine in their determination. By so doing, Toorop claims a space for herself.

Hence, the situation of women artists linking themselves to the 'isms' of the avant-garde was frequently ambiguous. While there were advantages to be had through such affiliations, the negotiations women artists had to make in order to become part of these groups sometimes worked against them. In the post-1968 generation, women artists often

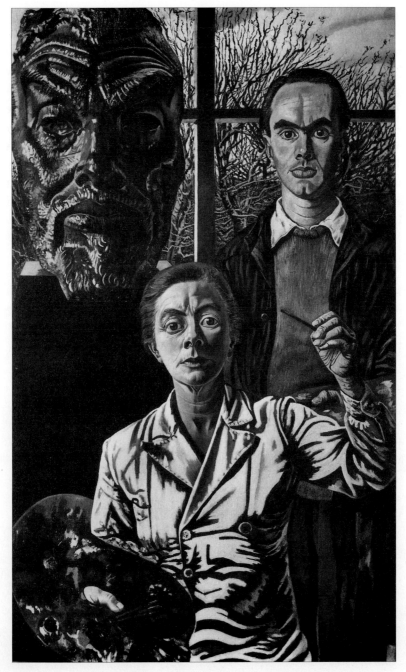

Charley Toorop, *Three Generations*, 1941–50

sought to redefine the nature of artists' groups in order to defy concepts
of genius and reinstate women at the centre of such activities. In two
group self-portraits, *SoHo Gallery* (1974) and *A.I.R. Group Portrait*
(1977), Sylvia Sleigh enacted just such a reversal. Both works show
groups of contemporary women artists who had formed women's co-
operative galleries in New York. By so doing, these works document the
radical feminist art politics of the 1970s. The Artists in Residence Gallery
was founded in 1972 by Barbara Zucker and Susan Williams who, with
the help of some 20 other women artists, renovated a space in the city
and founded an all-woman exhibition site. The SoHo Gallery, formed
by Sleigh, Mary Ann Gillies, Joan Gluckman and Marilyn Raymond in
1973, worked in a similar way.[32]

Sylvia Sleigh, *SoHo Gallery*, 1974

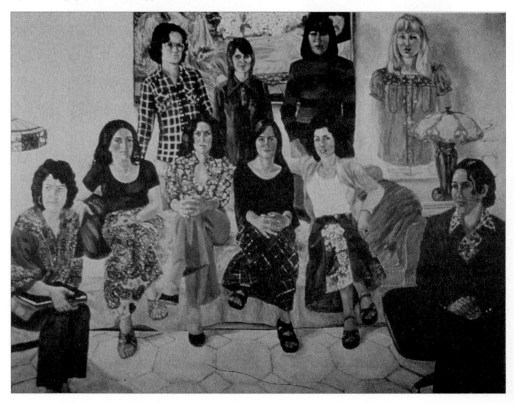

The two group portraits 'document' the women artists involved in these projects. They are not models and muses, they are producers. Their awareness of their particular position within the art world as potentially marginal is belied by the powerful images of unity which Sleigh produced. The very fact that they have entered art politics as a group and attempted thus to change the gallery system which marginalised them as individuals marks this work as a strategic intervention into self-portraiture. In terms of the traditions of women's group self-portraiture in this century, it is distinguished by its utter refusal to link women artists to male avant-gardists.

Sylvia Sleigh, *SoHo Gallery*, 1974

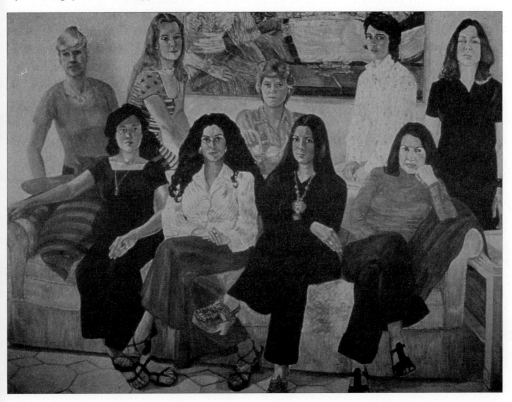

Postmodern Parodies: The Woman Artist as the Male Artist

In the post-1968 generation, a number of women artists, aware of feminist politics and the politics of the postmodern, have actually appropriated the representation of the male artist and used it to challenge the gender bias of the art world. The exclusivity of western fine art practice itself has been critiqued extensively through parodic, postmodern interventions by a wide range of artists. Two such interventions were made by the American artists Hannah Wilke and Cindy Sherman.

In 1976, Wilke, known for her filmed and photographed performance pieces, produced the documented performance *C'est la Vie Rrose* in which she played chess, nude, with a male opponent in front of Marcel Duchamp's *Large Glass* (1915–23). The title of the work, the performance and the posed photograph of the chess game are all carefully constructed subversions of the legacy of Duchamp.

Duchamp's version of Dada was highly influential for young artists of the 1960s and 1970s, including Robert Rauschenberg and Jasper Johns. Indeed, the so-called 'neo-Dadaists' of the period looked particularly to the work of Duchamp as a precursor to their postmodern subversions of the gallery system and the 'high art' object. Duchamp's 'ready-mades' – everyday, mass-produced items which he dubbed 'art' and placed in gallery space – as well as his performative work, made him, by Wilke's time, the 'father' of the contemporary avant-garde. Much of Duchamp's work centred on the figure of the artist himself. The power of 'the artist' to transform ordinary objects into 'art' through his personal decision was but one focus upon the artist. Duchamp also had a female alter-ego (to give this character a visual form, he was photographed in drag by Man Ray) who was called Rrose Sélavy, whose name itself is a phonetic pun on love and gendered relationships ('*Eros, c'est la vie*'). Furthermore, Duchamp staged a retreat into semi-retirement at the end of the 1920s, suggesting he would no longer make art but would play chess. Thus, at his first large retrospective exhibition in 1963 in Pasadena, he was, himself, installed in the gallery space (in front of *Large Glass*), playing chess with a nude woman.

Wilke's re-creation of this scene, with its inversion of the artist figure, thus plays upon a whole host of associations. Wilke developed her practice within the context of feminist performance art during the 1970s and 1980s and here she invoked the parodic, subversive legacy of Duchamp and then used this to challenge myths of the male artist. The 'artist' is now the 'nude model' at the chessboard. The appearance of the powerful, controlling male artist in the gallery is thus confounded. Duchamp's own play with gender, in the form of his alter-ego, is also invoked by Wilke's inverted title, *C'est la Vie, Rrose*. By inverting these signs and symbols surrounding the reputation of Duchamp, Wilke performed a very direct and obvious critique of the masculine-normative basis of the art world.

Fourteen years later, photographer Cindy Sherman also reinvestigated the legacy of a male artist in a self-representation, but with more subtle parody. Sherman's work of 1990, *Untitled, no. 224*, restaged the famous self-portrait of Caravaggio as Bacchus from the first decade of the seventeenth century. Such a reappropriation works on a number of different levels. In the first place, the Caravaggio work, like the work of Sherman, has itself a degree of distance built into the self-representation. The work is a portrait of Bacchus, the god of wine, for which the artist used his own likeness; it is not a straightforward self-portrait, but a masquerade. Sherman, as discussed in chapter 2, also places a distinct distance between 'herself' and the poses she takes up in her photographs. Hence, a work like this renders any attempts to locate a fixed identity useless. Sherman masquerades as Caravaggio masquerades as Bacchus; the identifiable, authoritative 'artist' is lost.

Moreover, this playful parody on identity is linked to traditions about *male* artists. Caravaggio, in traditional art histories, is known for both his wild (read masculine) lifestyle of drinking and brawling as well as his pioneering painting practice. He is the 'founding father' of a style of bold, figural painting characterised by sharp lighting contrasts and known as 'Caravaggesque'. The portrait as Bacchus has always been seen as doubly appropriate; it shows his powerful stylistic innovations and links to his character. Thus, Sherman's reappropriation of this image is a sophisticated parody of high art traditions and their gendered structure. In her work, Sherman confounds gendered identity by masquerading as

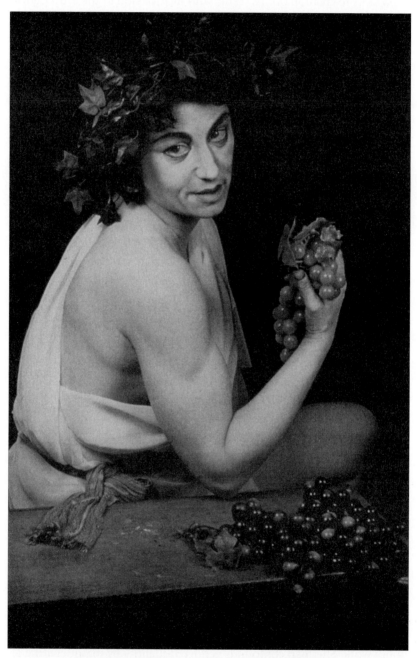

Cindy Sherman, *Untitled no. 224*, 1990

a man. Furthermore, she reinvents this style of fine art painting with a camera and robs it of its exclusivity and uniqueness. The subversion is complete.

The Artist as God

The two most pervasive tropes which developed in order to link the mythical artist-as-genius with self-portraiture were representations of the male artist as Christ and representations of the male artist with his nude female model. Both of these operated through associations particular to the societies in which they were produced; neither self-portrait mode is intelligible outside the context of the post-Renaissance western intellectual and artistic traditions. Furthermore, these tropes were masculine in their iconographies and they excluded women artists by definition. However, some women artists actually took these tropes and manipulated them in order to subvert their authority and show them to be socially constructed stereotypes. These works parodied or inverted the imagery so closely associating masculinity and creativity in order to assert the woman artist in her own terms.

Between 1973 and 1974, the American feminist artist Ilse Greenstein decided to produce a large collaborative piece which would be done by women artists and centre upon the re-examination of Christian myths in relation to women. This was a typical move in 1970s feminist politics when women began to assert their place within the traditional hierarchies of society such as the legal system, the academic disciplines and, of course, the Judeo-Christian tradition. In Greenstein's own words: 'Where was Eve in man's relationship to God? In retelling the myth from a woman's point of view I conceived the idea of the Sister Chapel.'[33] Although the Chapel was never constructed as a permanent memorial to women's contribution to culture, there were two exhibitions of the wall and ceiling panels in 1978. The project itself acted as a catalyst for a number of women artists who produced separate pieces for the whole, including Alice Neel who painted a portrait of Bella Abzug and Judy Blum who painted Betty Friedan as a prophet. Cynthia Marlman's work for the Sister Chapel is especially notable in

the context of this book. Marlman's work, *Self-portrait as God* (1977), challenged both the western fine art tradition and religious orthodoxy by introducing a reinterpretation of goddess mythology into women's self-portraiture. The nude body of the artist is shown towering over the spectator, encircled by the universe. The pose dominates the spectator and we are placed under her. The image likens the 'god' to a woman about to give birth. It is a heady piece of renegotiation and a powerful revision which links the notion of spiritual creation and the goddess with that of 'giving birth' or creating an artwork.

Continuing this line of challenging work, during 1982 and 1983 Cheri Gaulke performed the piece *This Is My Body*. This work set out in eight tableaux to reinterpret the Christian passion through a feminist revision, using the body of woman as the central figure. The whole piece charts the Christian story from the fall from grace to the crucifixion; from sin to redemption. Women's position within Christian theology is that of pure body, excessive desire which leads men to their doom. Traditionally, women were argued not to have souls and were often not permitted to have access to the most sacred objects and rituals of the Church. The marginality of women in world religions and the inability of many conventional religions to address women's spirituality are feminist concerns. Mary Daly's *Gyn/Ecology* (1979) asserted the imperative for women to work through the myths of Christianity to find their own voice within its texts. Gaulke specifically drew on Daly's text in her performance piece along with Elizabeth Cady Stanton's *Woman's Bible*, Susan Griffin's *Pornography and Silence* and Helen Diner's *Mothers and Amazons*.[34]

In her performance, Gaulke used taped text, slide projection and her own body to encounter the Judeo-Christian tradition as patriarchal and then reverse its own standpoints. She adopted multifaceted roles such as Eve, the Serpent and Christ in order to negate the fixity of women's positions in these stories and to re-empower herself as a female. It was readily apparent that a woman could not simply step into the role of Christ, but needed to problematise it. The assertion, 'This is my body', was critical, as Arlene Raven pointed out:

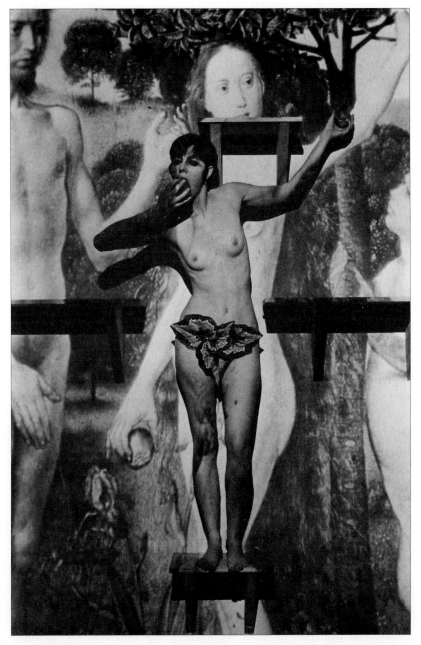

Cheri Gaulke, *This Is My Body* (photo by Sheila Ruth), 1982–1983

> This work also commemorates the crucifixion of Christ: His is a
> death normal and mortal for being human, but a transcendent death
> which marks the beginning of the patrilineal tradition from which
> she seeks healing and herself and about which she comments here.
> To be able to say, simply, 'This is my body', is to have journeyed
> through the (Christian) faith of her father(s) to her authentic Self.[35]

Without recourse to concepts such as 'authentic Self', this work is still a
powerful piece of feminist theology which does derive in part from the
tradition which was so dominant in Gaulke's own life as the daughter of
a Protestant minister. It is 'autobiographical' in that sense, but also
attends to the wider implications of Christianity for women. Moreover,
many of the projected slides and poses which Gaulke took up in the
work are from the canonical tradition of western fine art painting. Thus
the work also contends with the patrilineal artistic context in which the
Christian myths were given visual form.

Another work which explored this context, but without the elaborate
references to a feminist theology, was the group self-portrait by Mary
Beth Edelson, *Some Living American Women Artists/Last Supper* (1971).
Edelson's work considered the gendered nature of Christian narratives
more particularly through the western fine art tradition itself. Her work
parodied Leonardo da Vinci's *Last Supper* (1495–8), a work of art nearly
as sacrosanct in our culture as the moment it commemorates. Most
significantly, Edelson's work affirmed the particular empowerment of
women as artists through this trope. The main characters of Christ and
the Apostles are replaced by well-known women artists; the alternative
canon is placed into the sacred seats of the Last Supper. Christ's position
is occupied by Georgia O'Keefe, with such artists as Elaine De Kooning,
Louise Nevelson, Helen Frankenthaler, June Wayne, Lee Krasner, Louise
Bourgeois and Yoko Ono as 'apostles'. Framing the picture are the faces
of contemporary women practitioners, including Edelson herself,
'canonised' by their proximity not to the men of the Christian tradition,
but to the women artists who preceded them. Thus, the work effectively
subverted the patrilineal traditions of both Christianity with its cast of
male characters handing down religious authority from generation to
generation and the canonical tradition of the 'Old Masters', another

masculine line of inheritance. In its place is the history of women artists, a matrilineage overlaid on to the conventional model. This was, of course, a preliminary strategy for undermining convention and not an attempt to replace one absolute and gender-biased system with another.

The Artist and Her Model

Manipulating Christian symbolism to assert female identity and the power of women artists required self-conscious negotiations and subversions of a white, western tradition. The use of the female nude model by women artists in self-portrait iconography was equally difficult to appropriate. For the most part, both of these tropes were avoided by women artists in their self-portraiture. However, in some instances, the nude model could be used to assert artistic authority. For Charlotte Berend-Corinth and Lotte Laserstein, this trope was used to acknowledge their place within academic, figural practice as artists in their own right.

Berend-Corinth's art practice and subsequent reputation were overshadowed by her marriage to her former teacher Lovis Corinth. Her diary entries from the period of her marriage make this absolutely clear; she was 'mother' to both Lovis and their children.[36] In self-portraits by Corinth, Berend-Corinth is frequently shown as his nude model; her role as lover, supporter and muse to his creativity places his works formally within the traditional representations of artists and models and occludes the serious, professional practice of his wife. Corinth's 1910 self-portrait, *Self-portrait: The Victor*, for example, shows the huge Corinth in armour clutching the breasts of his partially nude wife. By contrast, in 1931, Berend-Corinth produced a self-portrait which responds in kind to this tradition. *Self-portrait with Female Model* represented Berend-Corinth as the clothed artist who works in the studio with the nude female model. Significantly, she is not in sexual control of the model and we, as viewers, are not given the body of the model as an object. Rather, the model stands behind the figure of Berend-Corinth and both female figures look directly at the spectator.

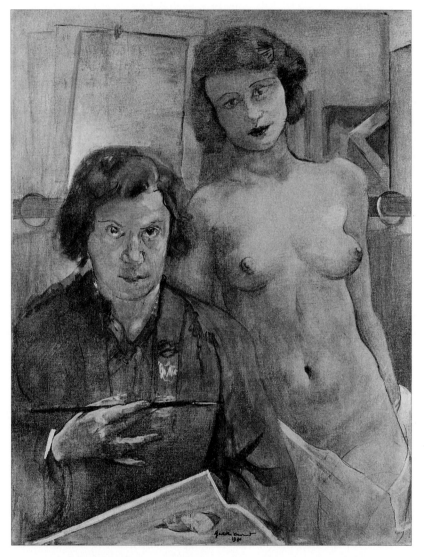

Charlotte Berend-Corinth, *Self-portrait with Female Model*, 1931

This use of the trope both acknowledges Berend-Corinth's place within the tradition and subverts the sexual politics of the imagery when the male artist is a dominant creator and the female model merely his 'material'.

Lotte Laserstein's representations of female nudes in her self-portraiture are slightly more ambiguous, but equally question the gendering of artistic creativity. Laserstein frequently turned to the trope of the artist and nude female model in her self-portraiture (see, for example, *Traute in the Mirror*, exhibited 1930, and *Artist and Model in the Studio, Berlin Wilmersdorf*, 1929). Significantly, Laserstein had one particular model throughout her career, Traute Rose, who is in many of Laserstein's works and even occasionally named in the titles. Despite this collaboration between artist and model and the importance given to the model in the production of the work, the ambiguity of this imagery in the work of women artists is apparent in Laserstein's self-portraiture. For example, in *Artist and Model in the Studio, Berlin Wilmersdorf*, Traute Rose is figured in the foreground, reclining and fully displayed to the viewer, rather than in a position which would make internal pictorial sense with the figure of the artist looking at the model. Laserstein's self-portrait image is dwarfed by the representation of Rose and she is the small figure in the background working at the easel.

Read within the context in which Laserstein was working during the period, this image is paradigmatic of the problematic relationship between the categories of 'woman' and 'artist' and attempts to find some form in which they can be brought together meaningfully. In the early years of Laserstein's career in Germany (being half-Jewish, she was forced to emigrate to Sweden in 1937, where she remained for the rest of her life), she self-consciously eschewed domesticity in order to promote her professional artistic practice.[37] More than aware of the ways in which marriage and family could impinge unfavourably upon her career, Laserstein allied herself with the 'New Woman'; she chose not to marry, attended the Berlin Academy, set up her own studio and adopted the androgynous styles associated with such modern roles for women of the 1920s. Debates raged in these years about the 'making manly' (*vermännlichen*) of these professional women and Laserstein's purposeful assumption of this androgynous or even 'masculinised' self-

image in her self-portraiture (see also *Self-portrait with Cat* of 1925) was unmistakably an assumption of a powerful, masculine position – that of 'the artist'. Furthermore, Laserstein was involved with the academic art world in the period, which meant that the precise rendering of the nude female form would have been privileged in her circle. Hence, her androgynous posturing in the self-portrait in conjunction with the skilfully produced nude figure presents her as an artist, in the classic sense. Only the gender politics of the female artist and nude model make this image other than standard academic work. The inversion of the norm in representation forces an engagement with the social constructions of artist myths which otherwise might go unnoticed in the traditional reading of such a figural painting. These details problematise assumptions about the gender of creativity but do not undermine them.

Although it was difficult for women artists to appropriate the representations of nude models in their self-portraiture, it was easy for feminist artists to invert the iconography in order to expose the gender biases of the imagery. In her painting of 1971, *Philip Golub Reclining*, Sylvia Sleigh produced just such an inversion by representing herself as the clothed, active artist painting the nude, passive body of a male model. It is, specifically, an inversion of the stereotypical sexual politics of the studio, as the marks of masculinity (that is, action, control, creativity) are all assigned to the woman artist, while the usual marks of femininity (passivity, beauty, availability) are put on to the male figure. The work acts simply to expose the underlying assumptions with which we approach works of art and gender difference. It requires a 'double-take' to make sense of this image, as it confounds expectations. However, while the work reveals the construction of gendered norms for 'artist' and 'model' in imagery, it does not provide a thorough-going role reversal. It still appears forced and obvious; the male model in this guise does not appear 'sexy' or empower the female artist as a 'bohemian' in the way that the nude female model does in the self-portraiture of male artists. Inversions show the commonplace roles, but do not change them.

Throughout the century, women artists have been appropriating, inverting and challenging the modes of self-portraiture which reinforce the masculinity of the artist in both myth and history. This has been a

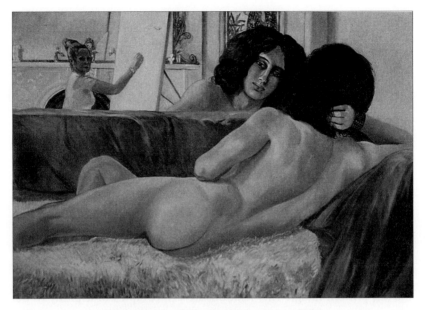

Sylvia Sleigh, *Philip Golub Reclining*, 1971

necessary exercise for women who wished to represent themselves as 'the artist', since the standard means by which this was signified were defined in ways exclusive of women. In some cases, it was enough merely to show yourself with the tools of the trade to subvert convention and declare yourself an independent woman. At other times, more active parodies and pastiches of the tropes associated with the artist myth were needed to find a place from which the woman as artist could speak. Whichever tack was taken, women's representations of themselves which engaged with artist definitions altered those definitions and the very ways in which self-portraiture as a genre can be read.

2: The Autobiographical Model

The Literary Paradigm

Conventional models of biography and autobiography are implicit within most critical work on self-portraits. This criticism is often inadequate in terms of contextualising self-portraiture as an art historical genre and in terms of the relationship between the artist and the self-portrait image. This relationship is a complex one, partly to do with the subject's life and personal history, but not reducible to it. The self-portrait is a mediation of the 'self' in social signification. Biography and autobiography, in traditional senses, posit concepts about the subjects of the works, the formal characteristics of the genre and the very nature of subjectivity. By reinvestigating the links between autobiography and self-portraiture, the place of women in these discourses can be reinscribed.

The problem for women artists who wish to represent themselves and for feminist theorists who wish to look at the instances of women practising as artists is clear. On the one hand, the traditional models of authorship and autobiography will permit only the most marginal space to subjects who do not fit the norm of 'white, male, middle-class'; women's practice will always only approximate the standards developed through such biased readings. Yet, if we completely lose sight of the 'actual', 'historical' author/artist as a reactionary, patriarchal convention, then we cannot justify looking at the ways in which women particularly come into representation. We do not so much need to lose the 'autobiographical' subject as to reinvent her. Furthermore, if all attempts at 'self-representation' are simply following outdated, conventional models of writing or producing art, then we must banish a considerable

proportion of the works of women artists throughout this century as outmoded. I am not willing to do this.

Autobiography, in traditional interpretations, is a sub-genre of biography. Significantly, its origins in the eighteenth and nineteenth centuries classed it as a marginal space, too personal to be considered a form of higher literature. Biography, by contrast, was thought to be objective when produced well, and thus a 'true' portrait of its subject. In this period, women and other marginalised groups were the main producers of autobiography in the form of diaries, memoirs and journals. However, as autobiography increasingly became a published form, its status changed. Thus, by the twentieth century, autobiography became a more public form of self-expression which acted to marginalise those very voices which first produced it. Self-portraiture is often seen to parallel this as a 'sub-genre' of portraiture which moved from highly personal sketchbook studies of an artist's likeness to a public statement about the nature of artistic creativity.

Conventionally, then, autobiography shows obvious biases towards the celebration of 'great men' and towards a particular version of history, narrative chronology and mimetic truth, the truth of 'likeness'. All of these presuppose a link between the persons and forms of autobiography and the nature of subjectivity which operates within masculine aesthetic traditions. In recent decades, autobiography has received much attention from literary theorists keen to revise traditional interpretations of the sub-genre in the light of both feminist and poststructuralist concepts of authorship which question the idea of the 'self', or subjectivity.

As traditional concepts of autobiography are the literary counterpart of conventional readings of self-portraits, in order to understand the relationship between women's practice of self-portraiture and revised theories of autobiography it is first necessary to examine the more traditional associations between the two. Certain assumptions are critical to conventional ideas about both autobiography and self-portraiture, and women artists (and indeed women authors of 'autobiographies') have had no choice but to contend with them.

Clearly, the first traditional assumption about the subjects of autobiography is that they are significant individuals, in other words the

'great men' of history, deserving a singular work about their lives. It is assumed that they were prominent, named individuals who in some way 'affected' the course of history. As historians have pointed out, prominent figures, in this sense, have tended to exclude women, people of colour and the working-classes who more frequently acted collectively or within the so-called private sphere.[1] These historically motivated definitions of the 'selves' of autobiography have defined other features of the genre, such as the idea of autobiography as an edifying model of a successful life and the concept of historical verisimilitude.

Autobiography as the 'story of the life' of a great individual has generated particular structures in the texts. One of the most significant is some sense of narrative chronology and historical truth. Autobiographical criticism often rests on checking the accuracy of the details within the text. If the autobiographical subject has altered these details, this must be accounted for in some way which does not challenge the fundamental 'truth' of the autobiography. That is, a writer producing an 'autobiography' about a character whose life story in no way resembles that of the author would be thought to be writing a novel. This would not be read as an autobiography in the traditional sense, but as a work of fiction. Conversely, subtle inaccuracies would be read as mistakes in memory or purposeful embroideries meant to enhance the reputation of the subject. Possibly, there would even be psychological readings to explain these 'inaccuracies' in terms of materials which had been repressed by the subject. Terms such as 'semi-autobiographical' have been introduced to describe just such instances of texts in which only a fleeting sense of verisimilitude or historical accuracy can be found.

The structure, therefore, of the autobiography tends to be that of a progressive chronology which follows the path leading to the production of the fully mature subject of the work. Autobiographies constructed through these conventional paradigms are frequently read so as to reveal the nature of a great individual. This sense of the 'nature' of the author of an autobiography is one of the most difficult features of the traditional reading. It presupposes a model of subjectivity based upon Enlightenment concepts of individualism which are inherently

male-normative, that is, they operate on the assumption that all subjects are male.

To analyse (frequently psychoanalyse) the significant or formative events in an individual's life has been assumed to explain their achievements. In such readings of these texts, there is proposed a transparent and immediate relationship between the subject of the work itself and the author. That is, it is assumed that the 'I' of the autobiography *is* the writer, who stands objectively outside the text, 'accurately' rendering the events of his life. This embodies the idea of a transcendental ego as the author; that the writer of an autobiography can be in complete self-conscious control of the production of the work. It presumes the author to be able to understand and represent fully his or her 'self', that the author is not in flux, but a fully formed and independent subject who 'knows' all about the self he represents. Thus, the autobiography reveals to us as readers the psychology of the author without any *lacunae* or myth-making.

Self-portraiture Read as Traditional Autobiography

There are numerous reasons why the conventional autobiographical model persists in the more traditional readings of self-portraiture, but this persistence is all the more marked for being implicit rather than explicit. Although there are many analogies to be found between conventions in autobiography and self-portraiture, the two forms are not, of course, merely reducible to one another. By examining the points of conjunction and disjunction between autobiography and self-portraiture, we can begin to understand where the critiques of autobiography can assist us in rethinking models for reading self-portraits which devalue or exclude the practices of women artists. One obvious link between the two forms is the subject of the work. If the 'great men' of history are the traditional subjects of autobiography, the 'great artists' or 'Old Masters' are the most usual subjects of self-portraiture. As Griselda Pollock and Roszika Parker have so eloquently pointed out, these subjects were, by and large, defined as male.[2] Lack of access to training and professional careers for marginalised social

groups militated against their appearance in a sub-genre which privileged such public displays of artistic practice.

Like the tests of historical verisimilitude which pervade readings of autobiography, self-portraits have been subject to tests of 'truth' or accuracy. If a self-portrait produced by an octogenarian represents the artist as a child, the work is read autobiographically as a statement about the nature of the artist, rather than as an historically accurate self-portrait. This concept of the mimetic truth of the self-portrait is linked to western traditions of thought which link seeing with knowing. In order to ascertain the truth of the representation, we should be able to perceive its accuracy, its likeness, its verisimilitude. This is a commonplace feature of the interpretations of self-portraits, especially in the instances in which an artist produced a series of self-portraits. In Jakob Rosenberg's volume of 1948, *Rembrandt: Life and Work*, for example, this autobiographical model was crystallised. The nature of the artist's monograph (that is, the artist's life and work thought to be fundamentally intertwined) privileges biographical readings of works, but this text actually separated the self-portraits produced by Rembrandt from the rest of his oeuvre for special consideration. These works were then seen to be a chronological narrative of the artist's life: 'Even in limiting our consideration to extant material, there is hardly any phase of the artist's life without its painted record of his likeness, making it possible for us to reconstruct the entire history of his outward appearance as well as the development of his personality.'[3]

As is the case with autobiography, such assumptions about the formal structures of the sub-genre underpin ideas about subjectivity which are reinforced by conventional readings. The 'truth' of self-portraits on this model is akin to the 'truth' of autobiography discussed above; it lies in the ability of the work to reveal the nature of the creative personality through the image. To cite Rosenberg again on this point, in reference to the late self-portraits by Rembrandt:

> To the keen self-observation of his earlier years has been added a pro-found thoughtfulness. He seems to look not only at, but within himself, seeing his personal life in its broader and more universal relationships. The dignity which speaks to us through these self-

portraits seems to be rooted in an uncompromising search for truth, and there is expressed the most intense integration of the artist's physical and spiritual existence.[4]

Such psychobiographical readings of self-portraits have been particularly persistent in art historical discourse since the Romantic period of the nineteenth century. Like psychoanalytic readings of autobiography developed in the twentieth century, they are intended to explain the psychology of the creative individual. These readings mirror the idea of the visual artist as a genius who has an especially sensitive, intuitive nature which unfolds in the artwork produced. The very language in which such interpretations are written is gendered. The sorts of readings of self-portraits which attest to this attitude are legion. For example, Leo Bruhns wrote in his 1936 book *German Artists in Self-representation* (*Deutsche Künstler in Selbstdarstellung*) of 'the creative man ... his eyes through which we see the creative soul within ...'[5] while in 1931 Fritz Ried, in a still-standard text on self-portraiture, *The Self-portrait* (*Das Selbstbildnis*), wrote:

> How painters saw the 'I–You' in the mirror and recorded in self-portraits, into what depths of introspection they descended and with what judgement of themselves they put down their brush, will now be presented to us through a series of self-portraits through six centuries.[6]

Lest we think that these were the excesses of early twentieth-century criticism alone, it is significant that Christopher White, in the 1994 *Omnibus* programme 'About Face', which concerned a contemporary exhibition of self-portraits at the Walker Art Gallery in Liverpool, was still able to discuss Rembrandt's self-portraits as 'an image of an artist developing and expressing himself'.[7] Thus, the autobiographical ideal is, in many quarters, still pervasive. Autobiography, however, has been challenged for its implicit renderings of a certain paradigm of western and masculine subjectivity, where self-portraiture remains, for the most part, undisturbed in its traditional readings. In order to begin to

reconsider women's interventions into self-portraiture, it is imperative that we look to feminist challenges in the critiques of autobiography.

Challenges to the Traditional Readings

As Sidonie Smith and Julia Watson argue in their volume *De/Colonizing the Subject: The Politics of Gender in Women's Autobiography*:

> Although the genres of life writing in the West emerge in Antiquity, the term *autobiography* is a post-Enlightenment coinage ... traditional 'autobiography' has been implicated in a specific notion of 'self-hood'. This Enlightenment 'self', ontologically identical to other 'I's, sees its destiny in a teleological narrative enshrining the 'individual' and 'his' uniqueness ... In order to unstick both this Man and his meanings, we need to adjust, to reframe, our understanding of both traditional and counter-traditional autobiographical practices ... While popular practitioners carry on the old autobiographical tradition, other practitioners play with forms that challenge us to recognize their experiments in subjectivity and account for their exclusion from 'high' literature.[8]

That is, autobiography is derived from a male philosophical understanding which presupposed that the world could be known and interpreted fully by the individual self. Significantly, literary theory has advanced a number of criticisms of conventional autobiography over the past few decades, while the topic of self-portraiture has not received such thorough-going revision. By looking at the works of women and other marginalised groups, scholars have criticised the ways autobiography has enacted political exclusions. Additionally, the nature of the sub-genre itself and the structures which it has imposed upon the telling of the story of a 'life' have been questioned through examining alternative forms. Caren Kaplan has labelled these forms 'outlaw genres' and has demonstrated their use in the production of 'autobiographical' interventions.[9]

Poststructuralist critiques of authorship, particularly those propounded by Roland Barthes and Michel Foucault, have meant that the concept of a stable 'I' self-consciously controlling the production of a text has been radically rethought. Two of the major problems one faces when looking at the intersection between autobiography, the 'self' and self-portraits produced by any marginalised group are the concept of the stable self and the conventional notion of the author. When Barthes challenged traditional views of the authors of texts in his essay 'The Death of the Author' in 1968, he liberated the meaning of texts from the bounds of particular biographical details and he separated the traditional connections between the 'life' and 'work' of the artist.[10] Clearly, this permitted many new readings of works to be produced and subverted models which insisted that works of art were reducible to the 'facts' of the author's life. Foucault took this a step further by introducing the notion of the 'author function' in his essay, 'What Is an Author?' (1969).[11] In this version, one does not simply 'kill' the author and invent the reader as the agency by which texts gain meaning, but social expectations about authorship and its uses are introduced. Thus, one can introduce a whole host of other texts and social discourses into the arena; the meaning of a work and the 'self' who produces that work become part of this social fabric. Obviously, these strategies, which subverted some of the more limiting constructs of the autobiographical model described above, were liberating for women's practice.

However, as many feminists have remarked, the displacement of the stable author came at just the moment when women and other previously unrepresented groups were beginning to become 'authors'. Tania Modleski makes particular reference to this point in her book *Feminism without Women*, saying:

> It is also easy to see why poststructuralist theories have appealed to feminists ... However, as feminists are increasingly pointing out, the once exhilarating proposition that there is no 'essential' female nature has been elaborated to the point where it is now often used to scare 'women' away from making *any* generalizations about or political claims on behalf of a group called 'women'.[12]

Linda S. Klinger also considered this issue with specific reference to the situation of women as visual artists in her essay 'Where's the Artist?: Feminist Practice and Poststructural Theories of Authorship'. She argued: 'Specifically, by looking at women artists as "authors", I'd like to consider in what ways recent critical theory cannot accommodate – literally "writes out" – feminist artistic practice ... the identity of the woman artist has been refigured in troubling ways.'[13]

Rather than allowing ourselves to be caught in an artificial methodological dilemma between, on the one hand, conventional authors and, on the other, no authors at all, we can begin to elaborate a whole host of alternative readings. These demonstrate the ways in which women came to representation while revealing the de-centred, multiple nature of this and exposing the constructions of the 'self' and the provisional nature of identity.

All of these criticisms have unsettled certain traditional assumptions while simultaneously permitting the introduction of alternative meanings, readings and methods of production which have enabled groups otherwise excluded from the categories of autobiographical subjects to begin to come to 'self-representation'. For example, the narratives of slaves, the testimonials of disenfranchised people, the diaries of women and even the basket-weaving and writing of cookbooks by native Americans and Hispanics have been considered as autobiographical work in the last few years.[14] The ways in which women particularly have had to manipulate the standard forms of 'writing the self' in order to represent their own experiences have had a deep impact on the whole concept of autobiography. Moreover, feminist theorists have begun to reassess the value of forms of autobiography as critical theory itself.

Rosi Braidotti, in *Nomadic Subjects*, begins her highly theorised discussion of 'situated knowledges' with the idea of investigating autobiography.[15] She argues that we must actually acknowledge our own desires and our own positioning before we can understand our investment in theory, politics and the creation of alternative modes of representation. With this as a working premise, she explores features of her own autobiography as part of the academic text. Such has also been the case in the work of other feminist scholars, such as Griselda Pollock

and Jane Gallop (see Pollock's *Avant-garde Gambits 1888–1893: Gender and the Colour of Art History*, 1992; and Gallop's *Around 1981: Academic Feminist Literary Theory*, 1992). Thus, coming to terms with autobiography and the various alternative readings of this sub-genre is fundamental for women who wish to enter into any form of self-representation, from academic theory to literary autobiography and the making of self-portraits. With this intervention in mind, it is possible to look at the self-portraits of women artists during the last century as a dialogue with the concepts of the autobiographical subject and to see the ways we can fruitfully review these works. Not surprisingly, women artists have subverted the conventional modes of autobiography at every turn, without ever relinquishing their claim to self-representation.

The features of women's encounters with autobiography and self-portraiture over the course of the last century have been determined by their lack of fixed subject positions and subversions of traditional narrative structures. Unable to represent their experiences in traditional modes which did not 'speak' to them or for them, they negotiated alternative paths. Their own lives and their own 'factual' histories were the reasons why they challenged the genre; we can no more dispense with them as historical subjects than subsume their production into the traditional male-dominated modes of interpretation. Women artists over the course of the twentieth century have challenged simple psychobiography in the form of serial self-portraiture, subverted easy 'historical' or 'biographical' accuracy, queried the significance of mimesis and revealed the ways in which their 'selves' were the products of shifting social constructs and definitions of 'woman'.

History, Time and Chronology

Any redress to the conventional constructs of autobiography must focus on the relationship between the autobiographical subject and history. Inasmuch as the traditional subject of autobiography was the 'great man' of history, there are conventions associated with the interaction between that 'man' and his society attached to the genre. For example, historical anonymity was rarely permitted in the standard

autobiography; the subject by necessity must have made his mark on a time period or in some way have left us a legacy through his life. Thus, it was edifying to read autobiography. One of the earliest feminist critiques of the sub-genre concerns precisely this feature which precluded most women from ever attaining the status of autobiographical subjects. There was a sense in which women's lives, connected more often with the details of home and family, were not appropriate to the genre. Moreover, women rarely attained the status in traditional histories as individuals, which was a necessary precondition of their production of 'autobiography'. Thus, women's diaries and memoirs were often classed outside the boundaries of the sub-genre; they were literally positioned in the margins.

Not surprisingly, there is a parallel position in the case of self-portraits in fine art practice. The conditions of women artists' lives and their associations with the domestic sphere meant that their self-portraits most frequently engaged with time and space at the level of the personal and the domestic respectively. Hence women artists seeking to represent time and history in their works have looked towards notions of genealogy or 'domestic' time and history as a model and local spaces as the place of self-portraiture. Frida Kahlo clearly used this sense of the personal passage of time in works such as *My Birth* (1932) and *My Grandparents, Parents and I* (1936), where she produced images which contend with birth and personal lineage. *My Birth* speaks of cycles; of the cyclical nature of birth and death and the bodily experience of menstruation and fertility as cyclical. It challenges concepts of time as linear and progressive and, in its pictorial returning of Kahlo to the womb, subverts the usual nature of chronologically determined readings of self-portraits as autobiography. *My Grandparents, Parents and I* refers Kahlo's 'self' to a sense of personal, genealogical chronology, through the integration of her own image with that of her family line. Again, this subverts a masculinist progressive sense of chronology in its assertion of domestic time.

Many other women artists also referred to domesticity and maternity in this way in their self-portraits, though these will be looked at more closely in chapter 3 in terms of the representation of the maternal body. Elsa Haensgen-Dingkuhn explicitly showed domestic time and space in

her painting *Self-portrait with Little Son in the Studio* in 1928, as discussed in chapter 1. The work linked Haensgen-Dingkuhn's professional practice as an artist with her domestic concerns as the mother of a young child. Additionally, Grethe Jürgens's self-portraits, as discussed later in this chapter, linked her image with the particular time and space of Hanover in the 1920s, but again, interiors and local places played the most significant role. Thus, even ostensibly 'public' representations tended to bear witness to women's alternative situations in time and space.

Since 1968, concepts of history as a public realm altered by the actions of great individuals were challenged in many ways, and women artists used these alternative concepts of history more self-consciously. The conjunction between the private and the public spheres became an issue on the agenda and representations of versions of history which suggested that the personal is political became integral to women's self-portraiture. For example, the American photographer Judy Dater in *Self-portrait with Parents* (1981) placed herself underneath the photographs of her parents on their wedding. In this, she played upon the differences between the qualities of the older photographs and the contemporary work to indicate history and the passage of time in her own life. With the advent of photography, memories of past history have become associated with black and white or sepia images and they evoke past times to the wider audience as well as working within the specific context of Dater's family history. Furthermore, the work again affirms the significance of family, or domestic, history in the lives of women.

Marikke Heinz-Hoek used similar family photographs as historical documents in her self-portrait of 1979, *From the Foundations of the Second World War*. This work combines collaged photographs of herself as a child with her parents and textual diary entries. There are also absences in the work which suggest that photographs have been taken out of the 'album' and lost or destroyed. The scripto-visual elements combine to evoke the notion of memory in history as imperfect and incomplete; history as a perfectly objective science is challenged by such evocations. Furthermore, by associating her own birth (in 1944) with the wider context of the Second World War, the artist places the domestic history into the wider context and subverts the concept of

Marikke Heinz-Hoek, *From the Foundations of the Second World War*, 1979

'history' as that which merely takes place in the public sphere. Especially for Germans of Heinz-Hoek's generation, who lived so thoroughly in the shadow of the atrocities of the Third Reich and the war, the interchange between personal identity and public events was powerful. For the generation which had to dispel so-called 'collective guilt', works such as this perfectly engender the complexities of alternative histories.

The American artist Tee Corinne has also explicitly contended with concepts of time and history in her work, *A Self-portrait Dialogue with Time and Circumstance* (1967–92). This photomontage consists of multiple images of the photographer taken over a 25-year period. In one sense, it presents an autobiographical chronology; this is the life story of Corinne during that period. However, as the artist has neither dated any of the individual images nor standardised any of the self-portrait formats, the whole work plays upon the instability of the 'self' of the title. The work reveals the multiple and disparate nature of a self in time, rather than a chronological progression or narrative of the completion of the 'person'. The title also suggests such a lack of fixity, by

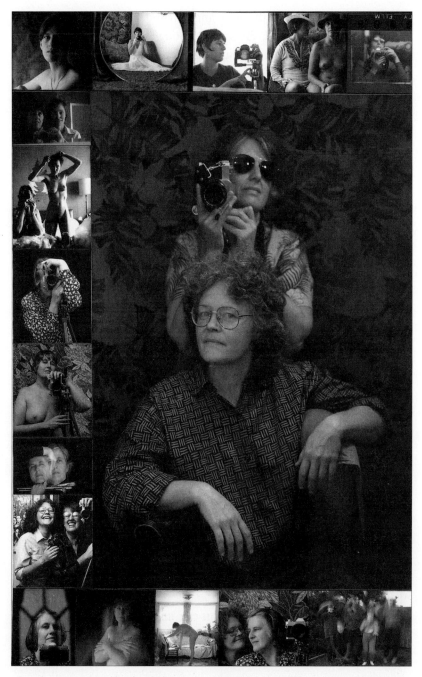

Tee Corinne, *A Self-portrait Dialogue with Time and Circumstance*, 1967–92

describing a dialogue with time and circumstance. The provisional identifications made and discarded throughout the artist's life are presented by the work as a dialogue rather than a monologue; the artist does not attempt to claim the single voice which 'explains' the imagery finally for us. This dialogue with history and time is particularly relevant to the lesbian politics of the work. Many of the images show Corinne with partners, and the woman-centredness of her life is documented in the work. As the relationship between lesbianism and conventional history is one of invisibility and lack of representation, this is a powerful political engagement. However, in coming to representation in this fashion, the work signifies the limits of conventional history for marginalised groups; the artist simply cannot use the fixed models of identity to represent her own lesbian history, for they are inadequate.

The conventions of traditional autobiography which presuppose particular concepts of chronology and narrative history, therefore, are incapable of containing or explaining the interventions into self-representation made by women during the course of the twentieth century. Furthermore, the conventions are derived from written sources which lend themselves to concepts of chronology and narrative far better than do visual works. When these modes are assumed for self-portraiture, they enforce certain notions of narrative, history, mimesis and the subject which serve to marginalise the works of women artists. By exploring the conventions and the subversions of these throughout the period, alternative models for the reading of self-portraits come into view. This is also the case for women artists who produced self-portrait series. In these instances, there have been even more pervasive attempts to reduce the self-portraits to an inappropriate autobiographical model which suggests women's work is contained fully by references to their personal life. This psychobiographical approach is part of the conflation of conventional autobiography and readings of self-portraiture which does little to examine the multiple frameworks within which women's work acts.

The Self-portrait Series in the Work of Women Artists: Psychobiography

Artists who frequently represented themselves in their art have often been subject to having their complex self-portraits 'explained' with simplistic reference to anecdotal details of their personal lives. This psychobiographical approach is particularly acute in instances where the artist's life was scandalous or otherwise marked by personal trauma. The work of women artists has suffered from this approach even more frequently than that of male artists because of assumed links between women and the personal sphere. It has been difficult for many critics to transcend the personal details of the lives of women artists and enter those details into the wider context of history. Probably the most obvious instance of this tendency to reduce the works of an artist to the details of her biography can be seen in the mainstream critical work on Frida Kahlo. The images produced by Kahlo are striking and the circumstances of her life equally so; in recent years, her life and works have become very well known and publicised for just this reason (including being collected by such media celebrities as Madonna). Unfortunately, much of the material written about the artist's work concentrates on her life; the illnesses she suffered as a child, the horrific tram accident as a teenager, her stormy marriage to the artist Diego Rivera, her many miscarriages and her various affairs. While Kahlo's works are undoubtedly highly personal, it diminishes their power merely to construct them as responses to particular events in the artist's life.

For example, three works have often been read as revealing her personal feelings towards Rivera at particular stages of their relationship: *Frida and Diego Rivera* (1931), *The Two Fridas* (1939) and *Self-portrait with Cropped Hair* (1940). The first work is seen as a wedding portrait which clearly shows the dominance of Rivera within the relationship as artist/teacher and husband. As Hayden Herrera wrote in the catalogue entry on this work in *Women Artists 1550–1950*:

> Its very composition, with the couple's linked hands placed at the center of the canvas, suggests Kahlo's sense of security in their

marriage bond, a sense that proved mistaken for Diego was soon
unfaithful to Frida ... the twenty-year-old Frida looks tiny, delicate
and subordinate – the adoring wife rather than the committed
painter ... Diego's grip on Frida's extended hand is neither tight nor
truly sustaining – an example of art prefiguring life.[16]

The latter two works are meant to reveal Kahlo's despair at the
estrangement between herself and Rivera during the time they were
painted. *The Two Fridas*, by MacKinley Helm's contemporary account
(1939), shows 'the Frida that Diego had loved ... [and] the second Frida,
the woman whom Diego no longer loves'.[17] Kahlo and Rivera's divorce
papers came through as she was finishing this work, and she was
certainly distressed at the news. However, even Kahlo herself suggested
wider implications for the work, such as the idea that it showed 'the
duality of her personality'.[18] The fact that art historians tend to take
Helm's view, rather than confront other possible meanings for the work,
is significant.[19]

To view these works in this way is to reinforce both the conventional
assumptions about women artists married to male artists as derivative or
completely identified with their husbands and the stereotypical notion
of women as merely involved with the personal sphere. It is to treat
these artworks as though they do not operate in wider contexts of
signification such as Mexican politics, modernism, academic art practice
and gendered discourses. It is, in other words, to ignore their public role
as art. *Frida and Diego Rivera* and *Self-portrait with Cropped Hair*, for
example, each offer alternative notions of femininity and sexuality
which had political ramifications in their day. In the wedding portrait,
Kahlo has cast herself as a demure bride but, significantly, as a
Tehuanan bride. That is, she has allied herself with a native Mexican
image of femininity; this image strongly contrasted with the traditions
of the western, double portrait produced for a couple's marriage.
Trained academically, and with links to both European and American
art scenes, Kahlo would have known these sources and have been able
to use them quite self-consciously. The ideal of the Tehuanan woman
was quite different from that of the European 'blushing bride'. They

Frida Kahlo, *Self-portrait with Cropped Hair*, 1940

were considered the strongest of native women and the dominant partners in any liaison.

Self-portrait with Cropped Hair plays with conventional concepts of masculinity and femininity, through its use of both the hairstyle and the man's suit. Within the confines of modernist self-portraits by women artists, this androgynous imagery was a commonplace. As discussed in chapter 3, the New Woman was frequently pictured as having cut her hair and donned 'men's clothes' and the use of this self-image by such artists as Tamara de Lempicka, Grethe Jürgens, Hannah Höch, Romaine Brooks and Lotte Laserstein signified their serious professional practice in a male-dominated field. Among other things, Kahlo has placed herself as the woman artist in this work by using the title 'self-portrait', and this place dangerously challenged feminine and masculine borders by its very nature. Conventional definitions of 'woman' in this period which linked them to passive femininity and 'nature' were in opposition to definitions of 'artist' which were about the active producers of 'culture'. Women modernists had to contend with the disparate definitions of their identities and the adoption of an androgynous image (as either 'in-between' or as a masculine charade) was one possible tactic used.

In *The Two Fridas*, Kahlo again confronts concepts of femininity and the relationship between the European and the Mexican in her own identity and in definitions of 'woman'. Interestingly, it is the Mexican Frida who supports with her blood the European Frida; the Mexican heart gives life to the European heart which drips blood on to the white dress of the European Frida. Again, the imagery is very personal in this work, both because of the way in which Kahlo confronts the two cultural traditions from which she sprang (her father was German, her mother Mexican) and also because those two traditions come together in her art. Kahlo worked within an academic art tradition derived from European models and in materials which were part of this tradition. Simultaneously, she and Rivera were part of the group of Mexican artists who attempted at this time to revive interest in pre-Columbian art and native folk traditions for nationalist, political reasons. Thus, this work, like the others discussed above, can either be subsumed within a purely

anecdotal personal history, or be seen to have derived from the complex intersection between the artist and a series of social discourses.

Some of Kahlo's most challenging works also combine the personal and the universal in ways which transcend simple autobiography. Two works from the 1930s, *Henry Ford Hospital* (1932) and *Me and My Doll* (1937), concern the darker side of motherhood; *Henry Ford Hospital* represents a miscarriage and *Me and My Doll* the artist with a strange doll-child. Throughout her marriage to Rivera, Kahlo experienced numerous pregnancies and miscarriages; she had undergone such serious physical trauma during the tram accident of her adolescence that she was unable to carry to term. One miscarriage took place in the Henry Ford Hospital in Detroit during the time that she and Rivera were living there while he undertook a commission for the Fords. Clearly, in one sense, *Henry Ford Hospital* is a painful record of that biographical event. However, its combination of medical imagery, the self-portrait and the symbolic representations of fertility and fecundity, such as the orchid at the bottom of the picture, combine to speak eloquently of the multiple spheres within which such a personal event takes place. The concept of femininity which relies on women's fertility is challenged by such a trauma, while the cold, clinical treatment of women by the medical profession becomes part of the painful experience. Kahlo is defined in this work through these competing concepts and the image speaks of the provisional nature of identity for women whose link to so-called 'natural' female functions, such as childbirth, is severed.

Me and My Doll is also chronologically related to another of Kahlo's miscarriages and the dawning realisation on the part of the artist that she would never be likely to carry to term. In this sense, the doll acts as a replacement child and indicates her sense of loss. However, the work also subverts the definitions of femininity which rely upon motherhood, by showing the artificiality of mother–child relationships. The woman is not nurturing the 'child'; the two are estranged in an environment which suggests alienation and discomfort. Typical Madonna paradigms are refuted and more subtle questions about the links between women and motherhood are asked. As in the other examples of Kahlo's work, these representations are simultaneously personal, or psychobiographical, and signifiers within a wider social

field. It is necessary to understand them as artworks, as forms of social communication, in order to challenge readings which subsume women artists into the anecdotal.

The Self-portrait Series in the Work of Women Artists: Artistic Development

Other women artists who have produced self-portrait series are also caught in the difficulties of autobiographical paradigms. The pervasiveness of the autobiographical model has limited the scope of resistant readings available to us. We need to understand the ways in which these self-portraits are determined both by personal identity and by their social inscription. If Kahlo's series of self-portraits are susceptible to a reduction to the 'facts' of her biography and simplistic readings as autobiography because the details of her life were so dramatic, then Grethe Jürgens's self-portraits may find themselves structured as biography because of the artist's commitment to the 'realism' of the Neue Sachlichkeit or New Objectivity. Jürgens was part of the Hanover Neue Sachlichkeit group who produced their realist works during the 1920s and 1930s in Germany. Between 1928 and 1944, the artist produced four self-portraits in oils, each of which contained particular, 'accurate' details of the artist's circumstances at the time of production. Additionally, she included a representation of herself in the work of 1929, *The Labour Exchange*. In some ways then, these works document the artist's life and mimetically represent her. However, to ignore their associations with the 'realist' aesthetic of the New Objectivity and her role as a woman artist and member of the Hanoverian art scene would be to underestimate the ways in which these works operated in the public sphere.

In 1928, Jürgens produced the first of these works, simply entitled *Self-portrait*. The work shows the young artist in her attic studio in Hanover (nicknamed the *'Hündezimmer'*, 'dog room', because it was above a kennel), sporting the *Herrenschnitt* or 'men's cut' she had recently acquired. The other self-portraits, *Self-portrait in a Hat* (1932), *Self-portrait* (1938) and *Self-portrait in Front of Ruins* (1944), and the

work *The Labour Exchange* all share this commitment on the part of the artist to representing herself and her surroundings 'accurately'. The places in Hanover are carefully detailed, the artist actually lived in the places shown or, for example, visited the labour exchange on a regular basis when that work was painted. Despite their apparent simplicity, however, these works engaged with a host of difficult issues and demonstrated the artist's political commitment to the New Objectivity.

The young artists who formed the Hanoverian group of the New Objectivity all met through the graphics class of Fritz Burger-Mühlfeld at the Hanover Handwerker- und Kunstgewerbeschule (Arts and Crafts School). Of the six core artists who identified themselves with this realism and exhibited together under the banner of the Neue Sachlichkeit, two were women, Grethe Jürgens and Gerta Overbeck. The group became associated with the New Objectivity in about 1925, but did not actually show work under the heading until, significantly, 1928 when the Kunstmuseum Nordhausen held the exhibition *Die Neue Sachlichkeit in Hannover*. This was also the year in which Jürgens was finally able to quit her job as a commercial artist and practise full-time as a fine artist. Hence, the production of her first full-scale self-portrait painting coincides with two important outside events which defined the artist in terms of her professionalisation and her aesthetic commitments. Not surprisingly, the portrait itself acts in this way; she is shown as an independent 'New Woman' (in hairstyle and clothes) and is represented, stylistically, in an unflinching brand of the sober realism with which she was making her name. Her later self-portraits would continue to associate her with the New Objectivity.

The other feature of her self-portraits which was used to signify her aesthetic, and therefore political, allegiances was the faithful representation of the city of Hanover. Germany's art scene was multicentred in this period and regional variations in styles and movements were often marked. Certainly this was the case with the New Objectivity, which was manifested differently in Dresden, Berlin, Karlsruhe, Munich and Hanover. In this period, Grethe Jürgens's success as an artist was intimately tied to this city; an adopted home for her which she never left. The young artists who introduced the New Objectivity into the Hanoverian art scene were acting in a particularly

political way. The bourgeois art patrons of the city were whole-hearted followers of international modernism and, more specifically, of abstraction. The Neue Sachlichkeit was placed, self-consciously by this group, in opposition to bourgeois art standards. It was meant to be sober, figurative and, significantly, local. It was seen as an art about and for the local working-class people. In all of Jürgens's self-portraits from the period, she represents herself in recognisable, working-class Hanoverian districts or settings. This connection of her 'self' with her stylistic affinities and location cannot but give the works a definitive public and political cast.

The last self-portrait reinforces the fact that these works acted within specific social contexts. In *Self-portrait in Front of Ruins*, the artist represents her likeness in front of the burning wreckage of the Podbielskistrasse, the Hanover street on which her studio was located and which had been destroyed by Allied bombing raids on the city. Again, she linked herself to particular locations and events; but these events were fundamentally to alter her practice. She stated in an interview of 1981, 'This time was very hard for me, and I no longer wanted to paint in a "sachlich" way ... I was always afraid that the Neue Sachlichkeit could be confused with Nazi art.'[20] In the late 1940s and 1950s, Jürgens changed from the realism of her youth to abstract art. At this time, all German realism was subject to misinterpretation as Nazi art and many of the left-wing artists associated with the New Objectivity suffered unfair criticism as reactionary. Thus, Jürgens's self-portraits are chronologically linked to the beginning and the end of her association with the Neue Sachlichkeit as well as being linked, stylistically and in terms of content, with this movement. They are not simply psychobiographical moments, but statements of artistic and political allegiances.

Self-conscious Positioning

Alternative explanations of the self-portrait series produced by Frida Kahlo and Grethe Jürgens based on different forms of authorship enable one to break with traditional notions of autobiography which

insist that these works reveal the psychological state of the artist in response to anecdotal biographical events and that they follow simple, progressive chronologies. The details of the lives are still significant, but in the sense of situated knowledges. What we can begin to infer about the self-portraiture of women artists is that these works constantly renegotiate the boundaries which defined them as both 'woman' and 'artist', and that they cannot rely on fixed and simple sets of identifications. Women artists of the post-1968 generation have also dealt with the implications of producing self-portrait images which do not fix the 'self' to simple definitions, but reveal the multiplicity of 'selves' available to one individual. Often, as these women artists have been informed through encounters with postmodernism and feminist theory, they self-consciously attempt to subvert conventional notions of self-portraiture.

The work of Jo Spence is extremely interesting in this context. Having begun her political photographic career with the Hackney Flashers in 1979, Spence's work has always been informed by a politics, from Marxist materialism to feminist theories of the acquisition of gender roles. In her phototherapy works from the 1980s, which explicitly concerned highly personal details of her own biography, Spence attempted to use photography as a therapeutic tool to help ease the emotional traumas brought on by her experience of breast cancer and the medical profession's treatment of her as a 'patient'. Thus, these works could be read in the most conventional way as autobiography, as could her encounters with the family album. That is, they represent visually the chronological experiences of an individual and they reveal the most personal, psychological responses of that individual to particular details in her life.

However, what complicates Spence's work and makes it resist this reductive reading is the very fact that the artist situates her work as a series of 'provisional' interventions into the nature of 'herself', rather than final, fixed identifications. This is achieved, in Spence's case, by the actual content and production of the photographs as well as by the fact that she wrote extensively about her work. By assuming various identities in her works and producing them in collaboration (most notably with Rosy Martin and David Roberts), Spence reiterated the

mediation involved in producing images; she resisted the reading of these works as 'natural' or transparent pictures of her real 'self'. Additionally, by writing about her work, she controlled some of its critical reception. She made her ideas explicit:

> I am variously positioned as a cultural worker (showing work in galleries); as a social historian (sharing work in politicized contexts); as a family archivist undergoing psychotherapy (sharing and discussing work in my own family and within a range of health contexts); as a phototherapist (working with people in therapy who are from a range of different cultural and economic backgrounds, on their psychic histories) ... As well as using existing family album photographs, another area of work has evolved in the synthesis of photography with therapy. This is a form of constructed or staged 'Self Documentation', which I developed with Rosy Martin.[21]

Spence's images, while specific to her individual experiences, transcend this single dimension by revealing that individual as a site of conflicting social discourses and definitions. For example, *Father and Daughter* (with Rosy Martin) and *Included* from *Narratives of Dis-Ease* (1989, with Dr Tim Sheard) concern the construction of the dutiful daughter. In the first image, Spence encounters herself in the guise of her father, with all of the unresolved desire and conflict that this entails, while in the second work she is positioned, nude, weeping and clutching a teddy bear, as the injured, vulnerable little girl. These are socially prescribed positions in the development of female children in our culture as well as moments in Spence's therapy which helped her to come to terms with her position in patriarchy as 'the daughter/patient' as well as a daughter and a patient. The very tension between these various positions highlights the provisional nature of the identifications and refuses to allow a sense of fixity.

So, too, her explorations of body politics, in which she frames her own nude body, are more than simple personal documents of her likeness. For example, *Exiled* from *Narratives of Dis-Ease* and *Untitled* (1988, with David Roberts) both challenge conventional fine art and mass media stereotypes which suggest that the only female bodies

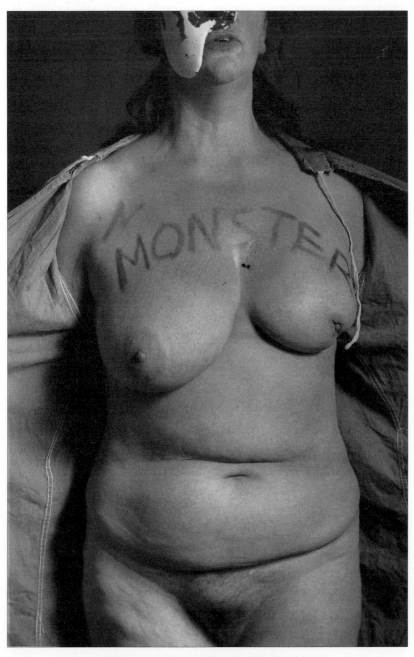

Jo Spence, *Exiled* (with Dr Tim Sheard) 1988

which are appropriate for display are young, nubile and healthy. In *Exiled*, Spence unabashedly opens the hospital gown to reveal her ageing torso including the scar from her lumpectomy. She redefines our relationship to the medical profession as one which frequently causes us as much pain as cure and, by labelling herself 'monster', she challenges traditional views of women as aesthetic objects, while engaging with its opposite tradition which evokes the monstrous woman. The distance between the fine art standards of aesthetically pleasing female bodies and her own experience of being a woman is reinforced by the second image in which she is shown in a back view holding a framed set of her own photographs. Both the 'self-portrait' and the picture within the picture are examinations of the female nude; in landscapes, in various positions and frames, and as problematic and subversive of cultural norms. Each stereotype is challenged; the voluptuous nude in the landscape as 'nature', the young nude in mass media representations, and the woman artist nude but not objectified.

If the personal self-portraits of Spence cannot be contained fully by a simple sense of autobiography and require the introduction of a split or multiple sense of the 'self', then the work of Cindy Sherman proposes the obverse. Sherman's images are self-consciously produced 'positions' or 'situations' which define women and have little to do with the personal biography of the artist or her psychological responses to events in her life. The distance between the 'real' person pictured and the 'types' explored in the works is critical to their meaning. These works are not about Sherman the woman or the artist, they are about the multiple guises assumed by women in our visual culture. They play on the many ways in which 'woman' is shown to us as an image in contemporary life, from cinema to fine art and mass media, and reveal the constructed nature of these representations. In many ways, these are not, therefore, 'self-portraits' at all. Certainly, they defy the conventional autobiographical model. However, as Rosalind Krauss has argued:

> If Sherman were photographing a model who was not herself, then her work would be a continuation of this notion of artist as a consciousness which is both anterior to the world and distinct from it, a consciousness that knows the world by judging it.[22]

Knowing that Sherman's model in her representations is herself is critical to our reading of them and they are presented, as fine art photographs in galleries accompanied by catalogues and critical reviews, in such a way as to ensure that most people who view them are aware of this fact. If it were the case that Sherman directed models to pose in these representations, they might have a very different effect. For example, in the *Untitled Film Still, no. 6* of 1977, there is staged a collision of the subject and the object; the woman artist masquerading as the pin-up challenges our objectification of 'woman' in these archetypal images. However, if Sherman were absent as the object and present only as the one who staged the 'masquerade', the representation might more easily be reappropriated as the typical objectification of a disempowered model by the empowered artist. Sherman's imagery, particularly in her early film stills, is always dangerously close to such reappropriation; it is the knowledge that the artist has posed for the work and yet that she refuses us any access to her 'self' that maintains the critical edge in these works. We must also look at them with a new sense of the term 'self-portrait', as they defy the definitions built around the autobiographical paradigm.

Indeed, in later works, Sherman has introduced slightly more problematic and obvious indications of the falsehood of the imagery to resist just such reappropriations. For example, *Untitled, no. 93* of 1981 reconsiders a 'pin-up' type, but without such unemotional distance as the earlier work. In this work, Sherman the model looks frightened and our position as dominating viewers is made less comfortable. Again, in 1985 with the work *Untitled, no. 153*, Sherman presents the troubling image of a dead woman. While we are made aware of the falsity of this representation, not least by our knowledge that the artist is the object represented, it is still uncomfortable to view the 'body'. However, the fact that she is the model is again very important and, unlike the work of contemporary American photographer Andres Serrano which pictured actual corpses from the morgue, it is her own involvement which enables such an image to maintain a critical politics and not descend into exploitation and voyeurism. Should the artist negate her own investment in the work and claim some pure, critical distance as an observer, she would risk objectifying the figures within the frame. In her

recent work, Sherman has engaged with the construction of 'femininities' and identities in the fine arts by parodying history paintings. Equally here, the edge is maintained by the obvious indications of this parody; for example, Sherman wearing false breasts in one of the 'history portrait' series, *Untitled, no. 205* (1989). The whole use of the 'history portrait' refers back to the western fine art tradition in which the sitter (including the artist as the sitter in self-portraiture) is assumed to be an identifiable, individual 'self'. Thus, while positing the inversion of the classic autobiographical notion of the self-portrait by revealing the constructed and mediated roles of women, Sherman's works are actually critically linked in their meanings to the fact that she uses herself in representation.

Shifting Subjects

If Sherman's work asks the viewer to reconsider the issue of subject and object and the ways in which representation can shape a woman's constructions of the 'self', she was not alone in this interrogation. One of the characteristic features of women's self-portraiture throughout the century lies in the production of imagery which suggests the shifting and provisional nature of identity, rather than its unity or fixity. The techniques of avant-garde photography from the first half of the century, such as double-exposure and montage, loaned themselves to women's experiments with just such strategies of self-representation. Florence Henri and Martha Hoepffner, working in European avant-garde circles in the interwar years, both manipulated their photographic self-portraits in ways which placed them firmly within the avant-garde while maintaining a critical position in relation to the representation of the gendered 'self'. Henri experimented with mirroring and framing in her imagery; false frames are shown to be such (*Self-portrait*, 1938) and mirrors become frames (*Self-portrait in the Mirror with Two Balls*, 1928). The formalism of the imagery is obvious and links her work to that of Man Ray and André Kertesz, but she does not use her body as an object in the way that both Ray and Kertesz manipulate the female model in their self-portrait images (see Ray's *Man Ray and Juliet* of 1940 and

Kertesz's *Kertesz with Image* from the *'Distortions' Series*, 1933). Rather, Henri denies the possibility of objectification by controlling the viewing of the imagery through the framing devices. These distance our relationship to the subject of the work and, in making the frames apparent, the artifice of the imagery is maintained and our 'natural' viewing disrupted. Furthermore, Henri's works often double the representation of the artist and render the sense of the unified subject unintelligible.

Hoepffner's *Self-portrait* (1941) trebled the image of the artist and again challenged the devices of framing which acted to objectify women. In the photograph, one representation is a painted self-portrait, 'unframed' on an easel, another is the full-frontal face of the artist looking out at us from behind the camera and the third is a large photographic portrait of the artist which hovers above the other two images. There is the suggestion of at least three frames within the work itself; the canvas, the enhanced viewing through the frame of the lens and the 'diagonal' light frame of the large portrait. The artist controlled the gaze and the manner of viewing in the work in such a way as to indicate the multiple nature of the subject. Hence, modernist techniques afforded Henri and Hoepffner the possibility of disrupting the objectification of 'woman' in their works and, at the same time, allowed their self-portraiture to be identified with radical art practice.

In her *Tentative Self-portrait* of 1978, Sarah Moon, an American photographer who lives and works in Paris, continued the tradition of multiple and shifting self-representations used by photographers such as Henri and Hoepffner, but in a way more linked to notions of the postmodern than the modern. Moon's work demonstrated her awareness of postmodern photographic practices which challenge the 'fine art' modes of early twentieth-century avant-garde photography by emphasising the lack of specialist production. The work is comprised of six 'snapshots', defined as such by their haphazard appearance and arrangement on the background, including hand-written numbers on each photo and a scribbled title on the sixth. Moon's work also showed that she was aware of the theoretical challenges to fixed subjects from the post-1968 schools of critical theory. The snapshots were composed in such a way as to reinforce the concept of the work as tentative,

provisional and unfixed; the artist's representation in the mirror on the wall is sometimes central, sometimes de-centred, whole and in parts. The work engages with the postmodern notions of destabilising the relationships between fine art and popular culture by constructing an 'artist's' self-portrait in the guise of haphazard, unprofessional snapshots, carelessly arranged on the wall. The 'tentative' shifts from representations of the artist to blank space in the frame of the mirror also served to de-centre the 'self' of the portrait's title. The shifting subject is merely a construction of the process of mass-media image-making itself.

African-American artist Malaika Favorite, in her work of 1986, *Portrait of Self Contemplating Self*, confronted the divisions from within a subject who is both 'woman' and 'artist'. As both subject and object, women artists must confound visual clichés and stereotypes which deny them access to the powerful positions occupied by male artists who can unproblematically position themselves in works as 'subjects'. The very structure of the image makes these divisions clear. There are two faces shown; one of the two is itself fragmented. The artist was actually moved to write about this particular representation and the difficulties she faced in producing it in 'Portrait of Self Contemplating Self: The Narrative of a Black Female Artist'. She located the fragmentation of the work and the way the image spilled over the boundaries of the frame in the multiple positions she occupied trying to forge a career as a black female artist. She was finding this situation extremely difficult in both financial and practical terms. Her resolution of her difficult position actually came through the use of her art as a tool for self-exploration. As she explained:

> It was like African sculpture and African music. It was everything you find becoming art, becoming music, becoming a picture of yourself broken up, studied and reassembled into what you had become ... It was me on that canvas, but not just the surface me but me in all my disguises, me from the inside out ... It was self contemplating self contemplating self and rejoicing in who self is.[23]

This expressed perfectly the dilemma for women artists working within a self-portraiture paradigm linked to autobiography. There is, on the one hand, a need to show the 'self'; to rejoice in being able to come to representation in your own terms rather than as an object in another dominant schema which forces you into the margins. At the same time, there is a recognition that the models used most commonly cannot simply be appropriated without critical adaptation. The final products, therefore, express the multiplicity of identity and concepts of negotiating positions and voices. The self, as literally seen in the work of Henri, Hoepffner, Moon and Favorite, is fragmented, re-presented as a provisional 'whole' which overspills the frames. And, as discussed at the beginning of this chapter, these frames are the ones which have traditionally marginalised women artists.

The Factual Author: Mimesis, Mimicry and Likeness

One of the critical areas of conventional autobiography described above is the notion of historical accuracy in the depiction of the life. This has its parallel in self-portraiture with mimesis or 'likeness'; that part of the self-portrait still most revered. But self-portraits produced outside conventional boundaries by women frequently challenge the idea of 'likeness'. The Venezuelan sculptor Marisol, who first made her name within the American Pop Art context of the 1960s, used tactics of excess to interrogate mimesis. Marisol's work often confronted the spectator with multiple 'likenesses' in positions which undermined conventional self-portrait readings. For example, in her work *Self-portrait* (1961–2), the mimetic image of her face, carved, cast and painted, tops the bodies of seven different sculptural 'people'. A work such as this can be linked directly to the interventions discussed above by women artists working later within a postmodern context of multiple subject positions and no fixed 'self', but also serves to pose other problems. It is, for example, the only work which Marisol entitled 'self-portrait', but not the only figural group in which the artist multiplied her likeness. As Roberta Bernstein has suggested, Marisol's works can be read in terms of the production of a highly complex self-portrait, but the artist 'shifted the emphasis away

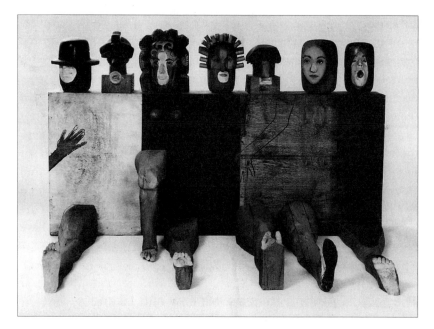

Marisol, *Self-portrait*, 1961–2

from specific autobiographical interpretations by representing anonymous types – ironically, figures living out the bourgeois identity she herself has rejected'.[24]

Thus, Marisol's work might prefigure the work of someone like Cindy Sherman in a number of ways, yet the repeated and excessive use of the artist's likeness in single works also challenges the viewer to consider simultaneous identifications. Furthermore, the multiplicity of the likeness reveals the masquerade and the mimicry which the works suggest underpin 'feminine identity'; their very excess confounds our attempts to use the mimetic likeness to locate the individual author of the piece. The one Marisol, whose likeness we can identify, is nowhere presented in these works. Rather, her likeness precludes her singular 'presence'. The sense of historical truth on the autobiographical model is inextricably linked to verisimilitude; to the sense that there is a unified, individual 'I' who can be found in the accurate details of the life story or in the mimetic representation of the body. The unitary nature of this

subject is critical to this 'truth'; where the mimetic image produces multiples, there is mimicry of the 'one' and a loss of the individual in a host of 'copies'. We are challenged to find any one 'true' likeness or subject.

This begins to indicate how difficult the issue of mimesis may be in the self-portrait practices of women artists. If we need to find the 'true' image of the artist to locate the self-portrait as an autobiographical genre, what might this indicate about our traditional assumptions regarding the interconnections between artist and representation? The reading structures implied in conventional concepts of self-portraiture are derived from a particular version of mimesis which places the emphasis upon the mimetic object. In western fine art, this is the tradition of naturalism, the idea that a visual image should show the correct likeness of the object represented. Rules of propriety in representation (themselves subject to historical change) ensure the link between object and image which guarantees 'likeness'. This particular version of the notion of mimesis, which became the dominant understanding of the concept in art criticism by the eighteenth century, is derived from a Platonic concept of mimesis which, in simplified terms, concentrated on the object. For Plato, there could be mimetic truth in naming accurately, but in rendering visual likenesses there could only be imitations of imitations of truth. Thus, art objects could only ever hope to mimic appearance through learned modes of propriety and find their value through their accurate 'likeness'.

In practice, this tradition privileged the links between seeing and knowing; and since it assumed the representation of the masculine as a norm, all other representations were deviations or 'other'. However, as Helen Chapman has pointed out in her lucid work on the Greek origins of the concept of mimesis, there have always been tensions inherent in the terminology.[25] Aristotle, for one, looked towards the notion of mimesis as process, as the way in which one imitates. For this very reason, many feminist theorists have taken up the issues raised by this tradition in terms of questioning the possibilities of representing the 'feminine' in any way which does not merely posit it in opposition to the 'masculine'. The feminine, it is argued by such theorists as Luce Irigaray and Rosi Braidotti, is intimately tied to mimicry and

masquerade. There is no 'transcendental' feminine position, merely mimes and parodies of the norm; negotiations of the fact of being 'other' to the mainstream. But, significantly, women are not simply mimics; rather they are able to use mimicry to subvert masculine norms. They can engage with mimesis as process by using imitation playfully, by using mimicry. As Irigaray writes:

> There is, in an initial phase, perhaps only one 'path', the one historically assigned to the feminine: that of *mimicry*. One must assume the feminine role deliberately. Which means already to convert a form of subordination into an affirmation, and thus to begin to thwart it ... It also means 'to unveil' the fact that, if women are such good mimics, it is because they are not simply resorbed in this function. *They also remain elsewhere.*[26]

Thus, to use mimesis itself as a process, while not being resorbed by the mimetic object itself, is the essence of a feminist renegotiation of the tradition. If part of the model of autobiography is mimesis, then women engaged in these practices must, by definition, be mimics or must manipulate representational mimesis in order to represent 'themselves' as part of the 'feminine'. So, Frida Kahlo's use of the doubled mimetic self-image is not merely the transparent revelation of her self, but, as we have seen in *The Two Fridas*, a sort of play with feminine identity.

Not only multiple likenesses can be used as a strategy for negotiating mimesis; the absence of likeness is equally subversive. A number of women artists actually produced works entitled 'self-portrait' which have no likenesses of the bodies of the artists at all. For example, Louise Bourgeois, who made her name in the surrealist-inspired Parisian avant-garde of the 1950s and 1960s, produced an abstract sculpture in 1963–4 entitled *Self-portrait*. The work contains references to both male and female genitalia (breasts, vulvic folds and the whole as a phallus), which makes it similar to the rest of her oeuvre. As a self-portrait, in the light of issues to do with mimesis, it is a work which confronts the boundaries between masculine and feminine and rethinks these positions.

Louise Bourgeois, *Torso/Self-portrait* (photo by Peter Bellamy), 1963–4

The scripto-visual is a realm often exploited by women artists through the 1980s who wished to produce highly personal works which, however, did not objectify the body of 'woman'. For example, Susan Hiller, an American artist living and working in Britain, has also turned to scripto-visual work in her practice. *Self-portrait* (1983), for example, used a personal calligraphic technique rather than any likeness of the artist to produce the 'portrait'. It would be sensible to question just how this black image with gold script functions as a portrait. Such a work, with its integration of concepts of language (script) and individuality ('self-portrait'), challenges simple distinctions between self and other. However, it does not reinscribe a unified self. As Hiller herself has said:

> 'My' hands made the marks that form the inscription, but not in my characteristic handwriting (e.g. personal style of mark-making) or voice (e.g. usual tone or mode of utterance). My 'self' is a locus for thoughts, feelings, sensations, but not an impermeable, corporeal boundary. 'I AM NOT A CONTAINER.'[27]

Again the nature of the traditional autobiographical model for representing the self is radically challenged by women artists through their responses to constructions of likeness. Bourgeois and Hiller confound our expectations of likeness by naming their works 'self-portrait' and open up alternative viewing strategies through this confrontation. They engage with mimesis and mimicry as models of process, rather than unproblematically attempting to speak from the position of 'truth' or fixed authority. Though most self-portrait works by women artists bear mimetic representations, the interrogation of mimesis fundamentally calls into question our simple reading of these as transparent representations of the 'selves' of artists. In addition to rethinking representation, one must reinvestigate reading strategies which problematise the autobiographical implications of traditional discussions of self-portraiture without losing sight of the situations of historical producers of self-portraits. Biography is significant for self-portraiture, but not as an implied masculine norm which presents

women's experiments in self-representation as mere psychobiography or less than adequate approximations of male practice.

Susan Hiller, *Self-portrait*, 1983

3: Women's Self-portraiture Explorations of the Body

The Significance of the Body in Self-representation

The most common issue addressed by women artists through their self-portraiture concerns their personal identity as 'women' constructed in and through representation. Many of the self-representations of women artists directly engage with the ways in which 'woman' as a sign operates in visual culture, the ways in which the ubiquitous representations of women structure and control the very definitions of 'woman' in our society. Not only do these works take part in defining and redefining sexuality, gender, maternity and concepts of beauty for women, they reaffirm the crucial role of visual representation in the acquisition of female identity and any attempt to subvert or challenge it.

The body, as the intersection of cultural meanings and psychic identifications, is the ground for these works. There are no 'natural' bodies in representation, there are only constructions of gender and the self. It is significant but not surprising that so many women artists chose to use self-representation to take on these issues. Women attempting to come into representation must negotiate the complex divide between their subject and object roles in visual imagery. Again, the commonplace assumption of masculinity as a norm has meant that male-dominant self-representations frequently occluded the work of women as subjects and reinforced the role of 'woman' as object. The binarism of male/female, in which the latter term has meaning only in opposition to the former, creates a structure in which masculinity is stable and in control of representation while femininity is defined as

difference (even deviance) from this norm. The power relationships in society at large and within the art world have colluded with this binarism so that men are more frequently in situations which permit them to represent themselves while women must be represented. Thus it is not coincidental that women artists who seek to become 'subjects' must examine gender difference and representational strategies in order to produce self-portraits; a woman artist simply cannot take for granted that she will be seen as the subject rather than the object in the work.

In their self-portraiture, women artists have considered the sexual body, the gendered body and the maternal body in order both to counter popular representational stereotypes of women and to question the socially determined nature of these 'types'. These images are the site where women artists can grapple with their own gendered identities and their subject positions as 'women' but, moreover, they allow the space to encourage female pleasure in viewing. By using their own bodies, women artists are able to rid the works of some of the inherent objectification involved in representing others and potentially liberate the images from stereotypical patterns of looking. There are, of course, possible reappropriations of these images as 'objects' in themselves which makes their production a difficult task. When one confronts the use of 'woman' as object and the nature of pleasure in visual imagery, rather than merely avoiding the representation, the potential exists for critical misreadings. One of the key elements in these self-portraits is the attempt to find new strategies for contextualising the representations of women which defy the conventions of objectification and visual mastery constructed as norms for both producing and consuming western artworks. It is, of course, impossible to control every meaning available to a work of art and audiences approach these images from a variety of predetermined positions. Thus, a liberating performance work to one audience could be a sexually arousing display of a nude female to another. This granted, works of art cannot have any meaning whatsoever, but are open to a range of interpretations; these works are frequently produced (and have their consumption controlled) in order to force audiences to challenge their preconceived viewing strategies and rethink representation.

Femininity, masculinity and androgyny play a primary role in these images as positions into which women artists move. Rarely are the gender labels fixed in the works; rather, they are characterised by the slippages between them, just as the roles that women as artists assume are heralded by awkward juxtapositions of gender definitions. The lesbian, heterosexual and maternal body come under scrutiny in many of the self-portraits in ways which challenge common media myths. While these works have currency as 'self-portraits' per se, exploring the concept of the artist or the role of the autobiographical subject as discussed in the preceding two chapters, the works addressed here tend to reverse the encounter between the positions of 'woman' and 'artist'. Rather than the woman attempting to find a voice through her role as an artist, we can see these images as the artist addressing her role as a 'woman'. Yet again, it is a strategy which enables us to rethink both ideas about self-portraits as works of art and the nature of the woman artist as an author.

The Sexed Body

The representation of female sexuality in the self-portraiture of women artists can be extremely contentious as it is clearly the area most open to reappropriation. Still, attempts to redefine the stereotypes of female sexuality as passive and submissive are significant manoeuvres in women's coming into representation in their own terms, rather than in binary opposition to definitions of men and male sexuality. For a woman to assert her own sexual identity, and to find ways of representing this which deny the typical use of the body of 'woman' as an object in an economy of male, heterosexual desire, is to take a critical step in self-representation. The difficulties facing women artists who engage with this problematic originate in the logic of western theories of human sexuality which for centuries considered male heterosexuality the norm. In this system, all sexual behaviour is judged with reference to this 'norm' and thus female sexuality (along with other variations from the 'norm' such as homosexuality) has been discussed in terms of its

relationship to male heterosexuality and judged to be 'other': passive, submissive or simply unable to be deciphered.[1]

Attempts to break through this simple binarism often lead women artists to contend with the multifaceted nature of female sexuality as it develops through both subject and object positions; they renegotiate the concepts of passivity and submission to find forms which simultaneously visualise the pleasures of activity *and* passivity, dominance *and* submission. They work to reassess the monolithic ideas which attach themselves to female sexuality when it is defined exclusively in terms of male sexuality. This key issue of multiplicity tends to be in line with feminist theorists, such as Luce Irigaray and Hélène Cixous, who also explored ideas of female sexuality as concepts through which unitary masculine models of knowledge and power could be subverted. Masculinist knowledge systems, or epistemologies, have operated through strict binarism, the placement of two opposing terms as a structure in which one term is always privileged. Thus we understand 'ourselves' in opposition to marginalised 'others', or 'man' in opposition to its negative, 'woman'. It is imperative to understand that challenges to the epistemological binarism which underpins western knowledge systems are always accompanied by challenges to the social order which supports and is supported by this empowering knowledge. As Irigaray wrote:

> How could discourse not be sexed when language is? ... Differences between men's and women's discourses are thus the effects of language and society, society and language. You can't change one without changing the other. Yet while it's impossible to radically separate one from the other, we can shift the emphasis of cultural transformation from one to the other, above all we must not wait, passively, for language to progress. Issues of discourse and of language can be deliberately used to attain greater cultural maturity, more social justice.[2]

In addition to looking at the subject/object divide in definitions of female sexuality in terms of the male/female binarism of western thought, self-portraits which examine this issue also need to address the

problematics of pleasure and power as they operate through the very structures of looking. The pleasure of looking, as defined through the theoretical positions of psychoanalysis, has been critically examined by feminist theorists for its inherent gendered power relations. Jacques Lacan, the psychoanalytic theorist, elaborated the significance of viewing inherent in the Freudian model of subjectivity. In his text 'The Mirror Stage as Formative of the Function of the I' (1949), Lacan posited the centrality of seeing oneself as a separate and whole body (however illusory this is) as the critical moment in attaining a sense of self. This sense of self is bought through a negation of the 'other', in this system the mother, and the separation of the child is a traumatic and aggressive experience.[3] The viewing position which permits voyeuristic and fetishistic looking in the Lacanian model is by definition the masculine situation; women who engage with the gaze in this traditional sense do so by identifying masochistically with the 'woman-as-object' or by taking up a masculine role. Both voyeuristic and fetishistic looking divides the subject from the object in such a way as to empower the viewer (defined as masculine) and disempower the object of the look (defined as feminine). These theories have been most thoroughly explored in relation to film theory, but can also be seen to apply to still representations.[4]

While in recent critical surveys the exclusivity of the 'male' and 'female' positions described in this classic Lacanian structure have been modified, it is still the case that historical and social structures have traditionally operated to reinforce such positionality, and the issue of pleasure and the body of woman is still hotly contested in feminist circles. Throughout the 1970s, much feminist work sought to deconstruct the viewing strategies and structures which allowed for masculine pleasure at the expense of objectified women; there seemed to be no room for feminine pleasure in this system whatsoever. More recently, however, women artists have attempted to challenge this dominating view by reinscribing alternative pleasures, defined as feminine in their structure. Again, film examples are the best known: Sally Potter's *Orlando* (1992) and Jane Campion's *The Piano* (1993), for instance.

The Sexual Self and Women Artists

It is one thing to recognise that the reinstatement of female pleasure in viewing and explorations of visual representations of female sexuality have a subversive and liberating potential, but another to act upon this insight. The social stigma attached to women who demonstrate their sexuality in any public form of visual media remains with us even today. In the early years of this century, it was nearly impossible for a woman artist to consider her own sexuality and sexual identity as topics worthy of representation. Not surprisingly, most of the self-portrait imagery which deals with female sexuality derives from the post-1968 period as a direct response to the calls of the women's movement to re-examine the variety of women's sexual desires and feelings in both physiological and psychic terms. However, there were some notable exceptions to this pattern, times when women artists from the early years of the twentieth century addressed female sexuality in their art. The artists Käthe Kollwitz and Jeanne Mammen who worked in Germany in the interwar years, for example, both produced expressive works which explored heterosexual and lesbian passion respectively, but not through self-portraiture. For example, Kollwitz's *Lovers* (1929) placed the embracing male and female figures on a parallel. The woman is not the passive object, but the active subject. Mammen's sophisticated representations of lesbian love in, for example, the lithographs she produced in 1931–2 to illustrate Pierre Louys's *Songs of Bilitis* allowed the variety of woman-to-woman emotions to emerge. From passion and jealousy to tenderness, Mammen's representations of lesbianism engaged with female sexuality in ways which denied masculine objectification. The women are not displayed to the viewer as objects to be looked at; rather the female subjects of the work are active in their own, internal dramas.

In two unusual self-portrait drawings from the early twentieth century, Gerta Overbeck and Renée Sintenis, working in the same context as Kollwitz and Mammen, did explore female sexuality in self-representation; Overbeck through parody and Sintenis by way of subversion. In *Liegende* (*Reclining*) of 1925, Overbeck cast herself in the role of the reclining nude of the fine art tradition; this image encompassed the associations of the female nude both with aesthetic

beauty and with the concept of courtesanship. While the courtesan figure was not so brutish in its connotations as the figure of the prostitute, it was still very much an image which placed 'woman' as a symbol in an economy of male, heterosexual desire. When Overbeck used her self-image in this way, and placed the figure in the contemporary artists' studio, she confronted the stereotypical representations of women's sexuality in the fine art tradition. Sintenis also faced these issues, but with less obvious parody, in her *Drawing Nude: (Self-portrait)* of 1917. In this work, Sintenis has placed her own image as an artist's model in the role of active artist. For the most part, the direct representation of their own sexuality or sexual pleasure was too risky for women artists working within modernism who wished to be taken seriously as artists. As discussed in chapter 1, women artists who became the focus of male artists' sexual desire, such as Gwen John, Nina Hamnett, Hannah Höch and Marie Laurencin, found it difficult to maintain their positions as serious practitioners in their own right. Furthermore, the representations of sexuality in the period were often more 'coded'; lesbian identity, for example, was sometimes represented through androgyny in the early years of this century.

The most notable exception to this rule, for reasons which will become clear, were women artists associated with the surrealist movement. Artists such as Eileen Agar, Claude Cahun, Leonor Fini, Lee Miller, Meret Oppenheim, Dorothea Tanning and Toyen all addressed female sexuality in their works and some concentrated on the self-portrait format specifically to explore this realm. The indebtedness of the surrealists to Freudian theory in part accounts for the strong emphasis upon sexuality in their works. Additionally, the theories of Surrealism reiterated the links between sexuality, creativity and the unconscious which, though tending to become exclusively masculine in the practice of the male surrealists, permitted women artists greater freedom to explore female sexuality in their art. The Czechoslovakian artist Toyen, who worked within Prague's avant-garde circles of the 1920s and 1930s, was notable for the frankness with which she considered female sexuality. So too was Meret Oppenheim, the young Swiss artist who became attached to the Parisian surrealist group. Oppenheim's works often pertained specifically to fetishism and were

thus particularly daring in their ostensible deviance. A number of works produced by the British surrealist Eileen Agar addressed sexuality and maternity through metaphors of creation which were specifically feminine in their structure.

However, the situation for women artists associated with Surrealism in these various regional branches was not simply one of liberated sexual experimentation. Freudian theory in conjunction with the bourgeois romantic ideas of the male surrealists confined 'woman' to the position of a simultaneously idolised and denigrated 'other' to 'man' in a system which was hardly conducive to women's artistic production. Within the surrealist cosmos, the 'feminine' was defined in terms of its relation to masculinity; women had their roles limited to lovers, models and muses. It is still true that the male surrealists opened up the arena of sexuality in ways which permitted debate and that, perhaps, this was a necessary precondition for the work of the women artists associated with this sphere. However, the strong women who worked within the constellation of Surrealism had to struggle for the independence necessary to work, as is clearly shown in the ways in which these women engaged with their own sexuality within the parameters of the group itself. For example, Man Ray photographed both Lee Miller and Meret Oppenheim and while these portraits were, ostensibly, collaborations, in practice they were often images which transformed these women artists into fetishistic objects of male heterosexual desire. Indeed, many of the women around the surrealist group were romantically linked to male members of the group and were acknowledged as 'muses' or as the 'inspirations' for male creativity. Female sexuality on this model is passive and merely responsive to male sexuality.

Hence, the works of Claude Cahun and Leonor Fini in which they used self-representation in order to counter concepts of female passivity are unusual, but demonstrative of the potential within surrealist aesthetics to challenge feminine stereotypes. Cahun's self-portrait photomontages from *Cancelled Confessions* (1930) took on the relationship between female sexual pleasure and the creative artist. In these montages, Cahun introduced multiple images of her own likeness juxtaposed with symbols typically identified with female sexuality, such

as lips and mouths. As Honore Lasalle and Abigail Solomon-Godeau have pointed out, the introduction of the imaged 'self' in these works as well as the link to a female viewer embed the representations in female and 'feminine' sexual dynamics: 'This relationship of self to self-image (although all are in fact images) is itself libidinally charged, although in ways that psychoanalytic theory associates with the pre-Oedipal.'[5] That is, our whole psychic investment in our self-image comes from our earliest attempts at differentiation from 'the mother'. It is within the feminine economy, before we enter into the realm of masculine language and law, that we are first seduced by our own image. Cahun's photomontage is also woman-centred in the way in which it deals with love and sexuality, making reference to her lover at the time, Suzanne Malherbe.

Fini's painted self-portraits, including *The Sphinx Amalburga* (1942) and *The Ideal Life* (1950), also refer to a 'female' sexuality but in very different ways. By casting herself in the role of the sexually voracious sphinx or cat goddess, Fini played with the typically surrealist alter-ego. Like Leonora Carrington, Fini associated herself with a mythical animal (in her case the sphinx, in Carrington's the white horse as described in chapter 2), in which guise she could counter traditional notions of 'woman'. The artist is shown in these images as active, rather than passive, and in *The Sphinx Amalburga* male figures are portrayed as the supine objects of female desire. Although Fini's works do tend to fit clichés both of ideal female beauty and of the feline nature of women's sexuality, they still act in ways which are potentially liberating for their day.

The Post-1968 Generation and Female Sexuality

In the post-1968 period, many women artists used their own bodies, in self-portraits and performance pieces, to confront stereotypes of women's sexuality which they found inadequate and confining. In terms of female heterosexuality, there were attempts to transcend the simple divide between subject and object and place women on both sides of the divide simultaneously; women artists who stepped self-

consciously into conventional stereotypes of 'sexy women' in their imagery occupied this space. Moreover, there were specific attempts made to celebrate women's bodies and their difference and to inscribe female pleasure into these representations. In certain forms, this worked with little difficulty. For example, the American feminist photographer Soledad Carrillo Shoats's work *Le Camisole* (*c*.1975) 'deals', as she said, 'with an aggressive "if you can" sexual come-on, with the idea of the "femme fatale"'.[6] The way in which the artist poses archly in such obvious costume and in front of the framed picture of two old men in the background makes this image parodic. It would be difficult to read the work literally; rather, the posing of the woman artist within a stereotypical 'femme fatale' role reveals the falseness of such situations. The fact that the posing is playful and excessive also permits female viewers to find a space for a pleasurable reading of the image as masquerade.

A number of other women artists have confronted masculine stereotypes of the female body in their work but, at times, these representations have become dangerously close to the very objectifications which they sought to dismantle. Such difficulties arise in the performance pieces and works of contemporary artists such as Valie Export, Carolee Schneemann, Marina Abramovic and Annie Sprinkle. Though these artists have worked within different artistic contexts, their works are connected through their problematisation of the body of woman and female sexuality. Indeed, the work of Annie Sprinkle is hotly debated by feminists as an instance in which a woman artist may have overstepped the boundaries into pornography. Anne Pasternak confronted Sprinkle with these accusations in her interview of 1992, in which Sprinkle put forward the way in which she sees the feminism and pornography debate:

> I consider a feminist a person who loves women and who wants the best for them ... I think women just choosing to be filmed having sex is a feminist act. Women are not supposed to enjoy sex openly and freely so just to suck and fuck on camera is a feminist act.[7]

Clearly, there are great difficulties with this position, politically, as 'women enjoying sex openly on camera' can be exploited very easily. Indeed, Sprinkle's own works are very open to misappropriation. For example, *Annie Sprinkle as $^1/_2$ Slut and $^1/_2$ Goddess* (*c.*1990) is meant to be parodic, but looks identical to a pornographic centrefold.

The thin line between visibly celebrating female sexuality and further objectifying the body of 'woman' can also be seen in the works of American artists Pat Booth and Hannah Wilke. In 1983, Pat Booth produced a book of self-portrait photographs entitled simply *Self-portrait*. Having been a photographic model herself, Booth's idols were fashion photographers such as Bill Brandt. The vast majority of the self-portraits included in the volume are glossy photographs of Booth nude or partially clothed (frequently in underwear, leather or PVC), placed in glamorous settings. The introduction to the text was written by Allen Jones, the artist for whom Booth used to model and who is well known himself for his fetishistic representations of women. The introduction affirms Booth's project as an exploration of female sexuality and beauty and chides feminism for having 'considered unacceptable' images such as these.[8] On the one hand, Booth's works attest to the pleasure involved in being the active maker of these images as well as their displayed object, and in that way they are interesting interventions for a woman artist. However, the framing of these representations is much more problematic than that and they are subject to the crudest reappropriation. Having the male artist verbally frame the works, the references to Booth as a model, unproblematic assumptions about female beauty and desirability and the stereotypical representational strategies which remain the uncontested standard for the self-portraits all combine to make these images an instance of a woman accepting a masculine, heterosexual evaluation of female sexuality as her own sexual identity. This raises the questions both of the extent to which it is possible for women to define their own sexual identities completely outside masculine models and to what degree it is personally expedient for some women (like Booth) to be defined by these norms.

Less obvious and more significant in this debate are the self-representations of Hannah Wilke. Wilke's work makes much more clear her own awareness and critique of the objectification of the body of

woman in our society. For example, her self-portrait photographs *I, Object* and *S.O.S. (Starification Object Series)* of 1974 both engage with Wilke assuming 'feminine' object roles and parodying these through her poses and titles. Wilke also engages very directly in her works with a celebration of female sexuality and indeed genitalia. Many of Wilke's works used a soft folded object which the artist suggested was a vulvic image. In *S.O.S.* these vulvic shapes were done in chewing gum and placed all over Wilke's body. In similar works they were made in other materials and acted as free-standing sculptural forms. Hence, Wilke's work addresses female pleasure and sexuality through the body without resorting to masculine norms.

However, there are times when the thin boundaries between these positions are crossed by Wilke. In 1973, an exhibition of Wilke's series of one-folded gestural ceramics was advertised by a photograph of the artist from behind, one leg raised on a chair, wearing nothing but a shirt, sheer tights and black boots. Clearly, in this advertisement the artist herself, as a sexually attractive young woman, was even more the object than her artworks. Though Wilke has avoided such direct appropriation of her body in later years, there are still awkward moments, such as the documentary material which accompanied the performance piece *So Help Me Hannah* of 1985. In this video work, Wilke, nude except for a pair of stilettos, was filmed struggling up stairs on all fours. The documentary photographs which show the scene of the men filming Wilke performing the piece could easily be misread as the exploitation of a female model in the manner of Yves Klein's anthropometries, those large-scale paintings which Klein produced by having nude female models covered in paint press themselves against canvas. Unless one knows the history and details of the piece as a whole, its critical function is easily lost. This fact emphasises the difficulties facing women artists who attempt to confront frankly female sexuality in their self-representations.

The Lesbian Body

Lesbian artists taking up the issue of female sexuality in their self-portraiture must engage with slightly different issues; while there are the traditional stereotypes of women as objects, there are also issues to do with visibility, deviance and the sexuality of the same. Unlike female heterosexuality, which has been defined as other to male heterosexuality, lesbianism has been either entirely occluded or defined as an illness, a sick deviation. Thus, there are heterosexual norms against which lesbianism has been contextualised in terms of health, sexual deviance and titillation. Both Rosy Martin and Persimmon Blackbridge have dealt with the consequences of such definitions of lesbianism in the mainstream heterosexual economy for lesbian artists who wish to find a form for their self-representation. In Martin's phototherapy work of *c*.1988, *Unwind the Ties that Bind* (in collaboration with Jo Spence), the artist represented herself wrapped from head to foot in bandages on which were written words and phrases usually associated with perjorative myths about lesbianism such as 'Dyke', 'Just a phase', 'Pervert' and 'Predator'. Significantly, these words were taken from the British Parliamentary debates about Clause 28, a legislative move to restrict public knowledge about homosexuality. Martin sought in this work to make visible the internalised social oppression enacted by heterosexist norms and regulations. The lesbian body is shown as ill (the bandages), deviant (the phrases) and confined (the wrapping), but the title invites us to set the body free. The parallels with coming out are obvious, as are the implications of liberation for self-identity in the process. The fact that the work is part of a phototherapy series further indicates the significance of representation in the acquisition of gender and sexual identity as described above.

In her self-portrait sculptural series of 1984, *Still Sane*, Persimmon Blackbridge, in collaboration with her partner Sheila Gilhooly, examined the 'treatment' of lesbians at the hands of the Canadian medical authorities who still define homosexuality as an illness. This is the extreme end of the spectrum in terms of lesbian experience and abuse in the heterosexual economy and should be recognised as relatively rare. Blackbridge's actual diagnosis, incarceration and shock-

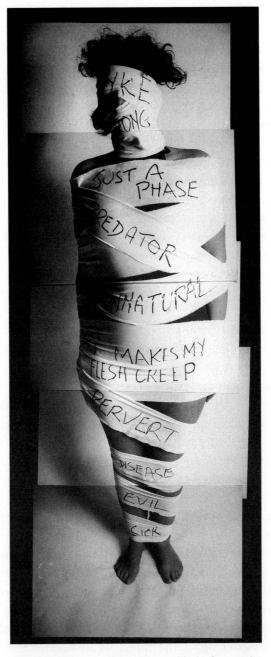

Rosy Martin (in collaboration with Jo Spence),
Unwind the Ties that Bind, c.1988

therapy are represented through self-portrait images (variously fragmented and rearranged) and text. For example, the text 'I told my shrink I didn't want to be cured of being a lesbian. He said that just proved how sick I was. He said I needed shock treatment' accompanies the charred remains of a cast of Blackbridge's head and torso which are attached to a frame of barbed wire. The pain, fragmentation and punitive nature of this 'treatment' cannot be in doubt. The series ends on a high note, however, with Blackbridge overcoming the medical establishment and finding a community of lesbians able to support her coming out; this is signified through the wholeness of the self-portrait image called *Still Sane* and in the group portrait entitled *Coming Out: Together*. Yet again, Blackbridge's series attests to the importance of self-representation for women who wish to refute negative self-images foisted upon them by mainstream culture.

In terms of representations of lesbians, the images of lesbians as 'oversexed' or as objects for male, heterosexual delectation are as difficult to defy as those which suggest dangerous deviance. The photographer Shari Diamond and British figural painter Rachel Field both produce self-portraits which attempt to reveal their sexuality without falling prey to these conventions. These artists represent the more ordinary, everyday experiences of lesbians to counter extreme stereotypes which define lesbianism as deviant. In Diamond's *Untitled Self-portrait* of 1986, for example, the artist represented herself and her partner lying together, partially draped, on a futon. However, neither body is displayed in such a way as to allow the viewer voyeuristic access to the scene. Rather, the intimacies of positioning, the closeness of the bodies and the tenderness of their touching are reserved for the subjects of the work. Such a work clearly engages with the sexuality of its subjects, but not in terms of presumed, outside, male norms. Rachel Field also defies the objectifying sexual look in her self-portraits with her partner. These works take the form of Field and her partner in bed together, which fact raises all sorts of titillating expectations that are then dashed by the banality of the imagery. The two women are shown eating, reading, talking in bed; anything but having sex for the pleasure of an external viewer. Again, the intimacies are reserved for the subjects, there are no displays of objectified sexuality. The extremism which

marks lesbianism as either sick or thrilling within a heterosexual economy are challenged by the ordinary nature of the imagery.

The Gendered Body

Unlike the biological sex of bodies which, arguably, divides humans fairly consistently into male and female, the categories of gender which are commonly applied to the sexes, masculine and feminine respectively, are neither so easily determined nor fixed in their meanings. While this section contends with masculinity, femininity and androgyny in ways which presume certain customary connotations to hold sway, it is understood that these categories are constructions which change from time to time and place to place. Considering femininity, masculinity and androgyny as representational strategies in women artists' self-representations acknowledges the significance of visual imagery in creating gendered identity. Women artists have exploited the visual tropes of these categories in order to expose the social constructions of 'woman' inherent in representation and, for the most part, reveal that these gender definitions are not fixed or stable, but open to revision. These socially defined gender roles are, of course, linked to sexual identity and cannot be divorced simply from issues pertaining to sexuality. Yet, it is important to note that, for all of these links, gender and sexuality are not synonymous; not all parades of androgyny correspond to statements about lesbian identification, for example.

It is also important to remember that theories of creativity developed over the course of the century have been gendered. As examined in chapter 1, 'genius' has been consistently linked to a particular version of 'masculinity', one which encompasses access to a 'feminine' side. The determination of the gender of creativity has been fraught with such ambivalences. However, the general consensus, from philosophy to psychology to physiognomy, has linked masculinity and masculine energy to the potential to produce art. Women as producers have engaged with this exclusion and countered it with alternative models, particularly those based around androgyny. Thus, self-portraiture which

engages with gendered subject positions does so through the veil of concepts of creativity.

Interestingly, the responses of women artists over the course of this century to masculinity, femininity and androgyny can be seen to follow a certain line, with few exceptions. Masculinities are usually parodied in very direct ways, signifying that the conventional senses of 'manliness' are both of little use to women and spent forces in society at large. This also suggests a controversial response to notions of masculine creative energy.[9] By contrast, femininity in representation has provided more fruitful encounters for women artists. Stereotypical notions of the 'feminine woman' permit parodic interchanges, but the more intense investment women artists have in myths of femininity make this area open to more subtle investigations as well. Yet, it is still in the androgynous self-representation that the greatest exploration has taken place. In order to find a form which can adequately place the woman as artist into the centre of cultural production, neither the masculine nor the feminine pole seems to suffice. Positions which double these strategies back upon themselves and question the boundaries of a binary gender pairing afford the greatest scope for new meanings and subversions.

Masculinities

The issue of cross-dressing becomes significant in terms of women artists who have adopted masculine roles in their self-portraiture, as the most obvious strategies have employed the wearing of men's clothes as costume. However, the phenomenon of transvestism, and the vast range of interpretations it encompasses from the sexual to the psychopathological, is not of use in explaining the significance of this. For women artists in the late nineteenth century and the early years of the present one, the wearing of men's clothes was dangerously transgressive, even if not in terms associated with transvestism per se. It was not the fetishisation of the clothing which caused the difficulties. Rosa Bonheur, who produced some of the best-known animal paintings of the nineteenth century, required special permission to wear men's

clothes while she worked on her monumental canvases. The British social realist painter, Joan Eardley, still caused raised eyebrows for this in the 1920s and 1930s because men's clothes indicated the public, professional, 'masculine' social standing of women artists. Paula Modersohn-Becker described with mixed shock and admiration the first woman art teacher with whom she worked who wore men's clothes.[10]

Hence, wearing the clothes associated with the opposite sex could be problematic for women artists in terms of their gender roles and the power associated with these, rather than because of any sense of overt sexual deviation. While hints of lesbianism attached themselves to 'masculine' women, it was the public and professional freedom which was more risky. In this light, Frida Kahlo's *Self-portrait with Cropped Hair* and the self-portraits of Pamela Valois (*Untitled, c.*1976) and Kathy Morris (*Fruit of the Loom, c.*1979) are particularly fascinating. In each of these works, the woman artist is represented in a highly self-conscious cross-dressing scenario: Kahlo's figure wears a huge man's suit which is obviously not her own, Valois puts on a false moustache and hat which make her look like the 'macho' man from the Marlboro advertisements and Morris is shown in men's underwear. These staged scenes query the power associated with the accoutrements of masculinity and work to subvert it through parodic appropriations. Kahlo's work, for instance, has distinct references to castration (the scissors and cut hair) and to the falseness of the external signs of gender (the hairstyle and the very scale of the suit). Valois's masquerade as the Marlboro Man, that quintessential icon of virile, active masculinity, utterly disempowers it and turns it into a foolish display.

At another level, it is interesting to compare the self-portrait advertisement of abstract sculptor Lynda Benglis discussed in chapter 1 (in which she posed nude holding a huge dildo) with these works, although Benglis was not 'cross-dressing' in the strictest sense. Morris's self-portrait photograph in men's underwear is effective only in the context of the explicit differences between 'jockey shorts' (y-fronts, indicated very clearly for an American audience by reference to Fruit of the Loom, the company which markets a common brand of men's underwear) and women's underpants; the extra flap of material which makes them 'men's underwear' apparently indicates the presence of the

penis. If Morris wore other sorts of men's underwear, the intention of the work might well be overlooked. Such a work points out how gender is encoded into the minutiae of our daily lives (for example, identical shirts which button on different sides) and subverts the power of masculinity through the reference to the lack of 'woman'. In this way, the castration references in Kahlo, the outrageous posturing with the 'phallus' (power) in Benglis's image and Morris's work all act to disempower the ultimate symbol of masculinity, the penis.

Rosy Martin has also used the technique of dressing as a man in her self-portraiture, but in order to come to terms with her own relationship with her father. In her phototherapy works *Dapper Daddy* and *Who's Guilty?* (in collaboration with Jo Spence), Martin masquerades as her own father; in psychoanalytic terms, the sign of the empowered masculine position assumed by boys during their development, but denied girls. By so doing, she challenges this simple model of development which assigns women to positions of lack and perpetual 'penis envy' and investigates her own relationship to her father as an introjected part of herself, rather than desired 'other'. This act simultaneously permits Martin access to the position of authority and undermines this phallic power through mimicry; she reveals the construction of this gendered privilege as an image which can be appropriated and reappropriated.

Femininities

Women artists confronting concepts and images of femininity in their self-portraiture did more than simply parody and subvert the meanings associated with the concept. They also attempted to redefine and appropriate the stereotypes of 'femininity' for their own ends. This is because the significance of femininity in representation to women is two-fold; on the one hand, 'the feminine' is 'other' to the norm and thus unrepresentable in itself, but as a powerful evocation of fantasy on the other hand, women frequently desire femininity even while recognising its restraining effect in our culture. For example, Paula Modersohn-Becker and Leonor Fini used clichés of femininity as associated with

Rosy Martin (in collaboration with Jo Spence), *Dapper Daddy*, 1986

nature or 'beauty' in their self-portraiture, such as an emphasis upon the maternal 'nature' of woman or the deliberate assumption of the role of the 'object' or displayed 'spectacle'. Yet these techniques are used in order to relate female creativity with artistic production and defy standards which exclusively associated masculinity with artistic genius. These works both engage critically with contemporary concepts of femininity and take these seriously as models for new notions of creativity and, therefore, artistic power.

Masking and masquerade have been powerful tropes through which women artists have brought femininity into representation. This concept of masquerade can be linked to the idea of excess and the carnivalesque body as described in the work of Mikhail Bakhtin, the Russian literary theorist.[11] For Bakhtin, carnival represented the space in which sharp boundaries between bodies could be less fixed or even removed. Through masquerade, identities normally fixed by social rules could be temporarily dislodged. At a basic level it allowed peasants to play kings, so to speak, but it also harks back to possible play with gender and sexual identity. Arguably, there are two potential outcomes from 'the carnival', one which resorbs the threat and retains order and one which permits change. That is, the carnivalesque identity changes may function as a pressure valve whereby everyone acts out fantasies and then happily returns to their 'proper' place. Conversely, the social definition of individuals could change, if only for a short time, permitting the revolutionary potential for more permanent change to be glimpsed. The critical notion in carnival is the excessive body, the body which surpasses strict limitations. These are multiple, mass bodies, bodies not defined clearly as 'individual' or even as separate and whole. Gender boundaries are included in this sense of blurring, and it is this revision which makes masquerade and excess of primary importance for any rethinking of the feminine in its own terms, rather than within the boundaries of masculinity.[12]

Excess and the masquerade have been linked to the very nature of 'femininity' in representation by feminist theorists including Mary Ann Doane. In 'Film and the Masquerade: Theorising the Female Spectator', Doane attempted to understand the ways in which women could enjoy traditional representations of 'woman' (such as those in mainstream

Hollywood films of the 1930s and 1940s) without simply having to identify with masochistic subject positions. Doane argued that masquerade was a necessary feature of representations of the feminine which could undermine patriarchal norms of viewing and controlling. She wrote:

> The masquerade, in flaunting femininity, holds it at a distance. Womanliness is a mask which can be worn or removed. The masquerade's resistance to patriarchal positioning would therefore lie in its denial of the production of femininity as closeness, as presence-to-itself, as, precisely, imagistic ... By destabilising the image, the masquerade confounds this masculine structure of the look.[13]

In fact, it simply overwhelms it in its excess. Or, as Nancy Spector wrote with reference to the video performance pieces of Cheryl Donegan:

> As a concept, masquerade identifies femininity as a gendered performance enacted to conceal an authoritative female subject, the presence of which would threaten the bi-polarisation inherent in sexual difference. In flaunting her femininity as a charade, Donegan parodies it and thus questions her relationship to it.[14]

The self-portraits of Claude Cahun and contemporary British artist Jenny Saville are interesting in terms of these ideas about the representation of femininity. Cahun frequently represented herself as literally masked. She queried the notion of a single, knowable femininity in this way and flaunted the artifice of both femininity and representation itself. In her *Self-portrait* of 1919, for example, Cahun posed in profile with a mask and short wig which made her appear male. And, in a self-portrait from 1929, Cahun used masquerade to present herself as Oriental. Hence, Cahun's work plays with social definitions of the body as definitively gendered or classed by ethnicity; her works confound such easy categories.

If Cahun's masquerade challenges the rigid boundaries of gender binarism which make femininity unrepresentable in itself, Saville's self-

portrait nudes overwhelm in their excess. Saville's self-portrait photographs from 1995 show the artist, nude, lying on large glass sheets. This technical device makes Saville's body press and distort against the glass in such a way as to blur the expected borders around

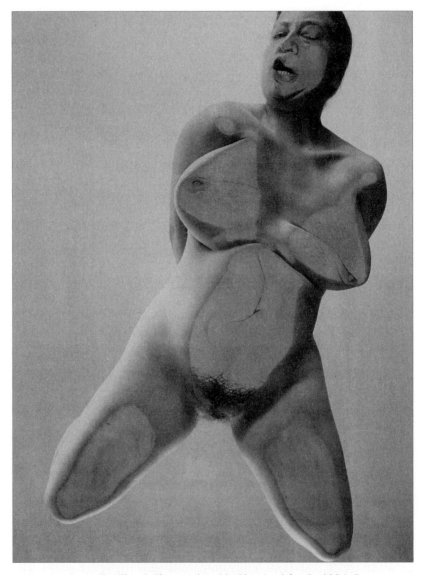

Jenny Saville, *Self-portrait* (with Glen Luchford), 1994–5

the body of a female nude. Her body appears much larger and as though it overspills the frame. In the context of Saville's monumental paintings of large female nudes from unusual angles, the self-portraits complete her figural project. Expressly related to feminist theory (one of her nudes has Irigaray's text written across it), Saville's work interrogates our perceptions of the female body in challenging ways. To use the self in this way is to come full circle in the questioning of fixed identity and the body.

The artist Mariko Mori, who was a fashion model, produced several self-portraits in which she self-consciously cast herself as a mannequin. These works deal again with femininity as a masquerade and as 'grotesque', since the artificial body evades forms which would ordinarily define 'woman'. Mori's works also use the techniques and the messages of fantasy and pleasure derived from advertising to challenge the negative stereotypes. At one level, they critique the idea of the woman as a mannequin, a mechanical commodity fetish. In this, they link right back to the early years of this century, when a number of women artists contended with the mannequin representations of women which were common tropes in advertising photography.[15] The commodification of 'woman' through mass-media stereotypes of 'feminine beauty' has dual ramifications for women in our society; first, they are likened to objects of exchange which are passed between men and, second, the unattainable image is used to disempower 'imperfect' women and turn them into more gullible consumers.

Thus, Mori's mannequin-woman is the commodity fetish; the very integration of our consumer culture and its definitions of women as objects within it. Additionally, however, these displays of mannequin femininity can be disruptive through their excess. The images permit women to enter into role-playing dialogues with these commodified, mechanised 'women' because the masquerade is obvious and parodic. It is possible for the viewer to engage in fantastic projections of femininities rather than be alienated by the 'otherness' of the machine. By dint of their technological links, they hint at notions of 'cyber-feminism' and concepts of future spaces in which femininity and masculinity would be so changed through technological manoeuvring as to be devoid of binary meaning. This could lead to a veritable

liberation for 'femininity' which, up to now, has had meaning only as the negative 'other' in such a binary system. The ideas of so-called cyber-feminism have, as Donna Haraway has suggested, developed from the nightmarish fears of destructive cyborgs to the realisation of potential change.[16] This potential rests in the fact that through science and technology we have already lost any sense of a natural body and thus need not be trapped by arguments which enforce false connections between biology and social behaviour. 'Male' and 'female' are outmoded terms which can be replaced with models of the body and the person which do not subjugate 'other' to 'one'.

The ways in which 'femininity' as a construct can be viable in women's self-portraiture practices while at the same time indicating virtual futures leads to the unusual 'self-portrait' project of the French performance artist Orlan (often discussed in terms of cyber-feminism because of its link to the technologies of plastic surgery). In a project which began in the 1960s and is still in process (the first of the current series of operations took place on her birthday in 1990), Orlan has undergone a series of operations which are altering her facial features to conform to the image of a variety of western icons of beauty, including Venus in Sandro Botticelli's *Birth of Venus* (1485) and Leonardo's *Mona Lisa* (1502). This project, in itself and in its various forms of documentation, is open to multiple readings in relation to issues of femininity, masquerade, self-portraiture and the commodification of women. The artist has actually confronted in a very direct way the concept of 'woman' as an object in representation; by using her own body as the 'canvas', she removes the sense of distance between artist and object implied in any artwork and undermines many of the senses of self-portraiture which rely on this critical distance. However, she fully objectifies herself vis-à-vis the medical establishment and, indeed, the contemporary art world, by allowing herself to be the raw material from which doctors fashion an image of 'femininity' and which paying art audiences control through looking. Her operations are both shown live in galleries (on video screens) and documented in photographs which are hung in exhibitions.

There are further ramifications of this project which are significant to the debates about women artists and issues of femininity as well. The

artist, by engaging in this work, has acknowledged her own investment in the images of female beauty enshrined by the western fine art tradition and has established a form of control over her own self-image which allows her to accede to the power of that image and her investment. However, this may be a pathological control; a 'self' control which is akin to eating disorders and other self-damaging behaviours undertaken by disempowered individuals struggling to maintain the last vestiges of self-determination available to them. The issue of control in the Orlan project is crucial because it alters the subject/object relationship in the work. If she can be said to control the project, it could be a dynamic response to the technological possibilities available to people in the late twentieth century and the concepts of excessive femininity as masquerade. If, however, Orlan is the material of surgeons and the art establishment, her work is little more than a radical restaging of the traditional disempowerment of women in our society. The artist herself stresses that these are not masochistic performances, but interventions into the technological reworking of the human body. Such a project re-emphasises the difficulties of women artists who attempt to come into self-representation through reappropriating femininities which operate within patriarchy.

Androgynies

In terms of women's uses of androgynous self-representations, there is a tendency towards far more sophistication in the imagery and less chance of reappropriation into the mainstream binarism which holds masculinity as the privileged signifier and femininity as its other. Androgynous imagery, as the term is used in this section, refers to visual representations which either work to combine gender stereotypes of masculinity and femininity or images which blur the distinctions between the two. The interest in the boundaries between masculinity and femininity mirrors the attempts to challenge boundaries between subject and object and is a critical space in explorations of identity for women artists. Androgynous imagery in women's self-portraiture over the course of this century has been voluminous; this section will give

only an overview of the ways in which this 'type' has come to signify a variety of identifications, from the New Woman to the lesbian and the cyber-feminist.

In the first few decades of the twentieth century, an androgynous image for young women became fashionable. Short hairstyles such as the 'bob' and the 'men's cut' (*Herrenschnitt*), combined with fashions which emulated men's suits or de-emphasised the curves of women's bodies, posited a new 'type' in the mass media. This 'type' was epitomised by the 'flappers' of the so-called Golden Twenties who were, ostensibly, young, economically independent and 'emancipated' women. Clearly, this fashionable image coincided with a number of changes in the status of women who did enjoy greater political, social and economic freedoms than they had in the nineteenth century, but it was also a glamorous myth which occluded the real lack of power most women in the period faced. The self-portrait of Tamara de Lempicka, *Tamara in the Green Bugatti* (1925), is exemplary of the tensions between fashion and reality in the period.

Lempicka represented herself in the driver's seat of a shiny, new green Bugatti wearing an extremely fashionable outfit, including a racing cap and flying scarf. The adaptation of men's racing and flying clothes links Lempicka to the fashionable image of the wealthy young women who enjoyed sports and, of course, the car is both an object of conspicuous consumption and an image of the latest technology and speed. Masculine clothing in this image is used to link the artist with action and power, unlike the use of male clothing as parodic critique in the work of Kathy Morris described above. The car and clothes, therefore, mix the realms of masculinity and femininity within the context of wealth and power. The artist's face is rendered in the 'mannequin-like' form typical of fashion advertising in the period which employed this form of androgyny to connote modernity or, more specifically, the *Moderne*. It is in the context of the *Moderne* that Tamara de Lempicka's self-portrait and her oeuvre as a whole are best understood.

By the mid-1920s, European modernism and the avant-garde formalism associated with it had become fashionable and were popularised through what became known as the *Moderne*, that style

which pervaded all aspects of design in the period and which was epitomised by so-called Art Deco. Lempicka's popularity in the period is linked to the vogue for Art Deco and her career was principally focused on producing fashionable society portraits in this style. Her sitters included the Marquis d'Afflitto, the Marquis Sommi and the Duchesse de la Salle. Her own biography is significant in this context, as she was part of this elite circle of patrons and enjoyed their lifestyle as well as their tastes, even becoming a baroness upon her second marriage in 1933 to the Baron Kuffner. Hence, her self-portrait is a perfect summation of her position within this sphere and acted as self advertisement, literally, as it appeared on the cover of *Die Dame*, the well-known women's fashion magazine, in 1929.

If Lempicka's work used fashionable androgyny, in the early twentieth century women artists also used androgynous female representation to indicate more than mere fashion. Many women artists in the period, from all across Europe and America, used this 'type' in their self-portraiture to signify their independence and seriousness as women artists working in a male-dominated sphere. In this way, the image was more closely associated with the idea of the New Woman, who was not only fashionable in the mass media, but hotly debated as a potential threat to womanhood, the family and, ultimately, the nation. The self-portraits of Renée Sintenis are interesting in connection with this phenomenon. Her use of androgyny was connected to the concept of the New Woman, that icon which she, as a professional woman sculptor, exemplified in her own practice. However, her works also ended up as fashionable publicity in a way which demonstrates the awkward juxtapositions of 'fashion' and 'emancipation' in the 1920s and 1930s. Sintenis's self-portrait sculpture (such as the terra-cotta *Self-portrait* of 1926) is decidedly androgynous in its imagery and the role of Sintenis as a professional sculptor who wished to assert herself as the subject of these works was enhanced by this imagery. What is more interesting in this case, however, is the way that Sintenis actually became the ideal image of the so-called New Woman in her own publicity which clearly associated the artist's own body with the self-portrait busts.[17] Indeed, there is some evidence that Sintenis's self-image actually linked her to the lesbian scene in Berlin during the 1920s

known colloquially as 'Eldorado'.[18] The possibilities opened up to women who wished to explore new forms of sexual and social identity through androgyny, therefore, were numerous.

Androgyny and Lesbian Self-representation

Androgyny has been explored during the course of this century as a possible strategy in lesbian self-representation, though the uses of this strategy have changed radically over this time. Moving from a sort of underground costume which would be recognisable to other lesbians without proving too risky in straight society to outright parades of 'butch' imagery, these works challenge the assumptions of, as Monique Wittig called it, 'the straight mind'.[19] By combining masculinities and femininities, this imagery posits a space in which the binaries of 'man' and 'woman' which underlie heterosexual social order might be overridden or superseded for the purposes of defining homosexual identities.

In uses of androgyny to reassess the dynamics of lesbian identity in the early twentieth century, the self-portraiture of the American modernist painter Romaine Brooks is exemplary. Brooks, like Gertrude Stein and Vita Sackville-West, lived a fairly conspicuous life as a lesbian protected by the reasonably wealthy circumstances of her circle and by the fact that she was associated with 'artistic' people. This privilege permitted these women to experiment with forms of aesthetic self-representation which would have been unthinkable to most lesbians at the time, including publicly displaying themselves in androgynous garb and being represented in photographs and paintings in ways which challenged gender boundaries. Such experimentation in self-image was crucial to lesbians later in the century who wished to assert their identity. Brooks's *Self-portrait* from 1923 typified the androgynous imagery associated with lesbianism for decades to come. In the work, the artist is shown in a stylised version of men's clothing which asserts an active, 'masculine' role while undermining it; she does not adopt, but adapt, men's clothing to the uses of a woman. Furthermore, the figure is powerful in its control of the picture space and gaze, despite being recognisably female. Again, this work plays on the boundaries of

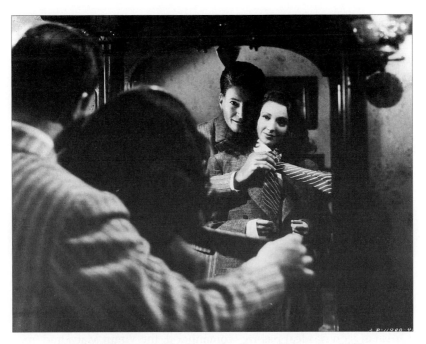

Deborah Bright, *Untitled* from the *Dream Girls* series, 1990

gender division by mixing symbols in order to present a new place in which to act out an alternative identification.

Later in the century, lesbian artists returned to androgynous representation in their self-portraiture, but in much more assertive and theorised ways. For example, in the *Dream Girls* series of photographs (1990) by Canadian photographer Deborah Bright, the artist has superimposed her photographed self-portrait on to a series of Hollywood film stills which represent 'dream girls', the famous starlets of the 1940s and 1950s. The starlets are archetypes of conventional femininity, by dress and pose. By contrast, Bright is represented as 'butch', in a leather jacket with trousers and very short hair. In classic Hollywood cinema of the sort that Bright was raised on, 'woman' is consistently staged as a spectacle for the masculine gaze; she represents the passive object of male, heterosexual desire, the perfect cliché of 'femininity'. As film theorists have demonstrated, this type of cinema

leaves the female viewer in a very difficult position; she can either identify with the masculine viewer in a sort of schizophrenic vision or identify masochistically with the female object. By placing herself in the position of the male protagonist with the very women about whom she fantasised in her youth, Bright confronts these anomalies of gendered viewing. More significantly, she posits a possible place for viewing which transcends the simple masculine/feminine polarity implied by the original structures of these films. Her own androgyny offers alternative readings of the displayed 'femininity' in the representations and the desire to be and possess this.

Sierra Lonepine Briano, a contemporary native American woman painter, also used 'butch' imagery in a way which directly questioned notions of ideal womanhood. In her self-portrait, *Broken-hearted Butch Madonna in a Dress* (1991), Briano staged a confrontation between a host of gender positions in representation. The title itself indicates three particular contexts for the work: 'butch' signifying the lesbian androgyny of the piece, 'Madonna' reminding the viewer of the Christian icon of ideal passive womanhood, the Virgin Mary, and 'in a dress' citing the common signs of femininity. The work also challenges preconceptions of ethnicity, as the sitter is of native American heritage. The work itself is structured to resemble a pre-Renaissance religious icon, thus taking this profane subject into the realms of the sacred. In all, the work queries the boundaries between definitions of 'woman' based on gender and the ways in which these are produced through recognisable visual tropes, such as 'butchness' and the iconography of mariolatry. It acts to mix a series of stereotypes together into a new prototypical icon.

Androgyny, Creativity and the Future

In the early years of the twentieth century, Virginia Woolf considered the gendered nature of creativity extensively in her writing in ways which further attempted to find a place for the creative woman in a patriarchal society. Her concept of the androgynous creative individual, who can muster both feminine and masculine polarities in the service of artistic

production, was a telling model of the gender politics of an artistic group such as Bloomsbury. Woolf was negotiating the difficult position of women in such communities who were, in some senses, particularly free to produce work and yet still bound by social convention and the legacy of inadequate education and opportunities. Woolf was not alone in her consideration of the relationship between gender and creativity in the early years of this century, and the issue remains on the agenda today.

The use of androgyny as a model of creativity must be one of the most significant uses made of androgyny for women artists this century. While concepts of masculine genius were the dominant paradigm for artistic production, there were ways in which women artists particularly sought to integrate or transcend such monolithic concepts and claim a role for both masculine and feminine sides. In the first half of the century, the more common ploy was to describe both masculine and feminine creative energy working in tandem, whereas the latter half of the period has borne witness to more decisive attempts to transcend such binarism altogether in favour of an androgyny which defies masculinity and femininity.

Artists working in such diverse situations as Käthe Kollwitz, Helene Nonne-Schmidt, Ithel Colquohun and Meret Oppenheim all referred to the gendered nature of creative production.[20] Kollwitz asserted that her powerful works were derived from masculine artistic capabilities mixed with feminine empathy. Nonne-Schmidt rather infamously made the essentialist claim that women artists had particular feminine talents unknown to men and that these should be exploited. Colquohun, more like Kollwitz, argued for the integration of male and female sides into an androgynous creative union and Oppenheim encouraged a similar sensibility. Oppenheim was the most vocal on this issue during an interview of 1984 with Robert J. Belton:

MO: It took me a month to write my little speech accepting the artistic prize at Basel in 1975 ...

RB: You take quite a strong position in that text, especially concerning the female artist.

MO: Yes. I thanked the city for the award and went on to say how

> difficult it is for a woman to receive such attention ... You see,
> any great artist expresses the whole being. In a man, a
> feminine part helps in the creation of this expression. In a
> woman, there is a corresponding masculine component. I
> added a note to my speech which clears this up ... I believe
> that women *are* like men. Man is a genius who needs a muse.
> Woman is a muse who needs a genius. It's a kind of
> androgyny.[21]

While Oppenheim's version of androgyny may be said to leave women
in the same binary set of male/female relationships which all the male
surrealists advocated, she has still here asserted a place for the woman as
artist, despite her awkward terminology. And, moreover, a place that she
insists operates through a notion of androgyny.

Where the women artists from the modern period discussed above
began to use the notion of androgynous creativity as the merging of
masculine and feminine, women artists in the last few decades have
been concerned to override such binary thinking altogether. Their work
and use of 'androgyny' stress the lack of fixed gender positions, rather
than the mixing together of two poles. This assumption of androgyny as
a position which permits us to think outside binary pairs has the
potential to create liberating roles for women artists. For example, the
contemporary Canadian photographer Diana Thorneycroft frequently
confounds attempts to define simply the gender of the subject in her
self-representations. In *Untitled (Family Self-portrait)* (1990) and *Untitled
(Brother Mask with Toy Gun)* (1990), the artist masquerades as her
mother and brother, confusing our expectations in each work. More
significantly, in *Untitled (Flower Boy)* (1990), the symbols of femininity
and masculinity (flowers, breasts and small waist, phallus) are
thoroughly integrated so that the viewer cannot determine or fix the
gender of the figure. Thorneycroft's large cibachromes have caused
controversy because of their overt, yet non-objectified representations of
sexuality. The images are sensuous, but do not permit traditional
readings of gender; their multiplicity and excess threaten to overwhelm
the spectator and enable new concepts of the sexual body to emerge.
Furthermore, the images are full of prosthetic bodies, masks and

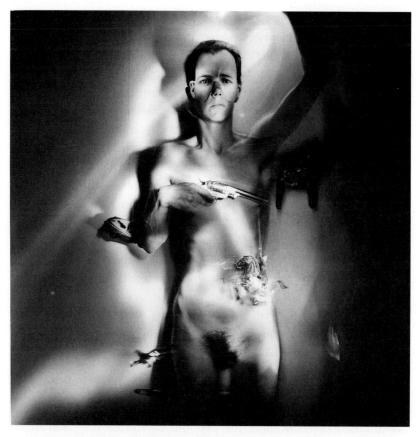

Diana Thorneycroft, *Untitled (Brother Mask with Toy Gun)*, 1990

references to animals, which fact again requires the spectator to rethink the relationships between bodies, gender, technology, pleasure and sexuality.

Yet another contemporary woman artist who uses self-representation to challenge simple binary logic about gender is British artist Esther Sayers. In Sayers's works, emphasis is placed upon the idea of the non-essential self, that is, the self which is a product of a series of identifications with various positions and representational strategies. This 'self', like the working techniques of Sayers, transcends a simple sense of origin. The body is always already inscribed and the works are

always in process. Androgyny figures in this work in the ways that the images, though representations drawn from Sayers's own body, are metamorphosed through her art-making processes so that they no longer function as either 'female' or 'male', but in a place which questions the very existence of those polarities. Thus, the gender blurring of the masculine and the feminine makes the work of Sayers a new encounter with a type of androgynous self-representation.

In her work, Sayers begins with her own body, a fact which is essential to the production of the works in much the same way that it is critical that Cindy Sherman uses herself in her photographic practice; the distinction between the subject and the object is from the outset problematised. The works are meant to contend with notions of binary oppositions between the self and the other by placing the body, as an unnatural, constructed icon, into the centre without permitting the viewer to make any definite assessments about the body's situation as masculine or feminine, subject or object. What is particularly fascinating about Sayers's approach to this topic is the way in which the very materials and process of her art practice are informed by the project. She often begins with body casts in latex and other tactile materials, produced within a 'craft' ethos which displays the concept of the 'feminine' in terms of production and then distances the casts and objects by photographing them. This second process connotes a masculinised objectification; the two-fold combination is akin to an androgyny which seeks to combine traditionally masculine and feminine creativities into a new unity. The sophisticated notions of technology and process, along with the appearance of the finished works, also links Sayers to the concepts of cyber-feminism, as discussed above, and a sense of a future space in which women's self-representations will transcend simple binary logic and could be reconfigured in totally new ways through technological manipulation.

If masculinity and femininity, despite women's investments in them, seem nearly spent forces in contemporary self-representations, androgyny would seem still to hold a fascination for many women artists. It offers a mediating space from which to challenge and subvert the binary logic of masculinity and femininity while holding out the possibility of the existence of genuine alternative gender identities.

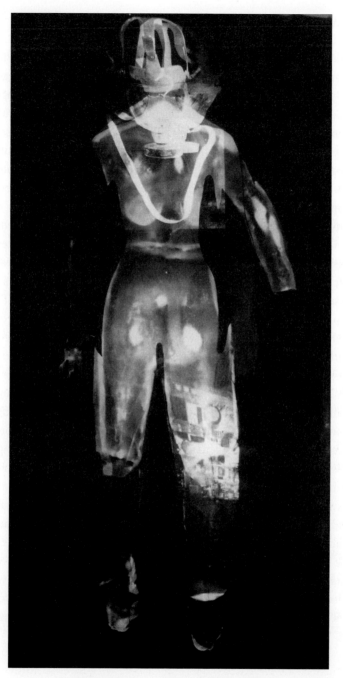

Esther Sayers, *A Picture of Me*, 1995

The Maternal Body

Representations of pregnancy and motherhood frequently appear in the self-portraiture of women artists for a number of pertinent reasons. Socially, the ability of women to bear children has militated against their participation in other realms of culture. Even now it is difficult for women who have children to balance their domestic duties with careers and certainly the activity of a professional woman artist must be negotiated when she has children. Moreover, childcare is a burden particularly placed upon women, who can be made to feel inadequate as women when they cannot meet social expectations. Thus, one's identity as a woman in a social context alters dramatically when one becomes a mother. Psychically, too, both the experiences of motherhood and the separation of the child from the mother can be critical to women's identities. Indeed, women's own relationships with their mothers often figure as major features of their sense of 'self'. The concepts of psychoanalysis which have traditionally rendered the mother as that object from whom we must separate to become individuals has left little room either to understand or depict mother–child relationships adequately. Additionally, the sense that daughters can achieve only incomplete separation (unless they are 'masculine' in orientation) has meant that the mother–daughter relationship, specifically, has had little space in which to be explored.

In classic psychoanalysis, daughters, unlike sons, cannot distinguish themselves fully from the mother through gender identification with the father at the time of the Oedipal crisis. Thus, on the Freudian model, they can be 'feminine' and not fully individualised, or 'masculine', individual but wrongly oriented in terms of their gender identifications. For Lacan, the Oedipal scene was fully workable only for a male, and female children could never enter into the so-called Symbolic order adequately. This meant they were forever at odds with the system which permits language. Taking up Lacan, Julia Kristeva has theorised women writers' relationship to language in this system, outlined here by Madan Sarup:

> Women tend to write in one of two ways. They may either produce
> books that are largely compensatory substitutes for a family, that
> simulate a family structure – novels of autobiography, romance or
> family history – they produce stories, images or fantasies in place of
> an actual family; or else, women write as hysterical subjects, bound
> to the body and its rhythms.[22]

That is, women can either take their proper place in the masculine
structures of meaning and reproduce patriarchal discourse, or they are
trapped within an 'hysterical', female economy which cannot represent
itself. Psychoanalysis has been significant in both social theory and
artistic practice during the twentieth century. Models of 'femininity'
based on psychoanalysis have operated to place women 'naturally' into
the private realm of domesticity, rather than the public sphere of
culture. Furthermore, feminist philosophers and artists have engaged
directly with psychoanalytic definitions of 'woman' in their work both
to critique and to amend these theories in ways which can empower
female subjects. For both these reasons, it is important to understand
the psychoanalytic concepts surrounding motherhood and female
identity in order to explore the work of women artists who turned to the
theme of the maternal body in their self-portraiture.

The theme of maternity also has resonances with art practice,
particularly for women artists of the twentieth century. There have been
distinct parallels drawn between procreativity and artistic creativity; the
idea of birth as a model for artistic production has been pervasive in this
century, especially among the avant-garde who have sought perpetual
regeneration through a quest for origins. The ways in which so-called
'primitive' art (such as that from non-western cultures, peasant
communities and art produced by those deemed insane) was embraced
by the avant-garde, for example, who stressed its links to creation in the
sense of mythical birth-giving. Moreover, physiological studies which
were invoked to ensure that the sexes remained in their proper places at
the turn of this century commonly asserted that women's procreative
energies were so great that they simply had none left to devote to
activities in the public sphere. Warnings were issued to the effect that
women who were permitted to be 'overeducated' would simply lose

their child-bearing capabilities.[23] Such ideologies meant that women who wished to be artists in the early twentieth century were faced with a strange anomaly; on the one hand, birth was the ideal model of artistic creation; on the other, only men could engage in this sort of 'birth' as women's actual child-bearing capacity rendered them inadequate for artistic pursuits. This was the same double-bind they faced with respect to male genius, that quality discussed in chapter 1 which was like 'femininity', but possessed only by men.

As S. Stanford Friedman discussed in her article, 'Creativity and the Childbirth Metaphor: Gender Difference in Literary Discourse', the metaphor of childbirth has been invoked for centuries to describe the process of producing literary works but it has a very different effect when invoked by a male writer and a female one:

> However, female and male metaphors mean differently and mean something different, indeed something opposite ... These gender differences in childbirth metaphors project contrasting concepts of creativity. The male childbirth metaphor paradoxically beckons woman toward the community of creative artists by focusing on what she alone can create, but then subtly excludes her as the historically resonant associations of the metaphor reinforce the separation of creativities into mind and body, man and woman. The female childbirth metaphor challenges this covert concept of creativity by proposing a genuine bond between creation and procreation and by suggesting a subversive community of artists who can literally and literarily (pro)create.[24]

The same is the case with the invocation of childbirth metaphors in the fine arts over the course of this century. While male artists using this sense of 'origins' reinforce their masculine abilities to produce 'culture', women artists have used childbirth as a model of creativity which subverts such distinctions between nature and culture.

Coming to terms with being both 'creative' and 'procreative' was an integral feature of the experiences of many women artists and was reflected by the concerns of their self-portraiture. Not only were representations of pregnancy and motherhood subversive of social and

psychic norms which excluded women from the realms of artistic production, they were also spaces in which women could explore areas of their experience hitherto hidden as 'feminine' and unworthy of representation. Women artists were able to investigate the realities and fantasies of the maternal body through self-representation in ways which brought this feature of women's experiences to light and also queried the relationship between artistic creativity and maternity in new ways. There are clearly two principal areas of activity within this realm: representations of pregnancy and representations of the mother and child. Pregnancy was not often deemed an appropriate subject for the fine arts, but the mother and child image has a long history which must be negotiated by women artists who wish to develop these themes.

Pregnancy

Social, psychic and creative concepts surrounding women's pregnancy have all been explored by women artists in self-portraiture from the first half of this century. In addition, the generation of women artists who matured after second-wave feminism also sought to document the physicality of childbirth and issues of abjection and desire. But the two generations are decisively linked around images of pregnancy and the woman artist; the representations confront stereotypical notions of 'woman' which confine the pregnant woman to the margins of culture and, ultimately, to near-invisibility. These works place the pregnant artist into the centre of the work and evoke powerful relationships between procreativity and creativity.

In 1906, the Worpswede artist Paula Modersohn-Becker painted a partially nude pregnant self-portrait entitled *Self-portrait on My Sixth Wedding Day*. In many ways, this work was a strategic intervention on the part of a woman artist working within the constructs of the early modernist movement in Germany with its emphasis upon 'primitivism' and creation. Modersohn-Becker was not, at the time the work was produced, pregnant. Rather, she projects herself as such in order to link her female body with monumental concepts of creativity. Rosemary Betterton has argued after Julia Kristeva that this image sought to rectify

false divisions between subject and object, artist and production through a reinforcement of a 'feminine' or pre-Oedipal sensibility.[25] While this argument is innovative, it is awkward to use Kristeva's theories to understand the production of a woman artist in modernism since Kristeva would suggest that male artists of the avant-garde were those who best accessed the 'pre-Oedipal' without being resorbed into it. The context of the work adds further subtleties to the reading. The work resonated with the theories of the early modernist male painters with whom Modersohn-Becker was familiar concerning the natural and 'uncivilised' role of woman; Modersohn-Becker used this, but turned it to her advantage in the work by invoking herself as 'nature' and 'culture-maker' combined.

By the 1930s in Germany, the New Objectivity was a flourishing style. This realist production worked in opposition to the structures of early modernism and sought soberly to document the realities of the day. Interestingly, Gerta Overbeck, a woman artist associated with the Hanoverian variation of the New Objectivity, painted a pregnant self-portrait in 1936 entitled *Self-portrait at an Easel* (see chapter 1). Unlike the work by Modersohn-Becker, the image documents accurately the date of Overbeck's only pregnancy and, through a view out of the window in the picture, her actual location at the time in Mannheim. Furthermore, the artist is shown clothed and working at her easel. Thus, this work does not particularly engage with concepts of 'primitivism' and originary creation, but documents the circumstances and experiences of women who combined their roles as mothers with professional careers. Yet, in its very insistence upon exploring such daily realities, it challenges the traditional divisions between masculine and feminine creativity and procreativity in ways very similar to Modersohn-Becker.

Frida Kahlo's work of 1932, *My Birth*, both harked back to and went beyond the biography of the artist in its meanings. This work again challenges the natural links between women and motherhood, revealing the underside of this association through reference to the experience of death in childbirth. The visceral imagery employed forces the viewer to contend both with the unpleasant realities of childbirth and with our social and psychic investment in this process. The self-

portrait casts Kahlo as the new-born infant (possibly stillborn), whose mother has died in childbirth. This was not the circumstance of the artist's actual birth, but a powerful reminder of the conjunction between life and death. The fact that the Mater Dolorosa, or the Lady of Sorrows, presides over the scene is simultaneously biographical (it is said that Kahlo's mother had such a work on her bedroom wall) and beyond biography. The Lady of Sorrows is an archetype who represents in particular the mourning of mothers; she is a figure who embodies specifically female forms of tragedy in the loss of one's children. The work evokes cyclical time and female forms of creativity, mourning and desire. It also foreshadows the theme of the union between mother and daughter which will be taken up in the next section.

In the same ways that women artists working within the structures of modernism explored pregnancy and childbirth in social, psychic and creative terms, contemporary practitioners have looked to these themes in order to challenge for space at the centre of representation. Increasingly, women artists have focused on their experiences of pregnancy and childbirth precisely because pregnancy has been unrepresented and mother and child images have been produced by men. Artists such as the American photographer Patricia Hurley and Susan Hiller have 'documented' their pregnant bodies; Hiller's *Ten Months* (1977–9) precisely recorded the changing landscape of her abdomen in a series of ten sets of photographs. The African-American photographer Cary Beth Cryor produced a series of five photographs entitled *Rites of Passage* in 1979 which, remarkably, details the birth of her child. The series was shot by the artist as she gave birth, using mirrors in some instances, in order to show the birthing process without objectification. In this sense, the title has a double meaning; there is the straightforward rite of passage implied by the birth and the rite of passage embodied by the woman artist producing art through this experience. She controls the representation of her procreativity and channels it into 'creativity' in this way.

Cath Pearson has photographed herself during pregnancy in ways which explore other possible areas of the experience which have tended to remain occluded in traditional discourse. Pearson's works are extremely significant for their reintegration of humour and candid

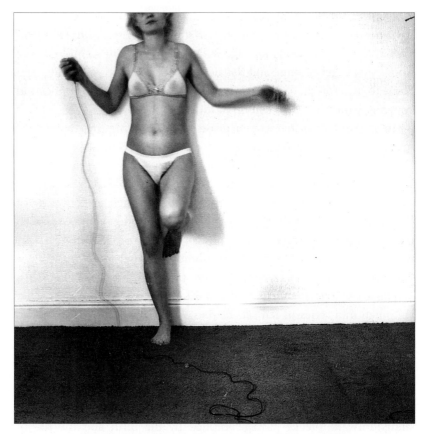

Cath Pearson, *25 October; 5 Months, 2 Weeks*, 1990

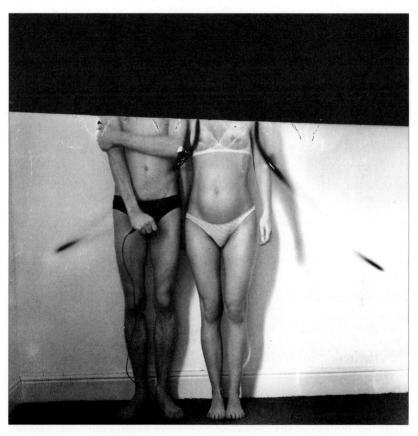

Cath Pearson, *13 November; 6 Months*, 1990

sexuality with pregnancy. Pearson documented her pregnancy while still a student of photography in 1990 with a series of self-portraits simply titled by date, such as *25 October: 5 Months, 2 Weeks*. In this particular image, she posed her pregnant body in ways which likened her to a 'pin-up' (underwear, etc.). The juxtaposition of the 'mother' and 'whore' implied by these works is a very subtle confrontation with limiting social stereotypes of woman in our culture. Furthermore, the images remind the viewer of the sexuality of the mother, something which is often lost in a plethora of maternal myths. As Luce Irigaray has suggested in a number of her texts, we must begin to reinvest the mother with her 'womanness' if we are to subvert the system which defines women purely in terms of their roles within patriarchy as 'daughters', 'wives' and 'mothers'.[26] In works such as *12 November: 6 Months* and *13 November: 6 Months*, Pearson injects more humour with the addition of a male figure (also in underwear) and, in the earlier work, a pumpkin head for Halloween. The casual nature of the works is a challenge to the sacrosanct image of the Madonna. Hence, these images operate to challenge traditions on a number of levels, from the social to the psychic. The representations of pregnancy in the self-portraiture of women artists this century can be seen to have provided potential alternatives to stifling definitions of woman as procreator rather than creator.

Mother and Child

In the same vein as the representations of pregnancy by women artists, representations which concern the mother–child relationship operate to challenge dominant stereotypes of women as natural nurturers and act to reinstate both social and psychic complexities into the mothering experience. At the simplest level, two German artists from different periods of this century, Hanna Nagel and Heidrun Maurer, have considered the pressures placed upon women artists by their domestic duties. Nagel's etchings, *Early Self-portrait* (1930) and *The Ideal Marriage* (1928), concern the difficulties facing a young professional woman artist of the period attempting to combine motherhood with her

practice. In *Ideal Marriage*, the artist has projected an image of herself and her husband (the artist Hans Fischer) as itinerant artists. The huge cart which is pulled by Nagel has her drawings and a number of infants in it; Nagel not only takes on this burden, but Fischer is shown to be leaning on the cart. Thus, the work satirises the ideal of the companionate marriage in which both partners would share equally in the domestic duties, as described most famously in the period by Theodor van de Velde in his text of 1928, *The Ideal Marriage*. *Early Self-portrait* carried on this theme, with the representation of the artist at her drawing-board completely unable to work because of large numbers of infants around her and a welter of little 'Fischers' tugging at her coat. Marriage and motherhood are here shown to be social institutions which support men and not women. In a work from five decades later, *Woman's Dilemma* (*c*.1979), Maurer almost perfectly reconfigured the Nagel scenario; the woman artist is rendered helpless by the crying and pulling of a number of little infants. Clearly, the relationship between motherhood and artistic production in a social sense can be seen to have changed little over the course of this century.

Jo Spence's work is an interesting case to use as a cross-over point between the social and the psychic elements of motherhood and artistic production. In works such as *Mother and Daughter Shame Work: Crossing Class Boundaries* (with Valerie Walkerdine, 1988) and *Mother and Daughter Work: Saying Goodbye to My Introjected Mother* (with David Roberts and Rosy Martin, 1988), Spence confronted both the social ambiguities of motherhood as inscribed in class conflict and the psychic 'introjection' of the mother by the daughter seeking to form her own identity. Through these photographs, Spence worked to overcome the problems inherent in her own relationship with her mother:

> In a photography session I try to come to terms with my own potential death. I enact a ritual for the camera to mark my willingness to say goodbye to my introjected Working-Class Mother, a person of whom I was taught to be ashamed. I deconstruct and reassemble, in order to reintegrate her into my history. A personal elision of the psychic, the social, the economic and the aesthetic in a death ritual.[27]

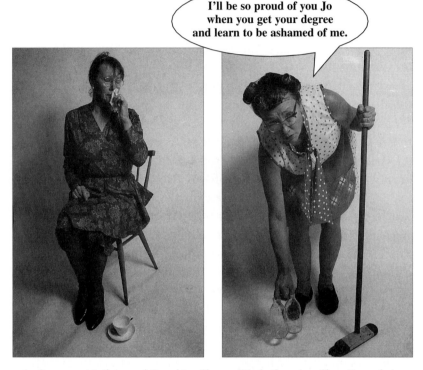

Jo Spence, *Mother and Daughter Shame Work: Crossing Class Boundaries*
(with Valerie Walkerdine), 1988

Significantly, Spence takes up the position of both mother and daughter in these images. One of the areas of greatest concern to women artists dealing with the psychic elements of the mother–child relationship over the last few decades has been the separation of the child from the mother. In the case of female children, this separation is often more troubled and has fewer representational modes with which to figure it. The reconfiguration of the mother and child relationship in imagery is exemplified by the work of three contemporary woman artists, Mary Kelly, Kati Campbell and Susan Czopor.

Kelly's installation piece, *Post-partum Document* (1973–9), is probably the best-known work to explore the dynamics of the entrance of the child into language and society as seen through the system of

Lacanian psychoanalysis. In the work, Kelly documented the process by which her son divorced himself from her and entered into the symbolic realm as an individual 'self'. The investment of the mother in this process, as well as the possibilities of a female fetishistic attachment to the son and the objects associated with him, were also part of this piece. Significantly, neither the mother nor the child is actually shown, mimetically, in the piece. By contrast, Kati Campbell, in her work of 1988, *Dyad*, used the representation of herself and her daughter to indicate the moment of Lacan's 'mirror-stage', the time at which the infant, through sight, first comes to separate herself from the mother. The photographic images are doubled (another reference to the dyad of the title) and taken with a mirror. These references emphasise the location of this work itself as process, rather than representation; the mother and child are both simultaneously subjects and objects of their own and others' gazes. As Campbell described it:

> *Dyad* is about a psychical relationship taking place at the level of the body which is a screen for and a site of reproduction, but which I can only make present through a structure ... I can only indicate what the mirror stage might mean for her [the artist's child] in the production of subjectivity, her attempts at incorporating the body as part of the self through the vehicle of the imaginary idealised other.[28]

Although both Kelly and Campbell make use of specific Lacanian terminology in their works, similar dynamics take place in the paintings of Czopor in which she considers her relationships with her three daughters. Czopor is a contemporary figural painter who came to her practice late in life and who seeks to investigate the social and psychic dynamics of familial relationships through many of her portraits and self-portraits. In images such as *The Mother Gives, the Child Takes* (1991), the artist represented herself in a mirror between her daughters. On the one hand, she is the pivotal centre point of the relationship; on the other, each daughter pulls in her own direction. There are likenesses between the women which forces the viewer to contend with the bonds between mothers and daughters at the very deepest level. Yet the work is marked by strong tensions between the women who are engaged in

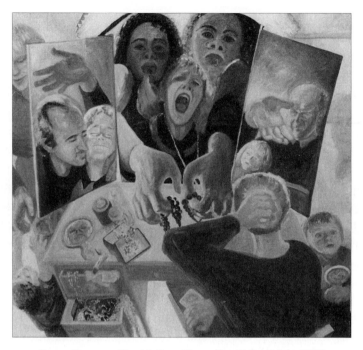

Susan Czopor, *The Mother Gives, the Child Takes*, 1991

struggles to maintain their individuality in the face of their very likeness. Significantly, the work does not merely suggest that the mother is an overpowering magnet from whom the daughters must break free in order to find their own identities. Rather, the struggle is shown to be two-fold: the mother must also seek distance from her daughters, lest she be devoured by their needs.[29]

The sense in which women artists need to confront their potential to be devoured as subjects and reconfigured as objects is a perennial concern of their self-portraiture, especially that which considers sexuality, gender and maternity. These aspects of female identity are produced internally through encounters with representation. To redevelop and reinscribe new definitions of female experience is to change conventions which have upheld binary forms of knowledge and society for centuries. To rethink difference is potentially the challenge of the century. Women's self-portraiture is just one area in which this challenge has been welcomed.

4: The Body Politic

Women, Art and Politics

Women artists have used self-portraiture in order to consider their role within the body politic, that is, the way in which they are placed as individual women artists within the wider social network of politicised identities. Many of the works already discussed in this book subvert dominant traditions of self-portraiture, the concept of the artist and notions of gender roles and as such could be termed 'political'. However, it is too simple merely to suggest that all art is political and everything we do in our lives has political implications, despite the fact that this is arguably the case. In order to assess the ways in which women's self-portraiture entered into the political realm, more definite concepts of politics must be developed. This includes, particularly, the importance of the concept of representation. The 'selves' who have been marginalised through dominant paradigms of political understanding have had to come into representation in order to posit a challenge to the paradigms themselves. Bringing these 'selves' into the centre of discourse has been one important strategy in this politic; self-portraiture is but one type of self-representation which acts in this way.

Feminist history and theory have indicated that the traditional, masculine concept of 'politics' must be rethought in order to understand and assess fully women's contribution. Assumptions that the political is defined by parties and their ideologies or by traditional forms of public action, for example, marginalise the roles that women have played historically and limit politics to a male sphere. As political scientists such as Bourque and Grossholtz have argued, women's political engagement cannot be measured in terms of men's: 'By

accepting the behaviour of those who presently exercise power as *the* standard of political behaviour, political science explains the failure of others to participate by their inability to approximate that behaviour.'[1] Alison Young, in discussing the politics of the Greenham Common women (British anti-nuclear campaigners) followed this line of debate in order to think through alternative models of political action based around ideas of the body. The Greenham women were an alternative group of political activists in a number of ways. First, they were women who engaged in long-term collectivist campaigning against nuclear weapons. Additionally, they used non-violent occupational tactics to make their protest, such as sit-ins, and they were not organised in a hierarchical, party-like structure, but had an egalitarian and individual approach to political action. Young employed the idea of the carnivalesque body (from Bakhtin) to describe the Greenham protests as 'truly transformative'.[2] She argues that they transform not only the political sphere, but also the concept of acting politically. Such ideas of politics transcend parties to include identity politics and the politics of the personal or the body and are relevant to deciphering the politics of women artists.[3]

There are many ways in which women artists may engage in their production with notions of 'politics'. The clearest interventions are produced when women actually make art for a political group or are members of factions whose ideals are 'illustrated' by their work. Such works are certainly 'political', but do not exhaust the politics of women's art production in any way. By contrast, the cultural politics of women's practice have placed them in far more wide-ranging political contexts. Just to become a professional artist implies a political imperative for women who are not traditionally defined in ways which permit them access to positions of discursive authority. By becoming 'culture-makers' rather than the objects of art, a gendered hierarchy which still has some currency today is changed. Moreover, for women artists to claim a particular speaking position as women is a highly charged political manoeuvre. The various ways in which women artists have acted politically have not, of course, always led to the production of self-portraits. The politics of self-representation are a particular case within the wider sphere of women's art politics.

In discussing women artists' engagement with the 'political', it is clear that there are differences over the course of the century in terms of the nature of this engagement. Generally, like other areas discussed in this book, it is possible to distinguish between the pre- and post-1968 generations; this is not an absolute distinction, but a difference of degree. That is, women over the course of the whole century have been active in producing art for political parties and politicised art groups. Furthermore, throughout the century women artists have been forming 'special interest' groups to increase their exhibition and education opportunities. It would be incorrect to assume that women artists became self-conscious in their politics only after the second wave of feminism. The example of Alice Neel is instructive in this context. Neel consistently produced socially critical realist paintings of Spanish Harlem throughout the 1930s and 1940s and then joined in with the younger generation of women artists who were active in feminist politics during the 1970s. This did not change Neel's politics, but provided her with a different forum in which to participate.

However, it is clear that the degree of 'feminist consciousness' differs before and after the late 1960s. Thus, women artists from the first half of the century were subversive just by practising, whereas feminist artists from the last three decades have actively challenged particular areas of representation in their works. Groups like the Guerrilla Girls in the United States and Fanny Adams in Britain have made their challenges to art institutions explicit by staging public protests within these institutions and have highlighted with statistical evidence the discrimination against women in the gallery system. This is not to suggest that the Guerrilla Girls and Fanny Adams have no differences; clearly, the Guerrilla Girls' project continues to be effective and subversive where Fanny Adams was quickly resorbed into the system. The political agenda of the women's movement (and the changes in this) has been reflected directly in the work of women practitioners as well. Women have used 'feminine' media such as textiles and ceramics purposely to subvert fine art practice and they countered prevailing media stereotypes of women with defiant performance works.

Hence, it is important to propose a working definition of 'politics' in order to assess adequately the political interventions made by women

artists through their self-portraiture and not simply collapse everything into a general concept of the personal being political. It is certainly correct to assert the politics of the themes in women's self-portraiture already discussed in the preceding chapters, such as the ways in which challenges to masculine definitions of creativity could be argued as a form of revolutionary cultural politics. Additionally, it is possible to reinterpret works previously discussed in terms of particular political readings. For example, the self-portraits of Hanna Nagel described in chapter 3 not only deal with issues of motherhood, but politicise domesticity. Or, Sylvia Sleigh's group self-portraits discussed in chapter 1 could just as readily be placed into an exposition of the art politics of 1970s feminist practitioners. While many works could thus be re-read in terms of the 'political', there are subtle inflections which differentiate some forms of political self-representation from others. For example, it is different for a woman artist to explore concepts of sexual identity and the self than to attempt to redefine female sexuality in the public sphere.

With this in mind, the term 'representation' becomes critical. In its broadest sense, the notion of representation acts in two ways. In one sense, it indicates representing something through symbols; with reference to art, this sense reinvests the pictorial image with the power to stand in for an object and reminds us that images are mediated constructions. In the other sense in which it is used, representation refers to legal or political authority, to be represented as an individual or a constituency in the public realm. It is not simply coincidental that this word works in these ways. To be represented, visually or verbally, is to be seen, to have a voice, to make a claim for recognition and power. Traditionally, it is misrepresentation and lack of representation which marginalise politically disempowered groups, such as women in patriarchal societies. Self-representation is but one strategy employed by such groups in attempting to gain access to power.

Clearly, other activities, including the founding of collective exhibition spaces and artistic societies as well as archival sources specifically devoted to women artists, have been critical in women's art politics. Furthermore, the number of women artists who have been involved with such cultural politics is vast; this chapter addresses only a

small selection of women who used self-representation as a political strategy.

It is the dual sense of representation that this chapter particularly addresses. Without suggesting an exclusive definition of politics or, as discussed above, suggesting that other works are not political, the self-portraits described here deal with the limits of representation as this affects the public sphere, or body politic. The works make moves to bring the unrepresented or unrepresentable into view. They try to renegotiate the very boundaries of modes of representation in the visual sphere which have an adverse effect upon political representation. They acknowledge the social interchanges in which private bodies become public selves.

Art Politics and Women's Self-portraiture

The politics of the art world itself have been used by women artists seeking to come into self-representation. By taking on certain styles, media and conventions, women artists have been able to use self-portraiture in ways which engage with art practice itself as a form of social intervention. For example, when Nina Hamnett produced her *Self-portrait* of 1913, she was linking herself to the prewar Parisian avant-garde. At that time, there were political overtones to such an association, not least in the framework of internationalism and a left-leaning tendency. However, the political ideologies of the avant-garde artist groups from the period are vague, to say the least, and cannot be seen to tie Hamnett to particular parties or groups. The most definitive statement that could be made regarding the bohemianism of the artists within her circle was that they were anti-bourgeois. By contrast, the self-portraits produced by Charley Toorop which specifically linked her to the Dutch circles around De Stijl (see chapter 1) enable one to make more particular assertions regarding the way art politics attached to the wider political sphere. The aims of De Stijl were derived from particular ethical and political concepts pertaining to universality and utopia. The group's works of art and design were meant to act within their society to change the way in which people lived. Like the constructivists, De Stijl

was a politicised art group which did not make a distinction between art and life. By associating herself with these artists, Toorop placed herself firmly within an art politics and the left cultural politics of the avant-garde.

Paraskeva Clark, who produced a number of formalist self-portraits during the 1930s and 1940s, exemplifies the case of a woman artist who used styles to associate herself with particular political ties. Clark was educated in Russia by the artist Kuzma Petrov-Vodkin, himself a member of the Blue Rose circle. This linked Clark to the Russian avant-garde tendencies of the first two decades of this century, whose formal revisions of Byzantine icons and Russian folk art combined with adaptations of French modernist form carried particular nationalist and socialist tendencies. The style in Russia termed 'neo-primitivism', that style which in the first few decades of the century engaged with French modernism but sought to reinterpret Russian folk tendencies, was in the avant-garde of Russian art practice. This type of 'nationalism' was critical to the early revolutions in Russia and, while later eschewed in favour of more international trends, it remained the basis for avant-garde formalism for decades. Indeed, Clark's *Self-portrait* of 1933 has visual similarities to Vladimir Tatlin's self-portrait *The Sailor* of 1911. What makes Clark's self-portraiture particularly interesting in this context was her situation between various political trends. By 1931, Clark had left Europe and its avant-garde circles for Toronto, Canada. Here she continued to work in a modified modernist style which maintained her position as part of the European avant-garde while integrating her into the more realistic Canadian tradition. Her 1933 self-portrait is the perfect accommodation between these two poles; she is rendered as fashionable and part of a socially elite Canadian circle as well as a woman modernist.

If these examples all use styles and devices in their self-portraiture to merge the individual identity of a woman artist with a collective social project, women's self-portraiture also functioned through its very form to assert its political allegiance. A number of women artists used collaboration and performance in this way. For example, Jo Spence and Rosy Martin collaborated on their phototherapy works, which fact proposed a new model of authorship and creativity in direct opposition

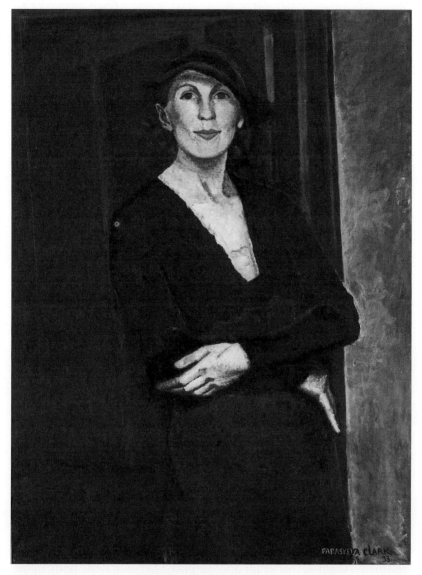

Paraskeva Clark, *Myself*, 1933

to the traditional modes which privileged male artists. Such collaborative efforts act politically in two distinct ways. First, they defuse the usual valuation principles which grant works of 'art' produced by single 'creators' the highest value on the open market. Collaborative works are harder to assess and require standards to change. Second, collaborations such as that between Spence and Martin are done in full awareness of the gender politics inherent in them. That is, models of authorship which herald great individuals tend to be masculine models. Furthermore, affective networks of interpersonal communications have traditionally been undervalued as 'feminine'. Thus, the works produced as collaborative efforts between two or more women artists engage in a host of art politics which have ramifications well beyond the art world.

The emphasis placed upon performance as a mode of art practice, particularly by women artists during the 1970s, was in direct response to art politics which marginalised women practitioners and manipulated the body of 'woman' in representation. Artists such as Ana Mendieta and Carolee Schneemann used their own bodies as art in order to control their 'objectification' and to stress alternative forms of viewing as well as production. Schneemann's *Interior Scroll* (1975) performance placed the artist uncomfortably close to the audience as she read from a scroll pulled from her vagina. Such powerful performance pieces confronted female stereotypes and positions in viewing women. Schneemann, as an American artist working in the context of first-wave feminist protest and body politics, used her body to renegotiate the ways in which we look at women as performers. Mendieta, on a slightly different tack, challenged the association of woman with nature in works which used her own body as art. Mendieta was also conscious of feminist body politics, but is also associated with some of the earliest interventions into 'Land Art'. In works such as the *Tree of Life* series, from 1977, Mendieta used both the form (performance) and the content (woman in landscape) to engage with traditions in western fine art practice which excluded women from being makers of culture and designated them as matter for art. She posed her own nude body in the landscape, but not as a classical nude, as part of the earth. Frequently, she was covered in mud or leaves and sometimes she merely left the

outline of her body in the earth. Yet again, these works use the self in order to negotiate the politics of culture and social power.

The medium in which women artists work can also indicate their engagement with art politics. Hannah Höch and Claude Cahun, for example, used photomontage for their self-portraits which linked them to a host of radical theories regarding the potential of such a dialectical image to political activism. Theorists of the Frankfurt School, such as Walter Benjamin, for example, argued that photomontage was a radical political art form because it could engage with mass media and yet subvert them through recontextualisation.[4] Women artists involved with avant-garde photographic practices in the early part of the century were keen to use a whole host of experimental techniques as part of their self-portraiture. Trude Arndt, for example, produced some 30 self-portraits in 1930 which used visual techniques associated with avant-garde formalism, such as double-exposures and complex framing arrangements. The politics of photography was significant for women's production in the period. As a relatively new medium, photography had yet to become part of the fine art hierarchy in the way that oil painting, water-colour painting, sculpture and print-making had. It still had a modicum of freedom within the system as its role as art was not wholly decided. It was associated with mass media and technology and perceived to be a more democratic form than bourgeois easel painting could ever be. Artists using the medium as an experimental technique could claim to be at the cutting edge in terms of the art world. Many of the politicised avant-garde groups of the early twentieth century embraced photography because of this newness and because of its mechanical, mass-media associations. This gave the medium a political edge against elitist, bourgeois production. Women artists involved with this experimental branch of the avant-garde were able, therefore, to adopt both the freedom and the potential political radicalism of this medium in their self-portraiture.

A similar circumstance in terms of politicised media occurs today with reference to artwork produced through advanced technologies. Like the arguments about photography a century ago, artists choosing to produce computer-aided digital images and multimedia works are working in areas of very uncertain status within the art world. Work on

the Internet is even more difficult to characterise and ideas about originality and uniqueness fall to pieces in the light of such artistic experiments. Again, this has been a mixed blessing for women artists who are frequently marginalised from the most technologically advanced developments through lack of training or unequal access to the tools needed to produce work in these fields. However, just as authors such as Haraway have begun to negotiate a theoretical space for women in the realm of the cyborg, a variety of practitioners are keen to address new technologies in art in order to investigate the potential there to create new gender identities.

Significantly, women artists have also reclaimed media traditionally denigrated through their associations with domestic craft, such as weaving and embroidery, in order to challenge the exclusivity of fine art production. Faith Ringgold, for example, used quilting and other textile crafts in her work to hark back to women's art production. Yet the content of her works, such as *Screaming Woman* (1981), reinterprets the history of African-American women through this seemingly traditional medium. Ringgold's political commitment to reinvestigating black culture decidedly influenced her choice of both subject-matter and media. Antipodean artist/craftsperson Heather Dorrough has used textiles and embroidery in her self-portraiture to reinvestigate concepts of femininity and interior and exterior space. Such work uses the politics of art hierarchies as a means to engage with wider socio-political contexts in which women produce meanings about themselves.

In 1983, Dorrough began a series of some 30 self-portrait hangings. The works consist of life-sized pieces of organza screen-printed with photographs of the artist (nude and clothed variously) overtouched with machine embroidery. Additionally, there are other images (such as landscape details) overprinted on the organza sheets and texts to accompany the work. The materials used act in very particular ways for Dorrough, ways which indicate art hierarchies and the politics of domesticity:

Covered and protected by the domestic quilt made from pieces of myself – comfortable, suffocating ... The material is a collaborator. Fabric – material, and thread are infinitely familiar. I have used them

all my life from my first table mat, made at boarding school when I was eleven years old, to the last patch on my daughter's old blue jeans, and yet they are also capable of expressing the most elusive of aesthetic concepts. I feel comfortable with a length of fabric; it is familiar and reassuring. With it I am able to express my 'femaleness' more forcefully than by using stretched canvas and oil paint.[5]

The materials Dorrough used relate directly to her experiences as a woman artist, including her place within a craft aesthetic and interior design. The multiple images were shown grouped together in a room to indicate the multiplicity of identity of a woman, as she said 'at the mid-point in one's life'.[6] Additionally, these works play with the dynamics of interior and exterior; the works are partially transparent, their placement confounds distinctions between inside and outside, the references to art and craft, domesticity and professionalism indicate public and private space and, lastly, some of the images reveal the internal organs of the artist, as if her body was both interior and exterior. This has a concerted political effect in the fact that all of those boundaries are socially regulated in order to keep them in place. Dorrough transcends such simplistic border policing and uses the self-portrait as her tool. The politics of domesticity has been considered by other women artists this century in their self-portraiture in ways which also confound strict boundaries.

The Politics of Domesticity

Understanding the politics of domesticity has been one of the main focuses of feminism since the late nineteenth century.[7] To begin to consider the situation of women in our society, it is necessary to examine the gendered division of labour under patriarchal capitalism which assigns women to domestic roles while denying those roles any social status. For professional women, including women artists, the pressures of domesticity tend to counteract many significant career moves and make their working lives a double burden. Moreover, domestic roles are defined socially, at the same time that being a

'mother' or 'wife' is internalised as a personal identity. Thus, the dynamics of domesticity are at the border of the public and the private, the social and the individual. This means that the politics of domesticity must engage with those borders and models of politics which presume the political to be purely public and do not suffice to understand the situation of women in our culture.

Women artists considering domesticity in their self-portraiture frequently contended with boundaries between the public and the private and the way in which society constructs definitions of the domestic woman. Elsa Haensgen-Dingkuhn, for example, delineated the complex spatial politics of domesticity and professional art practice in her self-portrait from 1928, *Self-portrait with Little Son in the Studio* (see chapters 1 and 3). Such a work shows the way in which Haensgen-Dingkuhn's studio space was simultaneously domestic and professional. The issues at stake in the Weimar Republic regarding women's work make this a politically charged image. There were, at the time, many critics of women's work arguing that women in professional employment would disrupt the boundaries between home and the public sphere. Even left-leaning critics suggested that it was a capitalist evil that women had to work outside the home.[8] Yet statistics suggest that many women in the period combined work with their domestic commitments and their experiences argue strongly against the masculine, traditional view of labour which separates public and private space; women's participation cannot be constrained so easily within such limited boundaries.[9]

During the same period, Marta Hegemann critically examined the theme of the family in one of her self-portraits, *Family Portrait* (*c.*1928, location unknown).[10] Unlike the work by Haensgen-Dingkuhn, Hegemann's image does not particularly look at the spatial boundaries of the domestic sphere, but at the concept of the family structure itself. Hegemann was married to the artist Anton Räderscheidt and the two of them cultivated the image of the ultra-modern couple in Cologne's fashionable avant-garde circles. They were both modern artists, they dressed in the latest fashions and they were, ostensibly, one of the new young couples enjoying a 'companionate' marriage, an equal partnership. However, these new models of marital bliss so strongly

advocated by many young artists and intellectuals during the period were more often fiction than reality. Significantly, Hegemann parodies this domestic harmony in sharp, satirical imagery in her self-portrait. The work shows Hegemann, with her New Woman haircut (a bob), utterly surrounded by domesticity; she is mixing something in a bowl, wearing a tiny, frilly apron, balancing two doll-like children. Räderscheidt, in this image, is the ultimate patriarch, standing next to Hegemann while two cherubs hover over his head crowning him with his ever-present bowler hat. The work plays on the falseness of their fashionable image, the image through which he had become known as 'the man with the stiff hat', and she 'the hundred percent woman'.[11]

The particular socio-economic structures which determine women's place in the domestic sphere were taken up some 50 years later by Jo Spence in her works. As part of the Hackney Flashers photographic group, Spence's Marxist politics influenced her representations of family life, most famously in the images produced by the Flashers which parodied advertisements showing women in idealised family settings. Spence and her collaborators paired these with images of single-parent families on the dole to make explicit the class assumptions underlying common representations of domesticity. In her self-portraits too, Spence located the politics of domesticity at the intersection of public and private socio-economic exchange. In her collaborative photo essay of 1982, *The History Lesson* (with Terry Dennett), Spence placed representations of 'woman' within particular class and economic boundaries. *Colonization*, for example, posed Spence, nude to the waist, on the doorstep of a working-class terraced house, holding a broom. The act of colonisation is thus doubled: the colonisation of 'woman' in representation and the colonisation of the disenfranchised working-classes. Domesticity is used here as a political tool to reveal the injustices of the social system.

The importance of strategies of representation in the fight for social meanings and power is forefronted by a number of women artists who used domesticity as a screen for their self-portraits. German painter Anneke Pinckernelle, in her work *Self in the Tea Pot* (1979), used the very objects associated with interiors and women's labour as the representational mode for her self-portrait. She is seen, so to speak,

through the guise of the domestic sphere. Contemporary British video artist Sarah Pucill similarly used certain domestic objects as the screen through which her self-image as a woman, defined culturally and psychically, was produced on film. In the work *You Be Mother* (1990), Pucill's likeness appears as a projection on white teapots, cups and bowls. These objects are 'feminine' by association with both domesticity and the female body. The boundaries between public and private are thus again evoked and challenged; domesticity is seen to be a construction which operates through both realms and politically defines gender roles. Additionally, Pucill's film refers to the mother, as ever-present ideal and as a role into which we step. This is the other side of domesticity. There are geographical, temporal and spatial boundaries which confine women and there are familial roles which are both personal and political. By imaging herself through the domestic objects and with the association of the mother-role, Pucill's video confronts the multifaceted meanings of domesticity in representation.

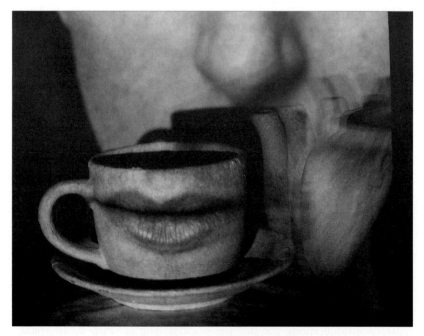

Sarah Pucill, *You Be Mother*, 1990

Body Politics and the Body Politic

The area of self-portraiture in which representational strategies act most directly as political strategies is the field of body politics. It is when women tackle the institutional restrictions placed upon their social representation that there are the most explicit confrontations with the limits of representation itself. Questioning the boundaries of acceptability in the representation of women in our culture places women artists into positions of conflict with masculine norms which can only be described as political. Clearly, the implications of enquiries into women's representation are personal as well as public. As discussed in chapter 3, for example, women artists seeking to redefine notions of female sexuality encountered stereotypes from art and the mass media with which they were obliged to contend. So, too, engagement with political 're-presentations' of the body of woman will naturally force encounters between external norms and internalised identities and desires. There can be no simple distinction between the public and the private with regard to these issues, yet some works are more directed towards internalised identities and others towards challenges to external establishments. It is to the latter that this section is addressed.

Representations of woman are ubiquitous in our society and mainly determined by male institutions. The body of woman is sharply defined, presented and monitored for acceptability by the pervasive cultural power of social institutions, including the art establishment, mass media and the scientific and medical communities. These groups determine the social definition of the body of woman as an object; beauty, femininity, sexuality, biology and the places and modes in which these may be seen are social constructs. Challenges to them have distinct political overtones. Rethinking representation in the visual sphere is accompanied by renegotiated representation in the socio-political arena. The significance of these links have been noted by a number of theorists concerned with political power and knowledge.[12] To control the production of meaning enables the control of knowledge itself.

Defining and limiting the body of woman are techniques which have been used to regulate society for centuries. One of the four

linchpins of the association between sexuality, knowledge and power as defined by Michel Foucault was 'a hysterization of women's bodies', described thus:

> a three-fold process whereby the feminine body was analyzed – qualified and disqualified – as being thoroughly saturated with sexuality; whereby it was integrated into the sphere of medical practices, by reason of a pathology intrinsic to it; whereby, finally, it was placed in organic communication with the social body (whose regulated fecundity it was supposed to ensure), the family space (of which it had to be a substantial and functional element), and the life of children.[13]

The details of this process have been explored elsewhere at great length and in a variety of forms; to decipher the ways in which the use of women's bodies has coloured their visual representation, it suffices to reiterate a few of these details. 'Woman' as a biologically defined object has had social currency most particularly through the regulation of female sexuality in the form of restrictions surrounding virginity, menstruation and fertility. Religious institutions of all sorts have been instrumental in this regulation through such things as menstrual taboos, female circumcision and even theological decrees which defined women as soulless, pure matter. Furthermore, as the Judeo-Christian tradition progressed, cults of goddesses and female deities were replaced by a male hierarchy. All of these religious and spiritual mores were in line with the secular apparatuses which sought to use woman as a symbol of cultural regulation.

The anthropologist Claude Lévi-Strauss, in examining the origins of social interchange, noted the primacy of the rules of exogamy in kinship. These regulations concerning the exchange of women as wives by men were widely used as the basis of cultural communication and, with the structures of religious regulation, placed woman as a symbol of social relationships. Lévi-Strauss has been challenged with respect to the universality of his claims, but woman as an exchange commodity in western, capitalist societies is still held as valid.[14] Other functions of woman as an exchange value within a male system have also been

inscribed in our culture, such as sexual fidelity. Women's bodies in patriarchy must be monitored, lest assurances of legitimacy and inheritance be contravened. Hence, the patriarchal state is also concerned with 'appropriate' female behaviour and the rules of female sexual conduct are important features of the body politic. One need only recall the Nazi party's emphasis upon declining birth-rates and theories of eugenics to be reminded that the body of 'woman' is still highly relevant in political terms.

In the wake of increasing secularisation during the so-called Enlightenment, science and the medical profession, rather than religious institutions, became the most important tools in the state's definitions of the body of woman. The quest to understand the interior workings of the human body progressed through the bodies of women who were dissected and examined. Particularly, there were elaborate studies of women's fertility and pregnancy which linked seeing with knowing in scientific discourse. Women's bodies were subject to intense scrutiny and depiction.[15] Furthermore, as the male medical establishment gained power, women's bodies were increasingly controlled by this institution and any deviations were checked. The rise of psychoanalysis completed the process of the 'hystericalisation' of woman.

All of these forces which defined woman as an object worked through the visual (at least in part) and constructed a certain limited set of body images as 'healthy' or 'normal'. Art, and later the mass media, further engaged in this process. As Lynda Nead discussed in her book *The Female Nude*, despite the large numbers of female nudes, there are only a small number of appropriate types; bodies which transcend permissible boundaries become defined as 'obscene'.[16] The beauty and wholeness embodied by representations of women require strict rules about the nature of that body to be upheld. The bodies cannot be outside certain norms. Traditionally, representations of working-class women, black women or images in which perceived physical traces of the visceral body are seen were too sexual, too real, to be beautiful. Clearly, the visual representation of woman was fraught with political tension. Some of these restrictions have continued in mass-media stereotypes of women, where only a small percentage of young, thin,

healthy body types are acceptable for display and these are displayed extensively as if they were a norm. The pressure of social regulation through visual representation has not abated.

Medicine and Health

Women artists attempting to regain power over their own bodies in the face of the medical establishment provides a rich vein of imagery. Frida Kahlo's works dealing with her own body as the site of an identity defined by medical treatment are particularly clear instances of this. In *Tree of Hope* (1946), Kahlo painted a double self-portrait in which one representation of the artist is the supine medical object on the hospital bed and the other is the powerful Tehuanan Frida looking directly at the viewer. These contrasting images place the medical treatment into the context of a woman's experience of her own body. On the one hand, the experience of illness is highly personal; on the other, the patient becomes nothing but a generalised specimen for treatment. The supine self-portrait faces away from the viewer and is shown opened by the scalpel for scrutiny. This is the woman as object. However, Kahlo did not merely leave the work with an objectified body but forced the viewer to contend with the individual who is that object. The dynamics of the work come from this encounter.

In *The Broken Column* of 1944, Kahlo produced another self-portrait which works in a similar way. The representation shows Kahlo nude to the waist and strapped in a back brace. She is rendered visually open and her broken spine, signified by a broken column, can be seen within her. The encasement in the brace and the way in which the interior of the artist is laid bare conform to medical definitions of the woman as a patient. However, the monumentality of the individualised self-portrait and the powerful rendering of the weeping face locate the medical 'object' as a subject. The confrontation between these internal and external senses of identification is a powerful refusal to permit institutions to have the final power of definition. The body is the site of this refusal. In *Henry Ford Hospital* (1932), Kahlo again produced an image which seeks to challenge the authority of masculine institutions

to control and define woman. Kahlo is represented having miscarried in a hospital bed with a series of six objects floating around her, attached to her body by umbilical cords. Three of these objects are directly derived from medical illustrations of women's bodies and the partially formed foetus. They define the visible norms of healthy women's bodies; Kahlo's visceral image of her miscarriage confronts those defining norms and places women's experiences into the centre of representation.

Nearly half a century later, Jo Spence confronted the treatment of women as objects by the medical establishment. Like Kahlo's works considering miscarriage, Spence's self-portraits dealing with her breast cancer refer to illnesses which are specific to women. While there are issues for both men and women regarding the treatment of patients as objects, the politics of the male medical establishment and female health needs are more particular. The usurpation of women's midwifery practices during the course of the nineteenth century, for example, is but one instance of male professionalisation coming into conflict with women's needs and overriding these in favour of increased social power. Furthermore, the subsequent history of the male medical establishment's treatment of women has been less than glorious, including the institution of clitoridectomies for 'hysterical' women, incarceration of those who had pre-marital sexual relations, enforced sterilisation of 'unfit' women and countless numbers of hysterectomies performed unnecessarily.[17] There has also been little sympathy for women suffering from menstrual difficulties (PMT) or such specific problems as postnatal depression.

Liberal feminism of the 1970s focused on the issue of women's health and body politics. Such pivotal texts as *Our Bodies, Ourselves: A Health Book by and for Women* (edited by the Boston Women's Health Book Collective, 1971) sought to introduce women to their own particular physical needs which were not adequately addressed by mainstream medicine. One of the primary issues was visibility, both in terms of bringing women's health into a forum for discussion and in literally showing and looking at hidden areas of women's bodies. Consciousness-raising groups encouraged women to examine their genitals with mirrors and learn to masturbate. Feminists debated the

'myth' of the female orgasm and discussed menstruation frankly. These were all moves to bring the 'specialist', hidden knowledge of the male medical profession into contact with its objects in order to demystify it and reclaim power. Feminist challenges to psychoanalysis were part of this demystification. At first merely hostile to a scientific discourse which defined woman in terms of lack and deviance, feminists over the course of the 1980s began to enter into fruitful dialogues with psychoanalytic theory, if not in its orthodox form.

The work of Jo Spence is exemplary in terms of its relationship to feminism's challenges to male institutional frameworks. In 1982, Spence was diagnosed as having breast cancer. She refused the more traditional treatments of mastectomy and radiotherapy in favour of a lumpectomy followed by Gerson therapy and Chinese herbs. In collaboration with Rosy Martin and Maggie Murray, Spence began work on the exhibition 'The Picture of Health?' in 1983 which addressed the range of positions into which one is placed at the hands of our traditional medical establishment. The work *Infantilization* (in collaboration with Rosy Martin) from 1984, for example, confronted her position as the disempowered patient. What is most significant about Spence's approach to the subject of her breast cancer is the way in which she located the personal 'therapy' (phototherapy) within the arena of the politics of medicine:

> Because I am a socialist I support the idea of a national health service within a welfare state, but because I am also a feminist I will fight with others against patriarchal medicine as it is currently practised in this country ... How do you deal with your own bravado/rebellion? Being the 'naughty little daughter' is all very well when facing up to doctor/daddy and nurse/mummy within the cancer field (where most top jobs are held by men) but what we need is knowledge of how to begin to take responsibility for ourselves and have a say in defining our own bodies. A well-trod path in feminism but not in relation to breast cancer.[18]

Spence's political confrontations with the definitions of woman produced by the medical profession were, like Kahlo's, pivotal

subversions of powerlessness and objecthood. Both of these artists located their self-definitions within the context of politicised cultural institutions and then redressed the balance of power.

Body Image

In addition to health and sexuality, the body of woman is defined through social representations which privilege a very limited range of bodies considered 'beautiful' or 'desirable'. For the most part, art, aesthetics and the mass media have been male institutions and have produced the frameworks within which woman is represented. Hence, 'beauty' and 'desirability' are functions of masculine desire and judgement as a general rule and the exclusion of the majority of women from these standards functions politically as a tool of regulation and power. Particularly, in the period of advanced commodity capitalism, idealised representations of women are used to sell products. The effect and value of the products are derived from their exclusivity and women, as a massive body of consumers, are made to feel inadequate in the face of these representations precisely to control their purchasing power. Additionally, maintaining the body of woman as an object reinforces women's lack of access to the role of subject in our society. Women continue to gain most of their value as objects to be seen (or 'owned') rather than as producers or owners. It is here that the dual meaning of 'representation' is most critical. Women as artists have challenged the conventional representations of woman to enact a reversal of the politics of subject and object. To come into representation has been invaluable for women seeking political change.

In her self-portrait of 1979, *In the Reflection of the News Stand*, the German figural artist U.B. Costard explored the disjunction between the ways in which women are so often seen in public and the representation of the woman artist as a subject. The artist has placed a small facial likeness of herself amid the fragmented images of nude and partially clad bodies of pin-ups from the news stand. The politics of self-representation are here explored within the wider social context of exploitative female imagery through which one must struggle for a

visual identity. The pin-up images, despite their ostensible sexuality, are not fully represented female bodies; they are icons of masculine, heterosexual desire. As a woman working in fine art, Costard questions both the relationships between high art and popular culture and the representation of women across a wide range of visual media in our culture. The obvious exploitation of the mass-media nudes is interrogated through re-presenting them as fine art sketches, and our responses to female objectification in a number of different forms are brought out by the work. The American artist Judy Chicago, well known today because of her pioneering feminist practice in the early 1970s, also dealt with the boundaries of objectified female sexuality in her work *Red Flag* (1971). The image is a close-up shot of Chicago removing a bloodied tampon. The challenges to pin-up womanhood are obvious. While this is a close-up of a woman's genitals, the act of representing menstruation subverts the codes which define female sexuality as image rather than physical body. The excessive body dispenses with acceptability and places female experience on to the agenda. The work was a politically empowering manifesto, a red flag.

British photographer and performance artist Mary Duffy's self-portraiture also deals with the politics of female body images and notions of representability, but in the context of disability. The 'disabled' are rendered invisible in our society not least because they are not usually seen and are not in positions of power which would enable them to produce their own forms of representation. The power of body politics renders those with different types of bodies invisible or, at best, visible in the context of deviance from the norm. Duffy, who was a thalidomide child, focuses her photographic practice on making her 'disabled' body the subject of representation and rethinks traditional aesthetic concepts as well. *Cutting the Ties that Bind* (1987), for example, is a series of eight photographs in which Duffy's white veiling drapery is slowly removed to reveal her nude, armless body. The drapery and the body poses refer back to the classical traditions of western fine art sculpture and thus place the self-portraits within the arena of conventional senses of beauty. The placement of a 'non-standard' body type into those contexts requires the viewer to renegotiate aesthetic

ideals. The works place a challenging female image into the centre of representation and are formed through a definite politics:

> I have been surrounded all my life by images of a culture which highly values physical beauty and wholeness, a culture which denies difference. My identity as a woman with a disability is one that is strong, sensual, sexual, fluid, flexible and political ... It [the work] is about finding a new identity for myself as a woman with a disability and my right to define that identity and its politics for myself.[19]

Video artist Lyn Hershman and photographer Maedbhina McCombe have both explored the politics of the body in terms of representations of eating disorders. In works such as Hershman's videos *The Electronic Diary* (1988) and McCombe's *Clitoris Allsorts* (in the series *Appetites* [1990]), the artists link female body ideals, eating as a social activity and cultural politics in ways which engage with contemporary stereotypes. Anorexia and bulimia are almost exclusively the disorders of young women. In these disorders, seeing and representation are inextricably linked to politics of the body. Women's inability to 'see' themselves accurately in a literal sense (often seeing themselves as 'fat' despite the fact that they are actually at starvation point) is related to their social disempowerment. In situations where young women are powerless, often they are able to express their control only through self-injury. The sense of self-control, self-definition and self-determination necessary to individuals cannot be gleaned from external sources and is found through acting on their own bodies. Hershman's video works, in which she is both artist and 'subject', confront these issues very directly. The 'diaries' deal with the experience of abuse and bulimia, the binging and purging syndrome.

McCombe's work links gender, body image and food in more subtle ways. In her self-portrait series *Appetites*, the artist photographed her nude torso with a variety of candy placed on it. Two interconnected areas of feminist body politics are here invoked: on the one hand, the link between eating/dieting and body image in our culture and, on the other, the association between eating, sex and pleasure in which 'woman' is the consumable quantity. The significance of bringing these

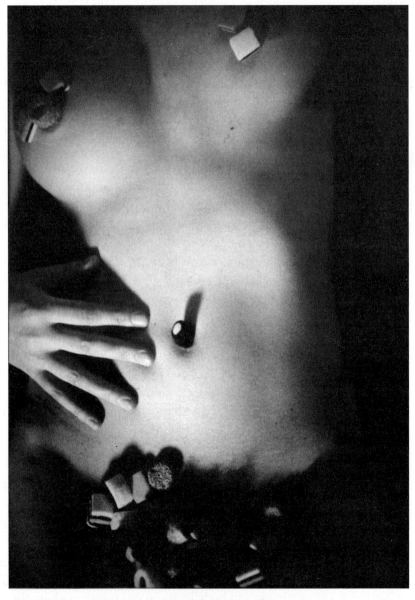

Maedbhina McCombe, *Clitoris Allsorts*, 1990

issues to light through self-portraiture is clear. Self-representation is an act of empowerment. Learning to look at and see oneself is critical to overcoming these particular disorders and to revise cultural stereotypes surrounding women's body image. These works act politically by entering the private self-image into the context of the public image of woman.

Ageing

Yet another unrepresentable body type for women is the ageing body. This body comes into conflict with a number of different stereotypes already discussed; old age in women contravenes the affiliation of beauty with youth in our culture and is associated with a loss of sexuality, with ill health and impending death. The very definitions of woman which our masculine-normative social structures invest with power are those to do with youth. That is, in the conventional model, representations of women embody a beauty born of just having reached sexual maturity, not having endured maternity or menopause. Signs of ageing are greeted with distress as women are thought to lose the very qualities which give them the little representation they have. The lack of power and representation given to older people in contemporary society is problematic for both men and women, but for women it is doubly compounded by the peculiarities of women's unequal social status. Since most representations of 'woman' derive from men, actual women find themselves invisible when they are no longer of use to patriarchy. This accompanies the ageing process.

In 1980, Alice Neel painted her self-portrait. Neel, as a veteran artist in her seventies, was a well-respected social realist by the time she produced this work. She was known for her unflinching representations of poverty and disease in Spanish Harlem. Her portraiture was direct and uncompromising; her portrait of Andy Warhol, for example, showed him partially clothed, seated on the edge of a bed, utterly exposed and vulnerable. She did not seek to flatter him or play to any of the media images of the fashionable artist. Her self-portrait is, perhaps, the most striking of her portraits for its directness. Neel represented

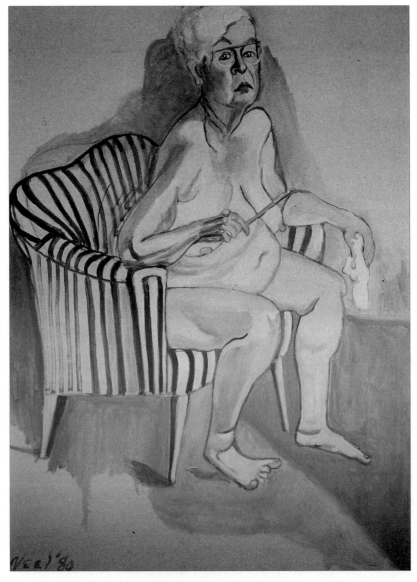

Alice Neel, *Self-portrait*, 1980

herself nude, seated in a chair. Such a revealing work is politically subversive in its directness. The self-portrait confronts stereotypes of women and artists by examining age in this manner. Neither is Neel the woman flattered, nor is Neel the artist made larger than life. Yet she is the centre of the work as the single, monumental figure, and her assertion of herself as the subject of the painting is powerful.

Anne Noggle has examined the dynamics of ageing as a woman in contemporary society in a number of self-portrait works. Noggle, born in 1922, had a career in the air-force before deciding in 1959 to attend the University of New Mexico to study for a degree in art history. In the 1960s, Noggle became a professional photographer; by the 1970s, she was concentrating on confrontational self-portraiture. Influenced by the work of Diane Arbus, Noggle's photographs share with Arbus's work the sense of a direct and unflinching encounter with the sitter. Unconventional in her own life, Noggle's work does not simply pander to stereotypes and traditional notions of acceptability. Rather, the works in which she considered her own ageing process are extremely challenging images which engage directly with the politics of female

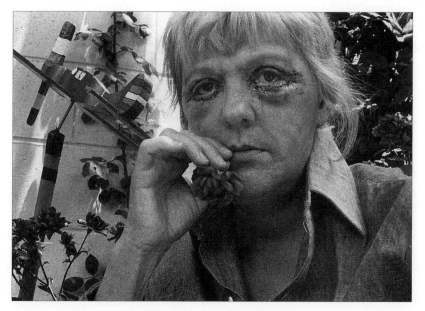

Anne Noggle, *Face-lift no. 3*, 1975

stereotypes. For example, in 1975, Noggle produced a series of photographs documenting her face-lift (the *Face-lift Series*). *Face-lift no. 3* is a striking representation of the painful process. In this work, Noggle is seen, close up, with the stitches and bruising around her eyes still visible. The work locates the individual woman and her struggle to maintain an acceptable 'face' within the social context of women's representation and exploitation by the media and the medical profession. Rather than revising concepts of beauty, women are asked to endure painful and expensive rituals falsely to change their bodies. The way in which Noggle posed in the self-portrait made these contradictions clear. She has a rose between her teeth, signifying female sensuality and pleasure, but her direct and sober look undermines any sense of playfulness in the image.

In *Reminiscence: Portrait with My Sister* (1980), Noggle again confronted the desire of women to be young and beautiful, to conform to socially defined concepts of womanhood. The double portrait shows the artist with her sister. Both women stare directly out of the picture while holding their faces taut with their hands. The title refers not only

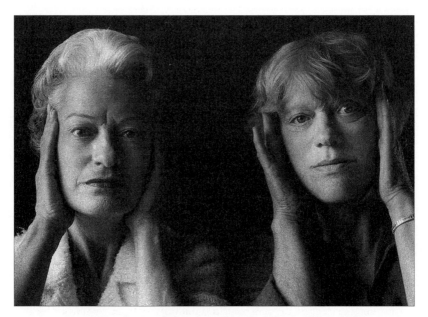

Anne Noggle, *Reminiscence: Portrait with My Sister,* 1980

to the personal history of the women, who 'reminisce' about their youth, but to the social context which valued them only as young. Although Noggle's works are challenging, they are not all pessimistic. *Myself, I Am* of 1977 is a work which confronts the body politics of ageing, but in a positive and self-affirming way. In this work, the artist is shown wearing a little shirt, open to reveal her nude body. The image is sensual, the aged body is not robbed of its sexuality. Noggle's self-portraits frequently contend with the sexual nature of older women in this frank way and take back the very qualities society and its conventions would steal from those women. The issue of power in representation and in having the power to represent the self places Noggle's explorations of female ageing at the centre of a concerted cultural politics.

Sexual Violence

A major area of feminist politics over the last three decades has addressed rape and sexual violence. The issues at stake are legal, sexual, emotional and representational. Sexual violence is a singular form of punishment meted out to women who transgress boundaries. Rape and sexual violence are present dangers to every woman and maintain through their threat the 'appropriate' standards for women's sexual behaviour in our society. There is still the erroneous, yet commonplace, assumption that women who are raped 'ask for it', that unbridled female sexuality is such a thrill to men that they cannot be held accountable for their violent actions against women. It is important to understand that there is a continuum which links sexual harassment to sexual abuse and the incidence of 'stranger-rape'. Although these forms of violence against women are very different, they are linked in the ways that they act to monitor and control women in our society.

It is also imperative, in terms of the representation of sexual violence, to differentiate between the concepts of 'victim' and 'survivor'. Many of the images produced in our culture which concern sexual abuse and rape are images of victims. On the one hand, this can be used to stir strong emotions and provoke political action against sexual violence,

but it also tends towards extremes in representation. That is, in order to provoke heightened emotional responses, the most dramatic and violent scenarios are often described. Clearly, the day-to-day business of living as a survivor is not as dramatic as the experience of the abuse or rape, yet it is on this that most survivors themselves would prefer to concentrate. Thus, women artists who have been raped have rarely used their self-representations to confront the experience itself. It could be that the experience was too traumatic to be relived in this way, or, as survivors, they want their self-representations to concern their survival, rather than the moment of their victimisation. Women artists who confront sexual violence in their work more often use representations of others.

Karen Augustine is one woman artist who used self-portraiture to look at rape. Augustine is a contemporary African-American photographer who both produces visual work and is involved with a journal which promotes black women's art, *At the Crossroads*. Hence, her work is explicitly defined by a politics of gender and race. In *Joe/Not in Me* (1992), the artist charted the banality of rape through the juxtaposition of the self-portrait image, in which she is shown holding her legs and arms closed together, and the textual 'tale' told in simple terms:

> He had me pinned to the bed/I tried so hard to free myself up from beneath his weight/I couldn't move/Fingered me/Searching for a wetness/He shoved another finger in me then rammed his whole hand up me/I screamed/He tried to calm me down/He said this was beautiful/He shoved his hand up me again/I was bleeding/I was naked/He chased me around the apt./He forced me back into his bed/I've blocked out everything else/I remember his hard white cock pressing against my thighs/He held me against him tightly/He let me leave the next day/I was sore for a week/He said he liked chocolate.[20]

Such a work refutes the notion of the purely sexual nature of rape and returns it to the arena of power relations between men and women and, in this case specifically, white men and black women. It is power

Karen Augustine, *Joe/Not in Me*, 1992

enacted through the terms of sex; women must contend with their oppression in patriarchy operating through the very mechanisms of their bodies and their sexuality.[21] The exhibition held on a university campus in Columbus, Ohio, during the autumn of 1978, 'RAPE', was a powerful testimony to the pivotal role such a trauma marks in the lives of women who experience it. For women artists, producing works which examine their personal experiences within the broader context of other women who have been raped and society's ignorance and intolerance can be a cathartic event. One of the works documented in the show was performance artist Ana Mendieta's piece *Rape-murder* from 1973. In this work, spectators invited to an unspecified performance were met with Mendieta's own body staged as a murdered rape victim in an abandoned house.[22] This early work inspired many other women artists to confront this issue and demystify it through their work, though not always using self-portraiture. Feminist critic Arlene Raven has written eloquently on this work, the exhibition 'RAPE' and of the actual violent death Mendieta suffered in 1978. Bringing into the open this side of women's experiences of themselves as sexual beings in an unequal and violent world has only just begun.

The Politics of Difference: Class and Ethnicity

Body politics and the politics of the personal appeal to similarities between women. Collective action is produced through an understanding of shared oppression and a sense of an identity as a 'woman'. Yet, there are many variables, particularly surrounding issues of class, race and sexuality, which separate women from each other. Even the ideals of womanhood itself change in different contexts; to be a white, middle-class woman is not the same as being a black, working-class woman. The variables of race, ethnicity and class add subtle political inflections to feminism which frequently are overlooked. Clearly, mainstream feminism, particularly liberal feminism, has tended to be a movement produced by and addressed to white middle-class women. Differences between women were minimised in order to develop clear political objectives and some form of unity. While this

was a very significant strategy in the early years of the feminist movement, throughout the last decade the agenda has been set to identify difference and renegotiate alternative politics.

Women's self-portraiture practices throughout this century have engaged with the dynamics of class and ethnicity while addressing a host of other issues as well. Many of the works already discussed in this book fit this description. For example, the work of Jo Spence always acknowledged her own position, including her situation as working-class. The class politics of her works differentiated her from other women even as she produced works dealing with the body and psyche of 'woman'. Furthermore, the medium and content of Spence's works are interdependent; she used very basic (democratic) technology to produce, in effect, snapshots. The dynamism of her photographs derives in part from the specificity and the universality which they embody simultaneously because of these features. Karen Augustine's work *Joe/Not in Me* shared this dynamic; it addressed the conditions of rape and sexual victimisation which unify women as a group, but did not ignore the specific racial overtones inherent in the situation of a white man raping a black woman. Lesbian artists too, in addressing the politics of sexuality, have worked through explorations of difference. The works examined in this section all frame the specificities and multiplicities of women artists' selves within the wider social contexts which define them. They enact difference as a political tool, both to expose the underlying 'sameness' of our homosocial system which uses men as the norm and to redefine political identities.

The work of Hanna Nagel is interesting in this context. As discussed in chapter 3, Nagel focused on the difficulties facing women who chose professional careers and yet had domestic duties with which to contend. In this way, Nagel engaged with the politics of domesticity and the sexual politics of the artist's studio wherein women had their roles limited to models, muses and supporters of male artists. Additionally, Nagel worked in the politically left context of Karlsruhe's artists such as Georg Scholz and Rudolph Schlichter and can be seen to have produced works which were decidedly working-class in their orientation. Nagel's prints and drawings were concerned with the plight of the poor and they were accessible in terms of both style and medium. Her domestic

politics worked through a concerted left-wing commitment and bore the inflections of class consciousness. In the work of 1930, *Do My Children Appear So Jewish?*, Nagel's domestic politics spoke of issues of class and ethnicity and the interconnections between all of these spheres for women.

The drawing shows Nagel (in an old-fashioned gown) with three children posing for her husband Hans Fischer. The whole scene mocks the conventional elite portrait sitting of the wealthy man's wife and children, posed as a display of his wealth. By harking back in terms of her own costume and by adding in three children, which, at the time, she did not have, Nagel evokes this tradition in portraiture. However, it is thoroughly subverted in her representation and through its title. None of the figures in the work smiles or enjoys the scene; the whole depiction of the portrait sitting is shown to be staged and laborious. The fact that the viewer knows the work is artificial, both because of the poses of the figures and the fact that it is a small drawing and not a large-scale painting, itself (thus, an inexpensive and quickly produced work, rather than an elaborate portrait commission) subverts traditional art practices.

But the title is the most significant political weapon in this critical piece, linking the racial theories of the right-wing German parties with visual representation and the role of women. By the time this work was produced, the association of racial and nationalist politics with the fascist parties of Germany was complete, and the dangers for Jewish artists and writers with left-wing commitments were particularly acute. Theories of eugenics made the seemingly personal realm of childbirth and motherhood a state concern. Motherhood was the duty of women, but only women whose offspring would fit the accepted, limited norms of Aryan beauty. Visual tests, based upon dubious notions of physiognomy, were one of the means by which people were separated as ethnically pure and impure. Hence, Nagel's work combines all of these socially critical positions to subvert fascism from the particular position of a woman within the system. She undermines the happy ideal of the beautiful family displayed in fine art portraiture and, in its place, suggests the fear of racial cleansing and the oppression of the working-classes.

Frida Kahlo's self-portraiture also linked ethnicity and political ideologies in ways which maintained a critical view of the role of women in these politics. For example, in *Self-portrait on the Borderline between Mexico and the United States* (1932), Kahlo's own dual ethnic origins are allied to both political and nationalist tendencies epitomised by the contrast between Mexico and the United States. The Mexican Revolution was a Marxist triumph, thoroughly supported by Kahlo, her husband Diego Rivera and the artistic circles in which they moved. The art and the politics of the Riveras were united. Moreover, the revolutionary Marxism of Mexico was associated with a strong revival of pre-Columbian culture, a search for authentic 'Mexican' ethnicity. Hence, an interesting political union was formed for artists in this period who were attached to a European Marxism (the communists in Russia and Germany were in constant communication with the Mexicans) which had strong pre-Columbian Mexican nationalism mixed into it, and who were straddling the divide between folk or ethnic art and European modernism.

It was America, and its powerful presence between Europe and Mexico, which provided the sharpest contrast and challenge to these artists. America provided Rivera with a number of important commissions during the 1920s and 1930s. Furthermore, it was the home of the most powerful of patrons and collectors of European modernism, including the Guggenheims, the Kaufmanns and the Rockefellers. New York city was beginning to develop the art scene which would usurp Paris after the war as the home of the avant-garde. Kahlo lived for periods in the United States while Rivera worked on commissions or she engaged in exhibitions. However, the all-pervasive capitalism of the country was not to her liking and she drew out its unfavourable features in comparison with Mexico in her *Self-portrait on the Borderline*. America is ugly and industrial. It is not like the beautiful and fertile Mexico. Mexico has magic and spirituality, where the United States has materialism. Kahlo's contrast between communism and capitalism was drawn out through ethnic associations. Her own awkwardness between these two poles is linked to her genealogy and her situation as a woman artist using the evocations of Mexico and the avant-gardism loved by American collectors.

Yolanda Lopez, some four decades after Kahlo, produced a self-portrait which used the specific context of Latin American revolutionary Catholicism to assert its feminist politics. In *Self-portrait of the Virgin of Guadalupe* from *A Guadalupe Triptych* (1978), Lopez cast herself as a modern-day icon of the Virgin Mary. The representation of Lopez, striding forward in contemporary dress, is the picture of liberal feminist consciousness-raising techniques which reinforced women's rights to self-representation and determination. However, Lopez's work is more particular and more evocative than that. By casting herself as the Virgin of Guadalupe, the artist reinvented a feminine icon and, rather than the passive, vessel-like virgins of the Catholic mariological tradition, she is an icon of action. Thus, this work speaks politically about female representation and challenges a religious tradition. At the same time, it speaks to wider political issues. The Virgin of Guadalupe is the patron saint of Mexico and the most important shrines in the country are associated with this appearance of the Virgin to the converted Indian Juan Diego in 1531. The representation of this particular vision of the Virgin Mary is usually dark-skinned and -eyed like the indigenous people of Latin America, and during the Mexican Revolution the Independents marched under the banner of Our Lady of Guadalupe. Thus, the Virgin of Guadalupe is a symbol of a unified mass politics through her associations with the indigenous population, the radical Latin American Church and the Mexican Revolution. For Lopez to place herself into the centre of this web of political and religious meanings was an empowering act; an action which empowered women as both feminine and active. It reclaimed a central position for women in the public sphere.

The self-portraiture of contemporary New Zealand artist Margaret Dawson is more controversial in its relationship to colonialism and indigenity. Dawson's work examines the identity of the British colonial New Zealander in juxtaposition to the native Maori people. In *Colonial Vision* of 1987, Dawson explained in a sub-text that:

Mrs. Victor England is admiring a small glowing replica of Michelangelo's David. In front of her, but to one side on the wall, is Augustus Earle's *The Meeting of the Artist and the Wounded Chief*

Hongi, at the Bay of Islands. Mrs. England is looking nervously at the conquering white hero.[23]

Dawson is cast as Mrs Victor England and the ambivalence represented in the work concerns the identity of colonisers; white New Zealanders may see themselves as European or as 'Pakehas', Maori-identified. In another image in which Dawson used her own likeness, she wears the costume of the Maori. *Maori Maiden* of 1985 used the ethnic garb of the indigenous population, but, of course, Dawson is not a Maori. Such shifting positions are strong metaphors for notions of identity in former colonial territories, but also run dangerously close to new types of colonisation. By assuming the external garb of Maori 'maidens', Dawson appropriated their cultural heritage and framed it in terms of white, western fine art. The politics of these works relies upon a recognition of their pastiche, but if their artificiality goes unnoticed, ironically they become another form of cultural exploitation themselves.

Margaret Dawson, *Maori Maiden*, 1985

Black Women Artists: The Politics of Gender and Race

In this final section, the case of the black women artists' movement in Britain demands attention in the light of its explicit politicisation of race and gender difference. There are a number of artists associated with this tendency who use their self-portraiture to address this politics of identity. Moreover, artists such as Maud Sulter, Lubaina Himid, Claudette Johnson and Dionne Sparks write eloquently on the politics of being an artist and a woman of colour in Britain and the specific concerns of that position. It is highly significant that these women identify themselves as 'black' in political terms, despite their widely varying ethnic backgrounds (Afro-Caribbean, Asian, South American). The most unifying feature of these artists is their commitment to an explicit political movement. For this reason, it is interesting to discuss their work particularly, although throughout this volume the works of women of colour (especially those of African-American women artists) have been explored in terms of their responses to the politics of difference. As Himid wrote:

> The artists I have mentioned here are all concerned with the politics and realities of being Black Women. We can debate about how and why we differ in our creative expression of these realities. Our methods vary individually from satire to storytelling, from timely vengeance to careful analysis, from calls to arms to the smashing of stereotypes. We are claiming what is ours and making ourselves visible. We are a few of the hundreds of creative black women in Britain. We are here to stay.[24]

The notion of making visible is particularly important; the political agenda of women of colour cannot have any effect if it is invisible. This is the dual sense of representation, which is so critical to women artists' politics, again making itself manifest. For women of colour, however, there are particular exigencies with respect to representation. As Claudette Johnson put it:

The experience of near annihilation is the ghost that haunts the lives of women in Britain daily. The price of our survival has been the loss of our sense of ownership of both land and body. The ownership of our ancestors' bodies was in the hands of slave owners. The horrors of slavery and racism have left us with the knowledge that every aspect of our existence is open to abuse ... This is reinforced by the experience of a kind of social and cultural invisibility ... As women, our sexuality has been the focus of grotesque myths and imaginings.[25]

It is thus imperative to render women of colour as creative agents visible, but to deny the colonising gaze which threatens to turn them into specimens in an ethnographic museum within a white-dominant culture. This is very difficult to do. Self-representation in all its senses is critical in this political process; clearly, self-portraiture has a role to play.

Dionne Sparks and Chila Kumari Burman both use self-portraiture to counter stereotypes and to reinforce their roles as subjects. Sparks's *Self-portrait* (*c*.1989) is framed as a monumental head-and-shoulders painterly portrait. The 'painterliness' is important in the context of twentieth-century self-portraiture. The marks of the artist's hand, evoking notions of inspired creativity and self-knowledge, were, as discussed in chapters 1 and 2, a signifier of the privilege of the individual artist/author. This places the black woman artist as the controller of the image and, indeed, the gaze within the work, as well as the maker of fine art paintings. Thus, Sparks entered into the most privileged area of artistic practice and declared herself visible. In the context of her other work, which uses black female figures to assert presence, this work finds its political footing.

Burman, as an Anglo-Asian woman, had special reservations about having herself represented visually and a particular sense of how to subvert this:

At Leeds Polytechnic in 1979 photo-technicians, tutors and student friends wanted me to model for them, but it had been drummed into me that this wasn't allowed and I felt an uneasiness; thinking back, it was because I was seen as an exotic, unusual Indian girl, but

most importantly, I was brought up to realise, think and feel that Indian girls 'don't model' ... The intention of the works is to challenge people's stereotyped assumptions of Asian women, and to make new, radical forms of intellectual representation. These photo-painting-drawing-laser works use wild, spacy, trippy, mega-blast 90's means of representation; radical ecstatic visions, magical elements of pain, passion and pleasure, affirming that me and my sisters are here to stay.[26]

Burman's self-portraits are not only significant for bringing Asian women into representation and reclaiming her right to her own image, but for the manner in which she represents herself. In *I Am Not Mechanical* (1991), Burman posed in Indian dress, with her hands hennaed in the traditional way. However, she wears a man's bowler hat and stands before a psychedelic sunburst pattern. These references to popular culture place Burman's image at the intersection of two cultures: her diasporan Indian roots and contemporary youth culture in Britain. Her dual identity cannot be labelled simply and her role as a demure Asian woman (defined as such in both Indian and British culture) is refuted. Her four-panel *Self-portrait* from 1991 is even more explicit in its challenges to stereotypes of Asian women and the political confrontation between the two cultures for an Anglo-Asian woman artist. The panels are brightly coloured mixed-media images of Burman in western and traditional Asian guise. The graphic qualities of the images make them more like advertisements than 'fine art' and thus engage with notions of mass-media representation. Furthermore, they parody the kitsch posters of Asian films mass-marketed in Britain. Such 'tasteless' images of an Asian woman are in sharp contrast with the prudish attitude which conditioned Burman's feelings towards her representation during her youth. The work finds a new voice between, but not dominated by, two cultures. The directness of the works, in addition to their refusal to fix Burman in a single role, presents the politics of women's self-portraiture perfectly.

In 1990, the contemporary photographer Roshini Kempadoo produced a series of six photographs with text entitled *Identity in Production*. These works sum up the possibilities of self-portraiture in

Chila Kumari Burman, *I Am Not Mechanical* (photo by Christine Parry), 1991

addressing issues of gender, ethnicity and political identity. Kempadoo used the work to consider her identity as a diasporan woman, her position within a set of cultural associations which define her as a woman of colour in Britain. Although Kempadoo is British by birth, she is of Caribbean descent and has lived in Jamaica and Guyana for much of her life.

The full series, *Identity in Production*, consists of six photographs and accompanying text lines; some of these photographs show the likeness of Kempadoo; in others, she indicates her presence through objects. In two of the works, Kempadoo photographed a number of objects ranging from family photographs to beads and ethnic jewellery. The accompanying text reads: 'Souvenirs and trinkets ... or cultural codings.'

Roshini Kempadoo, 'What do they expect me to be today?' from *Identity in Production*, 1990

These images make clear the interrelationship between the personal and the political in identity formation. On the one hand, these are the sentimental keepsakes of an individual, valued and read in the most intimate terms. On the other, our ostensibly 'personal' items are already culturally defined and constructed and they are part of the way in which we are inscribed into social positions.

Space was also considered by Kempadoo in the work. This is a crucial element in diasporan identity as the history of colonised people has been written in the language of the colonisers. Hence, a sense of roots, space as history and culture, has been forcibly displaced. Kempadoo's work examines this directly: 'Spaces can tell stories and unfold histories ... A sense of place, of not just who I am in the present but where I am coming from, the multiple voices within me.' The 'self' is inextricably linked to space, place and history. Furthermore, it is always multiple. The final image in the work actually uses a multiple exposure to show Kempadoo three times, each in different garb. She is presented as 'British', 'African' and 'Asian' in this work to indicate the multiple strands of her ethnic origins as part of the former British slave colonies in the West Indies. The text to this piece, 'What do they expect me to be today?', contextualises the meanings of these strands within a multicultural society. Again, this confronts the various social guises of the woman of colour and politicises self-representation. The artist has discussed the piece best:

> Photography has invariably been a medium used by myself and other Black practitioners living in Britain, to establish, create, form new identities, new images of ourselves ... They are not an effort on my behalf to come to terms with my true self – there is no such thing. They are dealing [sic] and raising issues of perception of the self within specific social remits.[27]

Kempadoo suggested a provisional, shifting identity which can come to terms with all of the interwoven threads without forcing a single and final definition upon them. It is both critical to come into representation and to try to rewrite history to include those marginalised by the dominant discourse. However, it is equally

imperative not to reinstate a single, unified subject who claims to be 'true' or 'real', but to produce new ways of defining the self which allow for fluidity.

Women artists during the course of the century who came to produce self-portraits did so within the context of a variety of social discourses which defined 'woman'. In order to find representation, in the political sense, it has been necessary to rethink all forms of discursive representation. The links between the visual representation of women and their political authority are clear; power is exercised by those who control representation in its broadest sense. To gain control of self-representation is to begin to challenge for political position. Significantly, the quest for adequate self-representation has not forced women artists merely to reiterate the idiom of their male counterparts, but to rethink the nature of representation itself. These works do just that and begin to redefine the very sense of women's identity as political actors in the process.

Conclusions: Reflecting on the Future

Vanity Reviewed

Between 1984 and 1986, British artist Helen Chadwick produced the installation piece *Of Mutability*. This multimedia work centred on the confrontation between the representation of the woman artist's body and the western fine art tradition. On the floor of what was called 'The Oval Court' were photocopied representations of Chadwick's body. These images were made from fragments photocopied individually and then recomposed into 'wholes'. The reconfigurations were multiple, excessive. As Chadwick wrote in the published statement about the piece: 'Out of the copier, no longer separate from other things, I am now limitless. The essential elementary self is gone, evaporated into a vigorous plurality of interactions.'[1] *Of Mutability* works through the self-representation of the artist, yet challenges the elementary self posited by traditional modes of self-portraiture. This work, like the others described in this volume, encourages us to explore more critically notions of self-portraiture, the representation (representability) of 'woman' and female subjectivity.

Chadwick's work plays with an excessive restaging of traditions, from Bernini's Baldacchino in St Peter's Basilica in Rome to the rococo church at Steinhausen in Bavaria or the Amalienburg, a tiny eighteenth-century palace by François Cuvilliés. The space of the installation was swathed in mock-baroque drapery and had large golden spheres arranged on the floor, scaled to a relationship in size to each of the artist's fingers. The golden spheres reflected and distorted the photocopied floor images. Another part of the installation was a Venetian mirror carved in such a way as to have on its surface a weeping face with *tromp l'oeil* tears.

Additionally, Chadwick produced a self-portrait photograph entitled *Vanity* which used 'The Oval Court' as its setting.

The restaging of tradition in *Of Mutability* operated through a reworking of mirroring and the 'vanity' image. The spheres repetitively 'mirror' the photocopied body, but not as flat mirrors would. These mirrors are like the speculum to which Irigaray referred, distorting and rendering the body mutable. The Venetian mirror and the self-portrait *Vanity* (in which the artist gazed into a mirror so placed as to reflect both her immediate likeness and 'The Oval Court' behind her) are again linked to the traditions of representations of women with mirrors in allegories of 'vanity', but the excessive reworking permits a critical distance to be maintained. The mirror and its implications for both the western fine art tradition and concepts of knowledge and subjectivity are explicitly revised by Chadwick. As she wrote about the piece:

> Within each event, the position of things is given, but the emotive momentum is left hanging. It may be perceived literally as an outwardly manifest reality, a mirror, or experienced by the eye alone, but will only become palpably real if felt deep within the reflexive domain of introspection ... Pleasure and pain are simultaneous in the illusory frame of this place, free from the dimension of shame and guilt ... The boundaries have dissolved, between self and other, the living and the corpse. This is the threshold of representation, not quite real, not exactly alive, but the conscious implicate depths of reflection.[2]

Produced a decade after Joan Semmel's *Me Without Mirrors* (1974), *Of Mutability* was still working through the language of the *Vanitas*, of the masculinist western tradition which understands 'woman' as other to man. But this work has moved further in its theoretical engagement with that tradition. The body of the artist is fragmented and then recomposed in new and challenging ways. The body is not natural, but a site of multiple meanings and renderings. Moreover, it is through the experience of the body that events come to have meaning, not, as Chadwick wrote, 'experienced by the eye alone'. The dominant language

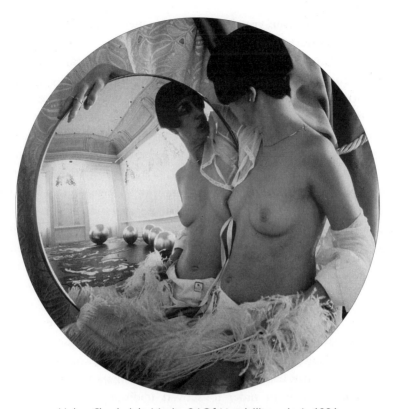

Helen Chadwick, *Vanity 2 (Of Mutability* series), 1986

of the tradition which asserts an objective 'eye'/I produced through the mimetic truth of the mirror is here used explicitly and then subverted.

It is, for example, highly significant that Chadwick produced an installation; she set the frame (or the limitlessness) of the piece and the ways in which it may be encountered. It is difficult to define the 'inside' and the 'outside' of the work and impossible to stand, objectively, 'outside' and read the content. The viewer's position is itself subtly interrogated by this technique and becomes more fundamental to the meaning of the work as a whole. Furthermore, the piece was documented in the book co-authored by Chadwick and Marina Warner, *Enfleshings*. This additional material provided both representational strategies and possible readings of the piece in unison. Rather than producing a single image, Chadwick has used an entire structure of

contexts (art, criticism, visual and linguistic metaphors) to rethink the 'threshold of representation'.

Such techniques question the dominance of the specular economy of the same, where the 'one' is privileged over the 'other', by insisting upon active forms of mediation between 'image' and 'truth'. A distance between the work and its meaning is opened up so that there is room for reflection, for active production of context and understanding. The language in which 'woman' attempts to come into representation may be pre-existent, but that does not mean that it is fully fixed. What is mutable is the position of discursive authority. Language can be used differently by 'others', provided that they engage with the process of making meaning, rather than being resorbed into structures which assert fixity or 'objectivity'. That is, there must be a reworking of both the representations and their contexts for new potential to be realised. This cannot happen if models based upon full, knowable subjects and singular modes of understanding are not challenged.

Works such as Semmel's began the feminist critique of the conventional forms of self-portraiture which relied upon the mirroring of the 'true' artist-subject. Chadwick's *Of Mutability* continued this engagement. There has been no wholly 'new' language invented from outside, as it were, in order to subvert traditional models of self-representation. Rather, new dialogues between the variety of self-representations made by women and their particular contexts have enabled contemporary practitioners to find modes which redefine the representation of 'woman'. The image of 'vanity', for example, need not confine woman to the role of object alone. That very language of subject and object binarism can be exploded by revealing the 'vanity' as a construct and not a natural representation. An excessive repetition of the mirroring of 'woman' can denaturalise the language itself and all of its presuppositions.

This is precisely why an exploration into the self-portraiture of women artists and their use of self-representation in other contexts is so vital. These images insist that the trope of woman-as-object be re-examined because they posit woman as both subject and object simultaneously. The gender binarism of the traditional specular economy is shown to be an artificial construct which cannot be

maintained. Self-portraits by women also grapple with questions of authorship and language. What happens when a woman assumes the role of the 'speaking subject'? Is 'woman' simply unrepresentable or must we reconsider our theoretical premises in the light of the sheer quantity of women's self-representations? Are all of these works merely recuperated by dominant visual languages and rendered ineffectual? If not, and it is highly suspect simply to assert that they are wholly resorbed into dominant discourse, their presence attests to the possibility of rethinking the representation of gender difference. These works have found visual modes for representing the 'woman artist', a site which in itself challenges any sense of a seamless, unified subject through its combination of contradictions. The 'woman artist' is, on the one hand, the empowered maker of culture and, on the other, the material of its making. It has been neither a static nor a homogenous category historically or theoretically. Because of this, it challenges viewers to construct new paradigms through which to understand its operation; models of embodied knowledge are a crucial step towards such paradigms.

Bodies and Embodiment

Rosi Braidotti is one of the current generation of feminist thinkers who are seeking alternative models of female subjectivity which can unite 'woman' with women (what she terms 'real-life women'), provide a forum for criticism and change and not nullify difference in the process. The points she makes in 'The Politics of Ontological Difference' are precisely the problematics involved in developing adequate strategies by which to reinvestigate the self-portraits of women artists. Her notion of the 'embodied subject' (which she shares with other authors such as Elizabeth Grosz and Donna Haraway, for example) is a powerful model through which to work out both the difficulties and the potentialities involved in this work.

The significance of the lived experiences of women in new forms of representation and thought is the first thing to which Braidotti addresses herself:

The starting point, however, remains the political will to assert the specificity of the lived, female bodily experience, the refusal to disembody sexual difference into a new, allegedly postmodern, anti-essentialist subject, and the will to reconnect the whole debate on difference to the bodily existence and experience of women ... one should start politically with the assertion of the need for the presence of real-life women in positions of discursive subjecthood, and theoretically with the recognition of the primacy of the bodily roots of subjectivity, rejecting both the traditional vision of the subject as universal, neutral or gender-free and the binary logic that sustains it.[3]

What is at stake in the acknowledgement of the embodied subject is both the refusal to accept the traditional masculine subject as transcendent and the refusal to eliminate the subject altogether. As discussed in relationship to autobiography earlier in this book, it is imperative to rewrite traditions of autobiography and self-portraiture which have made masculine representations appear to be universal norms. If these are not challenged, no space can be opened up for marginalised voices to be heard. However, the postmodern critiques of authorship which evacuate the 'real' person from the 'speaking subject' position entirely, disempower marginalised groups in different ways. It is not sufficient to discuss representations of 'woman' without reference to the gendered positions of their producers. Being a woman artist is different from being a male artist; people are produced as subjects through representation *and* they produce representations. It is still necessary to stage critical interventions into art practice and interpretation which acknowledge gender difference.

There are two important tensions brought out by such a theoretical position: first, the definition of 'woman' as social and biological; second, the struggle to understand both commonalities and differences between women. Each of these tensions has repercussions for notions of women's self-portraiture and the methods used in this text to approach the images. As Braidotti wrote:

One is both born and constructed as a *Woman*/'woman'; the fact of being a woman is neither merely biological nor solely historical, and the polemical edge of the debate should not, in my opinion, go on being polarized in either of these ways ... 'I, woman' am affected directly and in my everyday life by what has been made by the subject of '*Woman*'; I have paid in my very body for all the metaphors and images that our culture has deemed fit to produce of '*Woman*' ... This is why 'I, woman' shall not relinquish easily the game of representation of woman, nor shall I loosen the tie between the symbolic or discursive and the bodily or material.[4]

The body is the site at which the social and the biological/psychological meet. It is not just a natural 'given', but a constructed web of meanings and subject positions. Crucially, it is always both biology and history which define 'woman' and their effects are produced within and through systems of representation. For women producing self-portraits, these ideas are highly significant. This is where the link between lived experience as 'women' and the visual language which constructs 'woman' meet. In the discussions of the preceding chapters, it was intended to strike a balance between woman and women in interpretative terms. It is my assertion that it is significant that these women artists came into representation in so many forms and within so many different contexts precisely because the instances of self-representation can act as places in which woman and women coincide. Representation, in visual, verbal and political terms, constructs the experiences of women, and their voice in the discursive arena is necessary if these forms are to change. If, as Braidotti argues, 'The "body" in question is the threshold of subjectivity; it is to be thought of as the point of intersection, as the interface between the biological and the social', then the body of woman is also the threshold of representation and representability.

The problematic of asserting a powerful model of female subjectivity without essentialising 'woman' or homogenising 'women' is also of significance in the development of reading strategies for this body of work. What must be maintained is a dual sense of the concept of difference in feminist criticism. Difference must signify both women's

difference from men and the differences between women based on variables such as race, class, age and sexual orientation. Embodied subjectivity permits just such a subtle use of the concept of difference to become operative. When 'woman' is understood to be a web of interconnected social and biological definitions, it becomes possible to maintain both women's relationships to one another and the subtle inflections of difference between them in a critical analysis. Furthermore, the model of embodied subjectivity pertains also to the reader/viewer who is empowered in and accountable for her interpretative strategies.

Such a dual sense of difference was operating in this work. Arguments for strategies which women developed in order to assert their position as artists in opposition to masculine paradigms were made while the particular contexts in which individual women employed such strategies were described. Common points between women concerned the overriding issues of gender difference and representability, of 'femininity' and techniques of mimicry, masquerade and excess. The position of woman as other to man and of 'woman artist' as other to 'male artist' produced certain strands of representational interventions on the part of women artists. However, they were not argued to have existed or produced work outside of history, in a transcendent time or place. Rather, the particular features of individual works attest to the highly specific contexts in which they were produced.

Overall, then, this book is meant to be a sustained and engaged enquiry into the issues raised by the numerous and various self-portraits which have been produced in the twentieth century by women artists. The very nature of female subjectivity and the role played by representation and discursive authority in this are at stake in such a work. By no means is this meant to be the last word on the subject. The topic is vast and there is much room for debate and further exploration; the nature of this work invites just such intervention. It is imperative that feminist critics, art historians and theorists continue to engage in active dialogues with work produced by women in order to open up the discursive arena to new voices and new ideas. Women have been coming into representation for a very long time, but we have not had the means by which to understand them.

Notes

Introduction

1. A. Benjamin, 'Interpreting Reflections: Painting Mirrors', in *Art, Mimesis and the Avant-garde: Aspects of a Philosophy of Difference* (London: Routledge, 1991), pp. 7–41.

2. J. Lacan, 'The Mirror Stage as Formative of the Function of the I', in *Ecrits: A Selection*, trans. A. Sheridan (London: Routledge and Kegan Paul, 1977), pp. 1–8.

3. V. Woolf, *A Room of One's Own* (1929), ed. and introduced M. Barrett (Harmondsworth: Penguin, 1993), p. 32.

4. S. de Beauvoir, *The Second Sex* (1949), trans. and ed. H.M. Parshley (London: Pan, 1988), pp. 642–3.

5. E. Grosz, *Sexual Subversions: Three French Feminists* (Sydney: Allen and Unwin, 1989), pp. 130–1.

6. D. Haraway, 'Situated Knowledges: The Science Question in Feminism and the Privilege of Partial Perspective', in Haraway, *Simians, Cyborgs and Women: The Reinvention of Nature* (London: Free Association Books, 1991), pp. 183–202. Haraway was indebted to S. Harding and E. Fox Keller for the terminology 'situated knowledges'.

1: The Myth of the Artist

1. J. Reynolds, *Discourses on Art*, ed. R. Wark (New Haven, CT: Yale University Press, 1975), pp. 291, 309–10.

2. De Beauvoir, *The Second Sex*, p. 722.

3. For a detailed discussion of the art market politics of modernism see R. Jensen, *Marketing Modernism in Fin-de-siècle Europe* (Princeton, NJ: Princeton University Press, 1993), especially chapter 1, 'This Painting Sells'.

4. C. Duncan, 'Virility and Domination in Early Twentieth-century Vanguard Painting', in N. Broude and M. Garrard (eds), *Feminism and Art History: Questioning the Litany* (New York: Harper and Row, 1982), pp. 293–314, pp. 311–12.

5. M. Foucault, 'What Is an Author?' (1969), in C. Harrison and P. Wood (eds), *Art in Theory: An Anthology of Changing Ideas* (Oxford: Basil Blackwell, 1992), pp. 923–8, p. 927.

6. C. Battersby, *Gender and Genius: Towards a Feminist Aesthetics* (London: Women's Press, 1989), p. 14.

7. Ibid., p. 103.

8. Ibid., p. 113, and G. Pollock, *Vision and Difference: Femininity, Feminism and the Histories of Art* (London: Routledge, 1988), p. 11.

9. J. Wayne, 'The Male Artist as a Stereotypical Female', in J. Loeb (ed.), *Feminist Collage: Educating Women in the Visual Arts* (New York: Teacher's College Press, 1979), pp. 130–47.

10. I. Rogoff, 'The Anxious Artist – Ideological Mobilisations of the Self in German Modernism', in Rogoff (ed.), *The Divided Heritage* (Cambridge: Cambridge University Press, 1991), pp. 116–47.

11. Ibid., pp. 116–17.

12. E. Feldman, *The Artist* (Englewood Cliffs, NJ: Prentice-Hall, 1982), p. 121.

13. J. Lloyd, *German Expressionism: Primitivism and Modernity* (New Haven, CT: Yale University Press, 1991), chapter 3.

14. Dix painted a whole series of named prostitutes during the 1920s, such as *Elsa the Countess*; Picasso's 'watershed' painting *Les Desmoiselles d'Avignon* (1907) is a brothel scene.

15. C. Mann, *Modigliani* (London: Thames and Hudson, 1980), p. 159.

16. *Otto Dix: 1891–1969*, exhibition catalogue (London: Tate Gallery, 1992), p. 126.

17. R. Ferguson, 'Introduction: Invisible Center', in R. Ferguson et al. (eds.), *Out There: Marginalization and Contemporary Cultures* (Cambridge, MA: MIT Press, 1990), pp. 9–18, p. 9.

18. N. Hamnett, *The Laughing Torso* (New York: Richard Long and Richard R. Smith, 1932).

19. L. Tickner, 'The Body Politic: Female Sexuality and Women Artists since 1970' (1978), in R. Betterton (ed.), *Looking On: Images of Femininity in the Visual Arts and Media* (London: Pandora Press, 1987), pp. 235–53.

20. See R. Krauss, *The Originality of the Avant-garde and Other Modernist Myths* (Cambridge, MA: MIT Press, 1985).

21. E. Cowling, '"Proudly We Claim Him as One of Us": Breton, Picasso and the Surrealist Movement', *Art History*, vol. 8, no. 1 (March 1985), pp. 82–104.

22. H. Richter, *Dada: Art and Anti-art* (London: Thames and Hudson, 1965), p. 132.

23. M. Lavin, *Cut with the Kitchen Knife: The Weimar Photomontages of Hannah Höch* (New Haven, CT: Yale University Press, 1993), p. 5. Besides being an excellent text, this volume is lavishly illustrated with Höch's works.

24. W. Chadwick, *Women Artists and the Surrealist Movement* (London: Thames and Hudson, 1985), p. 11.

25. G. Griffin, 'Becoming as Being: Leonora Carrington's Writings and Paintings 1937–40', in Griffin, *'Difference in View': Women and Modernism* (London: Taylor and Francis, 1994), pp. 92–107, p. 98.

26. G. Apollinaire (1908), cited in S. Waller (ed.), *Women Artists in the Modern Era: A Documentary History* (Metuchen, NJ and London: Scarecrow Press, 1991), pp. 303–4, p. 303.

27. M. Hartley (1921) cited in ibid., p. 313.

28. M. Laurencin, cited in ibid., p. 305.

29. Ibid., p. 307.

30. R. Berger (ed.), *'Und ich sehe nichts, nichts als die Malerei': Autobiographische Texte von Künstlerinnen des 18.–20. Jahrhunderts* (Frankfurt am Main: Fischer Taschenbuch Verlag, 1987), p. 297; my translation unless otherwise indicated.

31. E. Billeter, 'Das Selbstporträt als Selbstschutz', in Billeter (ed.), *Das Selbstporträt im Zeitalter der Photographie: Maler und Photographer im Dialog mit sich Selbst*, exhibition catalogue (Bern: Benteli, 1985), pp. 46–58.

32. J.K. Brodsky, 'Exhibitions, Galleries and Alternative Spaces', in N. Broude and M. Garrard (eds), *The Power of Feminist Art* (London: Thames and Hudson, 1994), pp. 104–19, pp. 108–9.

33. J.E. Stein, 'Collaboration', in Broude and Garrard (eds), *The Power of Feminist Art*, pp. 226–47, p. 230.

34. A. Raven, *Crossing Over: Feminism and Art of Social Concern* (Ann Arbor, MI: University of Michigan Press, 1988), p. 49.

35. Ibid., pp. 47–8.

36. Berger, '*Und ich sehe nichts, nichts als die Malerei*', p. 281.

37. C. Stroude, *Lotte Laserstein: Paintings and Drawings from Germany and Sweden, 1920–1970*, exhibition catalogue (London: Agnew and Belgrave Galleries, 1987), p. 3.

2: The Autobiographical Model

1. For a general discussion of less traditional histories, see the introduction to the section 'History', in R. Warhol and D. Herndl (eds), *Feminisms: An Anthology of Literary Theory and Criticism* (New Brunswick, NJ: Rutgers University Press, 1991), pp. 761–4.

2. R. Parker and G. Pollock, *Old Mistresses: Women, Art and Ideology* (London: Routledge and Kegan Paul, 1981).

3. J. Rosenberg, *Rembrandt: Life and Work* (London: Phaidon, 1948), p. 37.

4. Ibid., p. 47.

5. L. Bruhns, *Deutsche Künstler in Selbstdarstellung* (Königstein in Taunus und Leipzig, 1936), p. 6; my translation.

6. F. Ried, *Das Selbstbildnis* (Berlin: Die Buchmeinde, 1931), p. 9; my translation.

7. C. White, 'About Face', *Omnibus*, BBC (1994).

8. S. Smith and J. Watson (eds), *De/Colonizing the Subject: The Politics of Gender in Women's Autobiography* (Minneapolis: University of Minnesota Press, 1992), pp. xvii, xviii.

9. C. Kaplan, 'Resisting Autobiography: Out-law Genres and Transnational Feminist Subjects', in Smith and Watson (ed), *De/Colonizing the Subject*, pp. 115–38, p. 115.

10. R. Barthes, 'The Death of the Author' (1968), reprinted in D. Lodge (ed.), *Modern Criticism and Theory: A Reader* (Harlow and New York: Longman, 1988), pp. 167–72.

11. M. Foucault, 'What Is an Author?' (1969), in Harrison and Wood (eds), *Art in Theory*, pp. 923–8.

12. T. Modleski, *Feminism without Women: Culture and Criticism in a 'Postfeminist' Age* (London: Routledge, 1991), p. 15.

13. L.S. Klinger, 'Where's the Artist? Feminist Practice and Poststructural Theories of Authorship', *Art Journal*, vol. 50, no. 2 (summer 1991), pp. 39–47, p. 39.

14. Smith and Watson (eds), *De/Colonizing the Subject*.

15. R. Braidotti, *Nomadic Subjects: Embodiment and Sexual Difference in Contemporary Feminist Theory* (New York: Columbia University Press, 1994), p. 1

16. A.S. Harris and L. Nochlin, *Women Artists 1550–1950*, exhibition catalogue (Los Angeles: Los Angeles Museum of Art, 1976), p. 336.

17. H. Herrera, *Frida: A Biography of Frida Kahlo* (London: Bloomsbury, 1989), p. 278. This text is lavishly illustrated for those interested in seeing the range of self-portraits Kahlo produced.

18. Ibid., p. 279.

19. Herrera uses it thus: 'The Frida Diego no longer loves wears a white Victorian dress' (ibid., p. 278) and Chadwick repeats it in *Women Artists and the Surrealist Movement*.

20. H. and G. Reinhardt, 'Grethe Jürgens – Künstlerin der Neuen Sachlichkeit', *Artis*, 2 (February 1981), pp. 12–13, p. 12; my translation.

21. J. Spence, 'Disrupting the Silence: The Daughter's Story', *Women Artists Slide Library Journal*, no. 29 (June, July 1989), pp. 14–17, pp. 14–15.

22. R. Krauss, *Cindy Sherman 1975–1993* (Milan: Rizzoli, 1993), p. 42.

23. M. Favorite, 'Portrait of Self Contemplating Self: The Narrative of a Black Female Artist', *SAGE*, vol. IV, no. 1 (spring 1987), pp. 39–40, p. 40.

24. R. Bernstein, 'Marisol's Self Portraits: The Dream and the Dreamers', *Arts Magazine*, vol. 59, pt. 7 (1985), pp. 86–9, p. 86.

25. I am indebted to Helen Chapman for both discussing this issue with me and allowing me to read her unpublished PhD thesis, 'The Tragedy of Philosophy: The Philosophy of Tragedy' (Warwick University, 1992).

26. L. Irigaray, 'The Power of Discourse and the Subordination of the Feminine', in Irigaray, *This Sex Which Is Not One* (1977), trans. C. Porter with C. Burke (Ithaca, NY: Cornell University Press, 1985), p. 124.

27. Hiller, cited in G. Brett, 'Singular and Plural', in G. Brett, R. Parker and J. Roberts, *Susan Hiller 1973–1983: The Muse My Sister* (Londonderry: Orchard Gallery, 1984), pp. 5–18, p. 14.

3: Women's Self-portraiture Explorations of the Body

1. See, for example, M. Foucault, *The History of Sexuality*, vol. 1 (An Introduction) (1976), trans. R. Hurley (Harmondsworth: Penguin, 1978), p. 104; and S. Freud, 'Femininity' (1933), trans. James Strachey, in *New Introductory Lectures on Psychoanalysis*, vol. 2 (Harmondsworth: Penguin, 1983), pp. 145–69.

2. L. Irigaray, 'Women's Discourse and Men's Discourse', in Irigaray, *Je, Tu, Nous: Toward a Culture of Difference*, trans. A. Martin (London: Routledge, 1993), pp. 29–36, p. 32.

3. J. Lacan, 'The Mirror Stage as Formative of the Function of the I', in Lacan, *Ecrits*, pp. 1–8.

4. L. Mulvey, 'Visual Pleasure and Narrative Cinema' (1975), in Harrison and Wood (eds), *Art in Theory*, pp. 963–70; G. Pollock, 'Woman as Sign: Psychoanalytic Readings', in Pollock, *Vision and Difference*, pp. 120–54.

5. H. Lasalle and A. Solomon-Godeau, 'Surrealist Confession: Claude Cahun's Photomontages', *Afterimage*, vol. 19, pt. 8 (1992), pp. 10–13, p. 12.

6. J. Tenneson Cohen, *In/Sights: Self Portraits by Women* (London: Gordon Fraser, 1979), p. 131.

7. A. Pasternak, 'Annie Sprinkle', *JCA*, vol. 5, pt. 2 (1992), pp. 100–13, p. 109.

8. A. Jones, 'Introduction', in Pat Booth, *Self Portrait* (London, Melbourne and New York: Quartet Books, 1983), no page numbers.

9. For a whole gamut of parodies as well as reinterpretations of masculinity in women's art, see S. Kent and J. Morreau (eds), *Women's Images of Men* (London: Pandora Press, 1985).

10. Paula Modersohn-Becker even thought up a name for her 'masculine' teacher Jeanna Bauck: *'ruppig-struppig'*, which, roughly translated, means 'shaggy-baggy'. Cited in E.C. Oppler, 'Paula Modersohn-Becker: Some Facts and Some Legends', *Art Journal*, vol. xxxv, no. 4 (summer 1976), pp. 364–9, p. 366.

11. M. Bakhtin, 'The Grotesque Image of the Body and its Sources' (1968), trans. H. Iswolsky, in S. Dentith, *Bakhtinian Thought* (London: Routledge, 1995), pp. 225–53.

12. D. Bauer, 'Gender in Bakhtin's Carnival' (1988), in Warhol and Herndl (eds), *Feminisms*, pp. 671–84.

13. M.A. Doane, 'Film and the Masquerade: Theorising the Female Spectator', *Screen*, vol. 23, no. 3/4 (September/October 1982), pp. 74–88, pp. 81–2.

14. N. Spector, 'Rock My Video', *Frieze*, no. 20 (January/February 1995), pp. 44–5.

15. Lavin, *Cut with the Kitchen Knife*, p. 35.

16. The best general introduction to the development of the concept of 'cyber-feminism' is Haraway, *Simians, Cyborgs and Women*.

17. E. Ranfft, 'German Women Sculptors 1918–1936: Gender Differences and Status', in M. Meskimmon and S. West (eds), *Visions of the Neue Frau: Women and the Visual Arts in the Weimar Republic* (Aldershot: Scolar Press, 1995), pp. 42–61.

18. See the photograph of Sintenis in *Eldorado: Homosexuelle Frauen und Männer in Berlin 1850–1950, Geschichte, Alltag und Kultur*, exhibition catalogue (Berlin: Berlin Museum, 1984), pp. 115.

19. M. Wittig, 'The Straight Mind' (1980), in Wittig, *The Straight Mind and Other Essays*, trans. M. Wildeman (Hemel Hempstead: Harvester Wheatsheaf, 1992), pp. 21–32.

20. Nonne-Schmidt's full discussion of 'femininity' can be found in Waller (ed.), *Women Artists in the Modern Era*, pp. 332–5.

21. R. Belton, 'Androgyny: Interview with Meret Oppenheim', in M. Caws et al. (eds), *Surrealism and Women* (Cambridge, MA: MIT Press, 1991), pp. 63–75, p. 69.

22. Freud, 'Femininity', pp. 160–3; M. Sarup, *An Introductory Guide to Post-structuralism and Postmodernism* (Hemel Hempstead: Harvester Wheatsheaf, 1993), p. 126.

23. S. Jackson, J. Prince and P. Young, 'Introduction' (to section on 'Science, Medicine and Reproductive Technology'), in Jackson et al. (eds), *Women's Studies: A Reader* (Hemel Hempstead: Harvester Wheatsheaf, 1993), p. 365.

24. S. Stanford Friedman, 'Creativity and the Childbirth Metaphor: Gender Difference in Literary Discourse' (1987), in Warhol and Herndl (eds), *Feminisms*, pp. 371–403.

25. R. Betterton, 'Die Darstellung des Mütterlichen: Der Weibliche Akt im Werk deutscher Künstlerinnen um die Jahrhundertwende', in *Profession ohne Tradition: 125 Jahre verein der Berliner Künstlerinnen*, exhibition catalogue (Berlin: Berlinische Galerie, 1992), pp. 89–104.

26. See for example, L. Irigaray, 'How Old Are You?', in Irigaray, *Je, Tu, Nous*, pp. 45–50.

27. J. Spence and R. Martin, 'Phototherapy: Psychic Realism as Healing Art?' (1988), in Spence, *Cultural Sniping: The Art of Transgression* (London: Routledge, 1995), pp. 164–80, p. 170.

28. *Identity/Identities: An Exploration of the Concept of Female Identity in Contemporary Society*, exhibition catalogue (Winnipeg: Winnipeg Art Gallery, 1988), p. 10.

29. L. Irigaray, 'How Can We Create Our Beauty?', in Irigaray, *Je, Tu, Nous*, pp. 107–12.

4: The Body Politic

1. S. Bourque and J. Grossholtz, 'Politics an Unnatural Practice' in J. Siltanen and M. Stanworth (eds), *Women and the Public Sphere: A Critique of Sociology and Politics* (London: Hutchinson, 1984), pp. 103–21, p. 104.

2. A. Young, 'Body/Politics: Our Bodies Triumphed', in Jackson et al. (eds), *Women's Studies: A Reader*, pp. 354–9, p. 359.

3. M. Meskimmon, 'Politics, The Neue Sachlichkeit and Women Artists', in Meskimmon and West (eds), *Visions of the Neue Frau*, pp. 9–27.

4. W. Benjamin, 'The Work of Art in the Age of Mechanical Reproduction' (1936), in Harrison and Wood (eds), *Art in Theory*, pp. 512–20.

5. H. Dorrough, 'Self Portraits: Recent Work by Heather Dorrough', *Craft Australia*, pt. 4 (1982), pp. 30–7, p. 36. This article is fully illustrated by Dorrough's series.

6. Ibid., p. 30.

7. See, for example, O. Schreiner, 'Woman and Labour' (1911), in M. Humm (ed.), *Feminisms: A Reader* (Hemel Hempstead: Harvester Wheatsheaf, 1992), pp. 18–20.

8. U. Frevert, *Women in German History: From Bourgeois Emancipation to Sexual Liberation* (Oxford: Berg, 1989), p. 185.

9. M. Meskimmon, *Domesticity and Dissent: The Role of Women Artists in Germany 1918–1938*, exhibition catalogue (Leicester: Leicestershire Museum, Arts and Records Service, 1992).

10. This work has been reprinted in *Marta Hegemann: Leben und Werk*, exhibition catalogue (Cologne: Kölnisches Stadtmuseum, 1989).

11. Erika Esau discussed the Hegemann–Räderscheidt situation in 'The *Künstlerehepaar*: Ideal and Reality', in Meskimmon and West (eds), *Visions of the Neue Frau*, pp. 28–41.

12. See for example, L. Althusser, 'Ideology and Ideological State Apparatuses', in Harrison and Wood (eds), *Art in Theory*, pp. 928–36; and J. Kristeva, *Desire in Language: A Semiotic Approach to Literature and Art*, trans. T. Gora, A. Jardine and L. Roudiez (Oxford: Basil Blackwell, 1981).

13. Foucault, *The History of Sexuality*, vol. 1, p. 104.

14. D. Leland, 'Lacanian Psychoanalysis and French Feminism: Toward an Adequate Political Psychology', in N. Fraser and S. Bartky (eds), *Revaluing French Feminism: Critical Essays on Difference, Agency and Culture* (Bloomington and Indianapolis: Indiana University Press, 1992), pp. 113–35, p. 119.

15. L. Jordanova, 'Natural Facts: An Historical Perspective on Science and Sexuality', in Jackson et al. (eds), *Women's Studies*, pp. 374–8.

16. L. Nead, *The Female Nude: Art, Obscenity and Sexuality* (London: Routledge, 1992), p. 21.

17. For a very good overview of these issues, see 'Science, Medicine and Reproductive Technology', in Jackson et al. (eds), *Women's Studies*, section 11, pp. 361–400.

18. J. Spence, 'The Picture of Health, Part Three' (1986), in Spence, *Cultural Sniping*, pp. 113–23, pp. 116, 122.

19. M. Duffy, 'Disability, Differentness, Identity', *Circa*, no. 34 (May/June 1987), pp. 30–1.

20. K. Augustine in C. Kelly (ed.), *Forbidden Subjects: Self Portraits by Lesbian Artists* (Vancouver: Gallerie Publications, 1992), p. 61.

21. For work on this, see D. Scully, 'Understanding Sexual Violence', in Jackson et al. (eds), *Women's Studies*, pp. 234–6.

22. See the detailed discussion of this exhibition in Raven, *Crossing Over*.

23. J. Hurrell, 'The Vacillating Personas of Margaret Dawson', *Art New Zealand*, no. 47 (winter 1988), pp. 68–71, p. 70.

24. L. Himid, 'We Will Be', in Betterton (ed.), *Looking On*, pp. 259–66, pp. 265–6.

25. C. Johnson, 'Issues Surrounding the Representation of the Naked Body of a Woman', *Feminist Arts News*, vol. 3, no. 8, pp. 12–14, p. 12.

26. C. Burman, in *The Circular Dance*, exhibition catalogue (Bristol: Arnolfini, 1992), p. 17.

27. R. Kempadoo, 'Identity in Production', in M. Sulter (ed.), *Passion: Discourses on Blackwomen's Creativity* (Hebden Bridge: Urban Fox Press, 1990), pp. 208–13.

Conclusions: Reflecting on the Future

1. H. Chadwick, in H. Chadwick, and M. Warner, *Enfleshings: Helen Chadwick* (London: Secker and Warburg, 1989), p. 29.

2. Ibid.

3. Braidotti, *Nomadic Subjects*, pp. 174–5.

4. Ibid., p. 187.

Selected Bibliography

General Sources

Battersby, C. *Gender and Genius: Towards a Feminist Aesthetics* (London: Women's Press, 1989).

Beauvoir, S. de. *The Second Sex* (1949), trans. and ed. H.M. Parshley (London: Pan, 1988).

Benjamin, A. *Art, Mimesis and the Avant-garde: Aspects of a Philosophy of Difference* (London: Routledge, 1991).

Berger, R. (ed.). *'Und ich sehe nichts, nichts als die Malerei': Autobiographische Texte von Künstlerinnen des 18.–20. Jahrhunderts* (Frankfurt am Main: Fischer Taschenbuch Verlag, 1987).

Betterton, R. (ed.). *Looking On: Images of Femininity in the Visual Arts and Media* (London: Pandora Press, 1987).

Billeter, E. (ed.). *Das Selbstporträt im Zeitalter der Photographie: Maler und Photographer im Dialog mit sich Selbst*, exhibition catalogue (Bern: Benteli, 1985).

Braidotti, R. *Nomadic Subjects: Embodiment and Sexual Difference in Contemporary Feminist Theory* (New York: Columbia University Press, 1994).

Broude, N. and Garrard M. (eds). *Feminism and Art History: Questioning the Litany* (New York: Harper and Row, 1982).

— (eds). *The Power of Feminist Art* (London: Thames and Hudson, 1994).

Bruhns, L. *Deutsche Künstler in Selbstdarstellung* (Königstein in Taunus und Leipzig, 1936).

Butler, S. 'So, How Do I Look? Women before and behind the Camera', *Photo Communique*, vol. 9, pt. 3 (1987), pp. 24–35.

Caws, M., et al. (eds). *Surrealism and Women* (Cambridge, MA: MIT Press, 1991).

Chadwick, W. *Women Artists and the Surrealist Movement* (London: Thames and Hudson, 1985)

—. *Women, Art and Society* (London: Thames and Hudson, 1990).

Chambers, E. and Joseph, T. *The Artpack: A History of Black Artists in Britain* (Norfolk: Thetford Press, 1988).

Chapman, H. 'The Tragedy of Philosophy: The Philosophy of Tragedy', unpublished PhD thesis (Warwick University, 1992).

The Circular Dance, exhibition catalogue (Bristol: Arnolfini, 1992).

Cohen, J.T. *In/Sights: Self Portraits by Women* (London: Gordon Fraser, 1979).

Collins, P. *Black Feminist Thought: Knowledge, Consciousness and the Politics of Empowerment* (London: Routledge, 1990).

Cowling, E. '"Proudly We Claim Him as One of Us": Breton, Picasso and the Surrealist Movement', *Art History*, vol. 8, no. 1 (March 1985), pp. 82–104.

Creed, B. *The Monstrous-Feminine: Film, Feminism, Psychoanalysis* (London: Routledge, 1993).

Dentith, S. *Bakhtinian Thought* (London: Routledge, 1995).

Derrida, J. *Memoirs of the Blind: The Self-Portrait and Other Ruins* (Chicago: University of Chicago Press, 1993).

Doane, M.A. 'Film and the Masquerade: Theorising the Female Spectator', *Screen*, vol. 23, no. 3/4 (September/October 1982), pp. 74–88.

Ecker, G. (ed.). *Feminist Aesthetics*, trans. H. Anderson (London: Women's Press, 1985).

Eiblmayer, S., Export, V. and Prischl-Mayer, M. (eds). *Kunst mit Eigen-Sinn: Aktuelle Kunst von Frauen* (Vienna and Munich: Löcker Verlag, 1985).

Eldorado: Homosexuelle Frauen und Männer in Berlin 1850–1950, Geschichte, Alltag und Kultur, exhibition catalogue (Berlin: Berlin Museum, 1984).

Feldman, E. *The Artist* (Englewood Cliffs, NJ: Prentice-Hall, 1982).

Felman, S. *What Does a Woman Want?: Reading and Sexual Difference*, (Baltimore, MD: Johns Hopkins University Press, 1993).

Ferguson, R., et al. (eds). *Out There: Marginalization and Contemporary Cultures* (Cambridge, MA: MIT Press, 1990).

Foucault, M. *The History of Sexuality*, vol. 1 (An Introduction), (1976), trans. R. Hurley (Harmondsworth: Penguin, 1978).

Fraser, J. and Boffin, T. (eds). *Stolen Glances – Lesbians Take Photographs* (London: Pandora Press, 1991).

Fraser, N. and Bartky, S. (eds). *Revaluing French Feminism: Critical Essays on Difference, Agency and Culture* (Bloomington and Indianapolis: Indiana University Press, 1992).

Frauen Museum (eds). *Neue Selbstbildnisse von Frauen* (Bonn: Frauen Museum, 1987).

Frauen sehen sich Selbst: Selbstbildnisse von Künstlerinnen der Gegenwart, exhibition catalogue (Hamburg: GEDOK, 1979).

Freud, S. 'Femininity' (1933), trans. J. Strachey, in *New Introductory Lectures on Psychoanalysis*, vol. 2 (Harmondsworth: Penguin, 1983).

Frevert, U. *Women in German History: From Bourgeois Emancipation to Sexual Liberation* (Oxford: Berg, 1989).

Griffin, G. *'Difference in View': Women and Modernism* (London: Taylor and Francis, 1994).

Grosz, E. *Sexual Subversions: Three French Feminists* (Sydney: Allen and Unwin, 1989).

Haraway, D. *Simians, Cyborgs and Women: The Reinvention of Nature* (London: Free Association Books, 1991).

Harris, A.S. and Nochlin, L. *Women Artists 1550–1950*, exhibition catalogue (Los Angeles: Los Angeles Museum of Art, 1976).

Harrison, C. and Wood, P. (eds). *Art in Theory: An Anthology of Changing Ideas* (Oxford: Basil Blackwell, 1992).

Humm, M. (ed.). *Feminisms: A Reader* (Hemel Hempstead: Harvester Wheatsheaf, 1992).

Identity/Identities: An Exploration of the Concept of Female Identity in Contemporary Society, exhibition catalogue (Winnipeg: Winnipeg Art Gallery, 1988).

Irigaray, L. *This Sex Which Is Not One* (1977), trans. C. Porter with C. Burke (Ithaca, NY: Cornell University Press, 1985).

—. *Je, Tu, Nous: Toward a Culture of Difference*, trans. A. Martin (London, Routledge, 1993).

Jackson, S., et al. (eds). *Women's Studies: A Reader* (Hemel Hempstead: Harvester Wheatsheaf, 1993).

Jensen, R. *Marketing Modernism in Fin-de-siècle Europe* (Princeton, NJ: Princeton University Press, 1993).

Johnson, C. 'Issues Surrounding the Representation of the Naked Body of a Woman', *Feminist Arts News*, vol. 3, no. 8, pp. 12–14.

Kelly, C. (ed.). *Forbidden Subjects: Self Portraits by Lesbian Artists* (Vancouver: Gallerie Publications, 1992).

Kent, S. and Morreau, J. (eds). *Women's Images of Men* (London: Pandora Press, 1985).

Klinger, L.S. 'Where's the Artist? Feminist Practice and Poststructural Theories of Authorship', *Art Journal*, vol. 50, no. 2 (summer 1991), pp. 39–47.

Kourany, J.A., Sterba, J., and Tong, R. (eds). *Feminist Philosophies: Problems, Theories and Applications* (Hemel Hempstead: Harvester Wheatsheaf, 1993).

Krauss, R. *The Originality of the Avant-garde and Other Modernist Myths* (Cambridge, MA: MIT Press, 1985).

Kristeva, J. *Desire in Language: A Semiotic Approach to Literature and Art*, trans. T. Gora, A. Jardine and L. Roudiez (Oxford: Basil Blackwell, 1981).

Kuhn, A. *Women's Pictures: Feminism and Cinema* (London: Pandora Press, 1982).

Künstlerinnen des 20. Jahrhunderts, exhibition catalogue (Wiesbaden: Museum Wiesbaden, 1990).

Lacan, J. *Ecrits: A Selection*, trans. A. Sheridan (London: Routledge and Kegan Paul, 1977).

Lloyd, J. *German Expressionism: Primitivism and Modernity* (New Haven, CT: Yale University Press, 1991).

Lodge, D. (eds). *Modern Criticism and Theory: A Reader* (Harlow and New York: Longman, 1988).

Loeb, J. (ed.). *Feminist Collage: Educating Women in the Visual Arts* (New York: Teacher's College Press, 1979).

Lyczywek, K. 'Does Photographic Autobiography Exist?', *Projekt*, pt. 3 (1991), pp. 32–5.

Mann, C. *Modigliani* (London: Thames and Hudson, 1980).

Meskimmon, M. *Domesticity and Dissent: The Role of Women Artists in Germany 1918–1938*, exhibition catalogue (Leicester: Leicestershire Museum, Arts and Records Service, 1992).

Meskimmon, M. and West, S. (eds). *Visions of the Neue Frau: Women and the Visual Arts in the Weimar Republic* (Aldershot: Scolar Press, 1995).

Modleski, T. *Feminism without Women: Culture and Criticism in a 'Postfeminist' Age* (London: Routledge, 1991).

Moi, T. *The Kristeva Reader* (Oxford: Basil Blackwell, 1986).

Moutoussamy-Ashe, J. *Viewfinders: Black Women Photographers* (New York: Dodd, Mead, 1986).

Nead, L. *The Female Nude: Art, Obscenity and Sexuality* (London: Routledge, 1992).

Otto Dix: 1891–1969, exhibition catalogue (London: Tate Gallery, 1992).

Parker, R. and Pollock, G. *Old Mistresses: Women, Art and Ideology* (London: Routledge and Kegan Paul, 1981).

Patemann, C. and Gross, E. (eds). *Feminist Challenges: Social and Political Theory* (Sydney, London and Boston: Allen and Unwin, 1986).

Pollock, G. *Vision and Difference: Femininity, Feminism and the Histories of Art* (London: Routledge, 1988).

Profession ohne Tradition: 125 Jahre verein der Berliner Künstlerinnen, exhibition catalogue (Berlin: Berlinische Galerie, 1992).

Raven, A. *Crossing Over: Feminism and Art of Social Concern* (Ann Arbor, MI: University of Michigan Press, 1988).

Reflections: Woman's Self-image in Contemporary Photography, exhibition catalogue (Oxford, OH: Miami University Art Museum, 1988).

Reynolds, J. *Discourses on Art*, ed. R. Wark (New Haven, CT: Yale University Press, 1975).

Richter, H. *Dada: Art and Anti-art* (London: Thames and Hudson, 1965).

Ried, F. *Das Selbstbildnis* (Berlin: Die Buchmeinde, 1931).

Rogoff, I. (ed.). *The Divided Heritage* (Cambridge: Cambridge University Press, 1991).

Rosenberg, J. *Rembrandt: Life and Work* (London: Phaidon, 1948).

Sarup, M. *An Introductory Guide to Post-structuralism and Postmodernism* (Hemel Hempstead: Harvester Wheatsheaf, 1993).

Siltanen, J. and Stanworth, M. (eds). *Women and the Public Sphere: A Critique of Sociology and Politics* (London: Hutchinson, 1984).

Sischy, I. 'Self-portraits in Photography', *Print Collector's Newsletter*, vol. 10, no. 6 (January/February 1980), pp. 189–92.

Smith, S. *Subjectivity, Identity and the Body: Women's Autobiographical Practices in the Twentieth Century* (Bloomington: Indiana University Press, 1993).

Smith, S. and Watson, J. (eds). *De/Colonizing the Subject: The Politics of Gender in Women's Autobiography* (Minneapolis: University of Minnesota Press, 1992).

Spector, N. 'Rock My Video', *Frieze*, no. 20 (January/February 1995), pp. 44–5.

Spence, J. and Solomon, J. (eds). *What Can a Woman Do with a Camera?* (London: Scarlet Press, 1995).

Steedman, C. *Past Tenses: Essays on Writing, Autobiography and History* (London: Rivers Oram Press, 1992).

Suleiman, S. *Subversive Intent: Gender, Politics and the Avant-garde* (Cambridge, MA: Harvard University Press, 1990).

Sulter, M. (ed.). *Passion: Discourses on Blackwomen's Creativity* (Hebden Bridge: Urban Fox Press, 1990).

Waller, S. (ed.). *Women Artists in the Modern Era: A Documentary History* (Metuchen, NJ and London: Scarecrow Press, 1991).

Warhol, R. and Herndl, D. (eds). *Feminisms: An Anthology of Literary Theory and Criticism* (New Brunswick, NJ: Rutgers University Press, 1991).

White, C. 'About Face', *Omnibus*, BBC (1994).

Whitford, M. (ed.). *The Irigaray Reader* (Oxford: Basil Blackwell, 1991).

Wittig, M. *The Straight Mind and Other Essays*, trans. M. Wildeman (Hemel Hempstead: Harvester Wheatsheaf, 1992).

Woolf, V. *A Room of One's Own* (1929), ed. and introduced M. Barrett (Harmondsworth: Penguin, 1993).

Individual Artists

The following are selected entries for some of the individual women artists discussed in the text. Where no article or book is devoted to an individual artist, there is no entry; where many works exist, the most relevant to this book have been chosen.

Karen Augustine
Augustine, K. 'Lesbians Get AIDS', *Matriart*, vol. 1, pt. 2 (summer/autumn 1990), p. 11.

–. 'Artist's Project: Joe/Not in Me', *Fuse*, vol. 15, pt. 6 (1992), pp. 35–7.

Rossella Bellusci
Cesoni, D. 'Rossella Bellusci: Le Declic Photographique', *Art Press*, no. 67 (February 1983), p. 34.

Ilse Bing
Barrett, N.C. *Ilse Bing: Three Decades of Photography* (New Orleans, LA: New Orleans Museum of Art, 1985).

Freund, G. Preface to *Ilse Bing: Women from the Cradle to Old Age: 1929-1955* (Paris: Des Femmes, 1982).

Persimmon Blackbridge
Blackridge, P. and Gilhooly, S. *Still Sane* (Vancouver: Press Gang Printers, 1985).

Patterson, P. 'Kiss and Tell: Representing Lesbian Sexuality', *Matriart*, vol. 1, pt. 2 (summer/autumn 1990), pp. 17–20.

Pat Booth
Booth, P. *Self Portrait* (London, Melbourne and New York: Quartet Books, 1983).

Ellis, A. 'Some Insights into the Work of Pat Booth', *British Journal of Photography*, vol. 130, pt. 42 (21 October 1983), pp. 1102–4.

Louise Bourgeois
Govoroy, J. *Louise Bourgeois* (New York: Bellport Press, 1986).

Meyer-Thoss, C. *Louise Bourgeois: Designing for Free Fall* (Cologne: Ammann Verlag, 1992).

Romaine Brooks
Breeskin, A.D. *Romaine Brooks* (Washington, DC: Smithsonian Institution Press, 1986).

Chila Kumari Burman
Burman, C.K. 'Power to the People: Fear of a Black Community', *Feminist Arts News*, vol. 3, pt. 9 (1991), pp. 14–15.

Nead, L. *Chila Kumari Burman: Beyond Two Cultures* (London: Kala Press, 1995).

Claude Cahun
Lasalle, H. and Solomon-Godeau, A. 'Surrealist Confession: Claude Cahun's Photomontages', *Afterimage*, vol. 19, pt. 8 (1992), pp. 10–13.

Lichtenstein, T. 'A Mutable Mirror: Claude Cahun', *Artforum*, vol. 30, pt. 8 (April 1992), pp. 64–7.

Phillips, C. 'To Imagine that I Am Another', *Art in America*, vol. 80, pt. 7 (July 1992), pp. 92–3.

Leonora Carrington
Chadwick, W. 'Leonora Carrington: Evolution of a Feminist Consciousness', *Woman's Art Journal*, vol. 7, pt. 1 (spring/summer 1986), pp. 37–42.

Helland, J. 'Surrealism and Esoteric Feminism in the Paintings of Leonora Carrington', *RACAR*, vol. 16, pt. 1 (1989), pp. 53–61.

Helen Chadwick
Chadwick, H. and Warner, M. *Enfleshings: Helen Chadwick* (London: Secker and Warburg, 1989).

Lingwood, J. 'Building the Self: "The Self Is a Project, Something to Be Built"', *Creative Camera*, no. 234 (June 1984), pp. 1412–15.

Paraskeva Clark
Redgrave, F. 'The Divine Grumpiness of Paraskeva Clark', *artmagazine* (summer 1983), pp. 58–9.

Tee Corinne
Grover, J. Z. 'Dykes in Context', *Ten.8*, no. 30 (autumn 1988), pp. 38–47.

Imogen Cunningham
Dater, J. *Imogen Cunningham: A Portrait* (London: Gordon Fraser, 1979).

Rule, A. (ed.). *Imogen Cunningham: Selected Texts and Bibliography* (Oxford: Clio Press, 1992).

Judy Dater
Enyeart, J.L. *Judy Dater: Twenty Years* (Tuscon: University of Arizona Press, 1986).

Phillips, D.-L. 'Personas of Women: Judy Dater', *Artweek*, vol. 15, pt. 13 (31 March 1984), pp. 15–16.

Margaret Dawson
Hurrell, J. 'The Vacillating Personas of Margaret Dawson', *Art New Zealand*, no. 47 (winter 1988), pp. 68–71.

Heather Dorrough
Dorrough, H. 'Self Portraits: Recent Work by Heather Dorrough', *Craft Australia*, pt. 4 (1982), pp. 30–7.

Mary Duffy
Duffy, M. 'Disability, Differentness, Identity', *Circa*, no. 34 (May/June 1987), pp. 30–1.

Mary Beth Edelson
Frueh, J. 'Revamping the Vamp', *Arts Magazine*, vol. 57, pt. 2 (October 1982), pp. 98–102.

Malaika Favorite
Favorite, M. 'Portrait of Self Contemplating Self: The Narrative of a Black Female Artist', *SAGE*, vol. IV, no. 1 (spring 1987), pp. 39–40.

Leonor Fini
Hubert, R.R. 'Surrealist Women Painters, Feminist Portraits', *Dada; Surrealism*, no. 13 (1984), pp. 70–82.

Lauter, E. 'Leonor Fini: Preparing to Meet the Strangers of the New World', *Woman's Art Journal*, vol. 1, pt. 1 (spring/summer 1980), pp. 44–9.

Gisele Freund
Catalogue de l'oeuvre photographique Gisele Freund (Paris: Centre National d'Art et de Culture Georges Pompidou, 1991).

'Gisele Freund', *Du*, pt. 3 (March 1993), pp. 12–73.

Cheri Gaulke
Raven, A. 'Passion Passage', *High Performance*, no. 21 (1983), pp. 14–17.

Elsa Haensgen-Dingkuhn
Elsa Haensgen-Dingkuhn: Arbeiten aus den Jahren 1920–80, exhibition catalogue (Hamburg: Kunsthaus, 1981).

Nina Hamnett
Hamnett, N. *The Laughing Torso* (New York: Richard Long and Richard R. Smith, 1932).

Marta Hegemann
Marta Hegemann: Leben und Werk, exhibition catalogue (Cologne: Kölnisches Stadtmuseum, 1989).

Florence Henri
Florence Henri: Artist-photographer of the Avant-garde, exhibition catalogue (San Francisco: San Francisco Museum of Modern Art, 1990).

Lyn Hershman
Dent, T. 'First Person Plural: The Work of Lyn Hershman', *Arts Magazine*, vol. 65, pt. 3 (1990), pp. 87–9.

Susan Hiller
Brett, G. Parker, R. and Roberts, J. *Susan Hiller 1973–1983: The Muse My Sister* (Londonderry: Orchard Gallery, 1984).

Hannah Höch
Adriani, G. *Hannah Höch 1889–1978: Collages* (Stuttgart: Institute for Foreign Cultural Relations, 1985).

Lavin, M. *Cut with the Kitchen Knife: The Weimar Photomontages of Hannah Höch* (New Haven, CT: Yale University Press, 1993).

Gwen John
Taubman, M. *Gwen John* (Aldershot: Scolar Press, 1985).

Grethe Jürgens
Reinhardt, H. and G. 'Grethe Jürgens – Künstlerin der Neuen Sachlichkeit', *Artis*, 2 (February 1981), pp. 12–13.

Sailer, H. *Grethe Jürgens* (Göttingen: Musterschmidt-Verlag, 1976).

Frida Kahlo
Herrera, H. *Frida: A Biography of Frida Kahlo* (London: Bloomsbury, 1989).

—. *Frida Kahlo: The Paintings* (London: Bloomsbury, 1991).

Zamora, M. *Frida Kahlo: The Brush of Anguish* (London: Art Data, 1990).

Mary Kelly
Kelly, M. *Post-partum Document* (London: Routledge and Kegan Paul, 1983).

Roshini Kempadoo
Gierstberg, F. 'Roshini Kempadoo: Cultural Identity and Representation',
Perspektief, no. 45 (December 1992), pp. 7–18.

Käthe Kollwitz
Käthe Kollwitz: Artist of the People, exhibition catalogue (London: South Bank
Centre, 1995).

Prelinger, E. *Käthe Kollwitz* (New Haven, CT: Yale University Press, 1992).

Germaine Krull
Bondi, I. 'Germaine Krull's Odyssey in Photography', *Print Search* (May/June
1978), pp. 4–7.

Lüpkes, M. 'Von Metallriesen und dem Wunsch, Sie Menschlicher zu Machen',
Fotographie, vol. 42, pt. 9 (September 1988), pp. 322–9.

Lotte Laserstein
Stroude, C. *Lotte Laserstein: Paintings and Drawings from Germany and Sweden,
1920–1970*, exhibition catalogue (London: Agnew and Belgrave Galleries,
1987).

Marie Laurencin
Marie Laurencin, exhibition catalogue (Paris: Galerie Daniel Malingue, 1986).

Marie Laurencin: Artist and Muse, exhibition catalogue (Birmingham, AL:
Birmingham Museum of Art, 1989).

Tamara de Lempicka
Néret, G. *Tamara de Lempicka: 1898–1980* (Cologne: Benedikt Taschen, 1993).

de Lempicka-Foxhall, K. and Phillips, C. *Passion by Design: The Art and Times of
Tamara de Lempicka* (Oxford: Phaidon, 1987).

Yolanda Lopez
Roth, M. (ed.). *Connecting Conversations: Interviews with 28 Bay Area Women Artists* (Oakland, CA: Eucalyptus Press, 1988).

Marevna
Marevna and Montparnasse, brochure to accompany exhibition (London: Wildenstein Gallery, 1992).

Marisol
Bernstein, R. 'Marisol's Self Portraits: The Dream and the Dreamers', *Arts Magazine*, vol. 59, pt. 7 (1985), pp. 86–9.

Grove, N. *Magical Mixtures: Marisol Portrait Sculpture*, exhibition catalogue (Washington, DC: National Portrait Gallery, 1991).

Rosy Martin
Martin, R. 'Dirty Linen', *Ten.8*, vol 2, no. 1 (spring 1991).

—. 'Don't Say Cheese, Say Lesbian', in J. Fraser and T. Boffin (eds), *Stolen Glances – Lesbians Take Photographs* (London: Pandora Press, 1991), pp. 94–105.

—. 'Unwind the Ties that Bind', in J. Spence and P. Holland (eds), *Family Snaps: The Meanings of Domestic Photography* (London: Virago, 1991).

Martin, R. and Spence, J. 'New Portraits for Old: The Use of the Camera in Therapy', *Feminist Review*, no. 19 (March 1985). Anthologised in R. Betterton (ed.), *Looking On*, (London: Pandora Press, 1987).

Ana Mendieta
Barreras del Rio, P. and Perreault, P. *Ana Mendieta: A Retrospective*, exhibition catalogue (New York: New Museum of Contemporary Art, 1987).

Varvalho, J. 'The Body/The Country', *Heresies*, vol. 7, pt. 3 (1993), pp. 43–51.

Paula Modersohn-Becker
Oppler, E.C. 'Paula Modersohn-Becker: Some Facts and Legends', *Art Journal*, vol. xxxv, no. 4 (summer 1976), pp. 364–9.

Perry, G. *Paula Modersohn-Becker: Her Life and Work* (London: Women's Press, 1979).

Mariko Mori
Haye, C. Review of Mori in *Frieze*, no. 24 (September/October 1995), p. 68.

Hanna Nagel
Hanna Nagel: Frühe Arbeiten 1926–1934, exhibition catalogue (Karlsruhe: Staatliche Akademie der Bildende Kunst, 1981).

Rühmer, E. *Hanna Nagel*, exhibition catalogue (Freiburg, 1973).

Alice Neel
Allara, P. *Alice Neel: Exterior/Interior*, exhibition catalogue (Medford, MA: Tufts University Art Gallery, 1991).

Castle, T. 'Alice Neel', *Artforum*, vol. 22, pt. 2 (October 1983), pp. 36–41.

Anne Noggle
Noggle, A. *Silver Lining: Photographs by Anne Noggle* (Albuquerque, New Mexico: University of New Mexico Press, 1982).

Orlan
Rose, B. 'Is it Art? Orlan and the Transgressive Act', *Art in America*, vol. 81, pt. 2 (February 1993), pp. 82–7.

Gerta Overbeck
Reinhardt, H. 'Gerta Overbeck (1898–1977): Eine Westfälische Malerin der Neuen Sachlichkeit in Hannover', *Niederdeutsche Beitrage für Kunstgeschichte*, vol. 18 (1979), pp. 225–48.

Reinhardt, H. and G. with M. Jochimsen, *Grethe Jürgens, Gerta Overbeck: Bilder der zwanziger Jahre*, exhibition catalogue (Bonn: Rheinisches Museum, 1982).

Jenny Saville
Brittain, D. 'Interview with Jenny Saville', *Creative Camera* (June/July 1995), pp. 24–9.

Eva Schulze-Knabe
Eva Schulze-Knabe: 1907–1976, exhibition catalogue (Dresden: Gemäldegalerie Neue Meister, 1977).

Uhlitzsch, J. 'Unser ist ihr Werk', *Dresdener Kunstblatter*, vol. 21, no. 1 (1977), pp. 15–19.

Joan Semmel
Marter, J. 'Joan Semmel's Portraits: Personal Confrontations', *Arts Magazine*, vol. 58, pt. 9, (May 1984), pp. 104–6.

Cindy Sherman
Hill, L. 'The Changing Face of Cindy Sherman', *Women's Art Magazine*, no. 40 (May/June 1991), p. 25.

Krauss, R. *Cindy Sherman 1975–1993* (Milan: Rizzoli, 1993).

Renée Sintenis
Kiel, H. *Renée Sintenis* (Berlin, 1956).

Sylvia Sleigh
Bowman, R. and Adrian, D. *Sylvia Sleigh: Invitation to a Voyage and Other Works*, exhibition catalogue (Milwaukee, WI: Milwaukee Art Museum, 1990).

Jo Spence
Spence, J. *Putting Myself in the Picture* (London: Camden Press, 1986).

—. 'Disrupting the Silence: The Daughter's Story', *Women Artists Slide Library Journal*, no. 29 (June, July 1989), pp. 14–17.

—. *Cultural Sniping: The Art of Transgression* (London: Routledge, 1995).

Annie Sprinkle
Pasternak, A. 'Annie Sprinkle', *JCA*, vol. 5, pt. 2 (autumn 1992), pp. 100–13.

Grethe Stern
Hambourg, M.M. 'Photography between the Wars: Selections from the Ford Motor Company Collection', *Metropolitan Museum of Art Bulletin*, vol. 45, pt. 4 (spring 1988), pp. 1–56.

Lavin, M. 'Ringl and Pit: The Representation of Women in German Advertising, 1929–33', *Print Collector's Newsletter*, vol. 16, pt. 3 (July/August 1985), pp. 89–93.

Diana Thorneycroft
Brunner, A. 'Diana Thorneycroft: Touching: the Self', *Blackflash*, vol. 9, no. 2 (summer 1991), pp. 7–12.

Enright, R. 'Touching the Self: Diana Thornycroft-Pura [sic] – Recent Photographs', *Border Crossings*, vol. 9, pt. 4 (autumn 1990), pp. 68–73.

Charley Toorop
La Beauté exacte: Art, Pays-Bas, XXe siècle, exhibition catalogue (Paris: Musée d'Art Moderne de la Ville de Paris, 1994).

Hannah Wilke
Kochheiser, T., Wilke, H. and Frueh, J. *Hannah Wilke: A Retrospective*, exhibition catalogue (St. Louis, MO: Gallery 210, 1989).

Wooster, A.-S., 'Hannah Wilke: Whose Image Is It?', *High Performance*, vol. 13, pt. 3 (autumn 1990), pp. 30–43.

Index